BEVERLY PEPPER

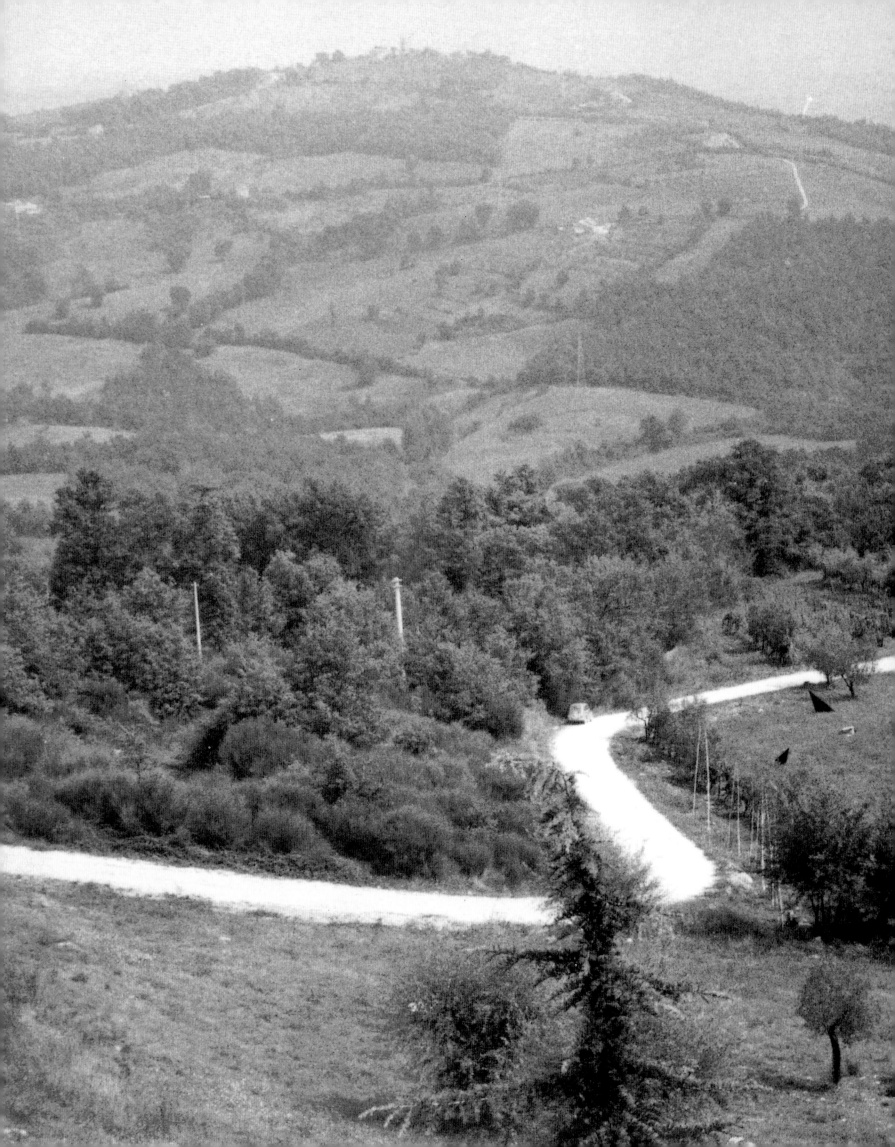

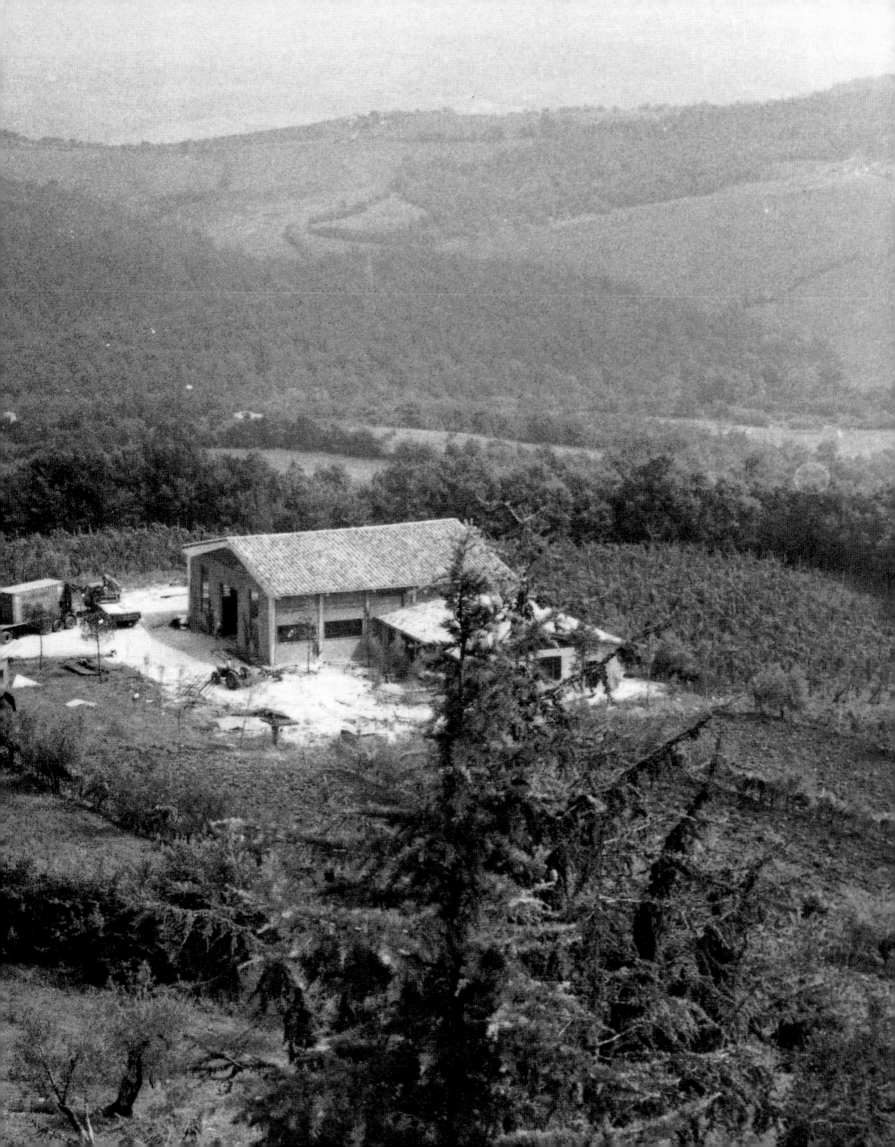

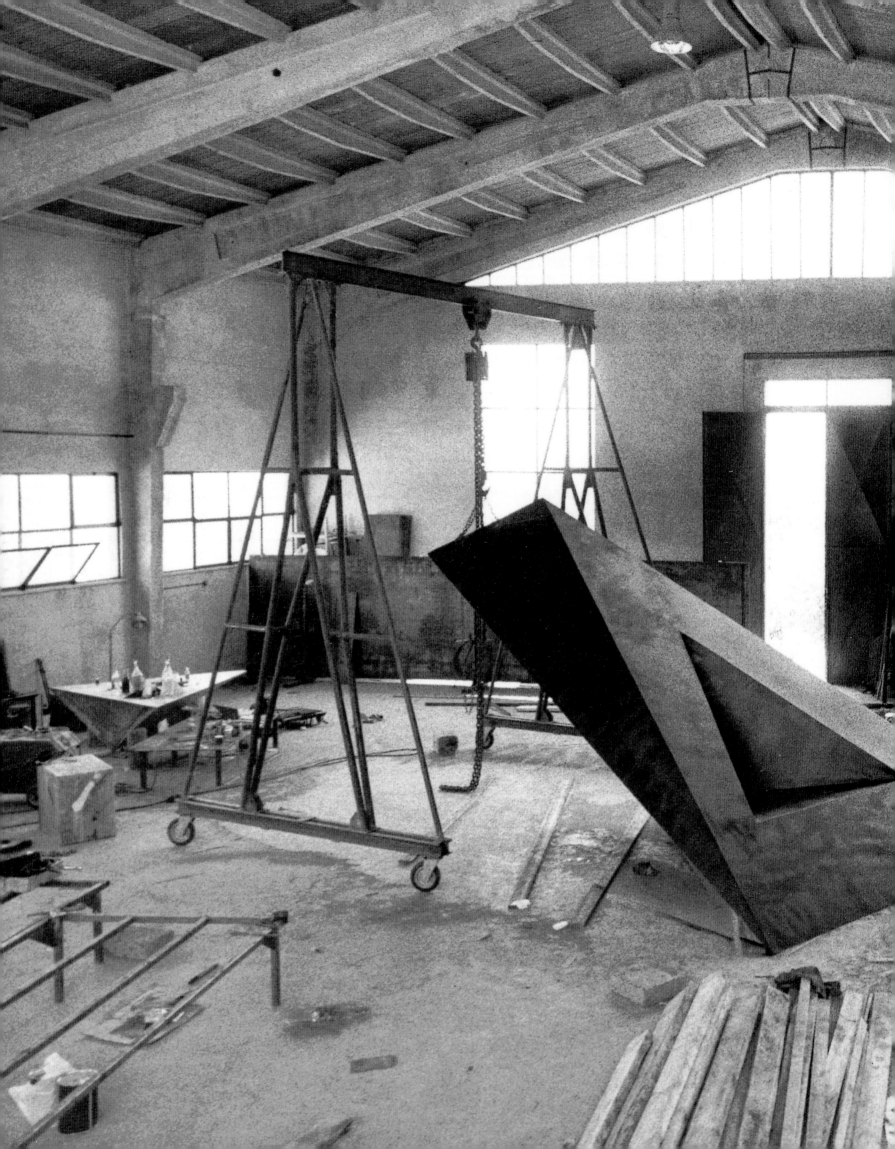

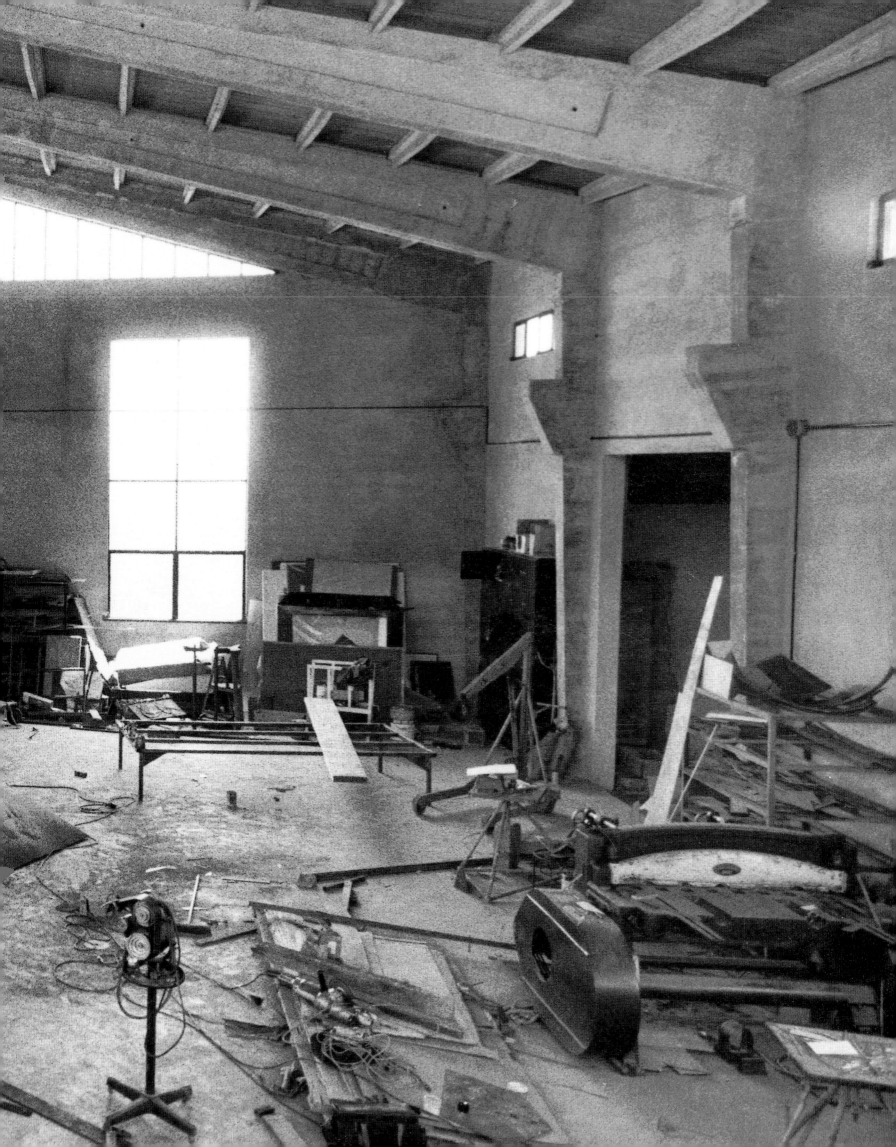

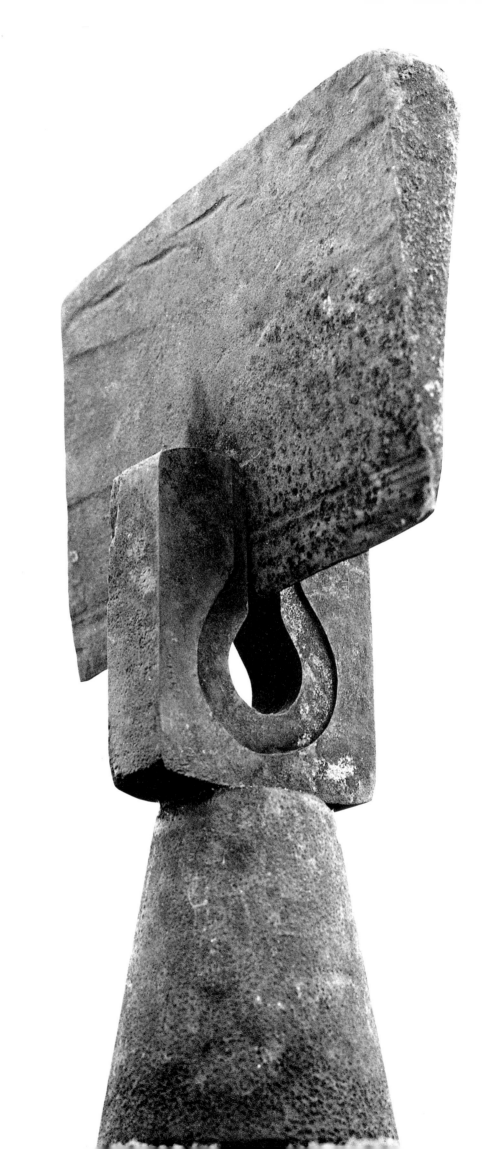

BY ROSALIND E. KRAUSS

WITH AN INTRODUCTION BY
DOUGLAS G. SCHULTZ

BEVERLY PEPPER
SCULPTURE IN PLACE

ALBRIGHT-KNOX ART GALLERY · BUFFALO

ABBEVILLE PRESS · PUBLISHERS · NEW YORK

This publication was prepared on the occasion of the exhibition, "Beverly Pepper: Sculpture in Place," organized by Douglas G. Schultz, Director, Albright-Knox Art Gallery. The exhibition was made possible, in part, with public funds from the New York State Council on the Arts and the National Endowment for the Arts. It was also made possible by a grant from GFI/Knoll International Foundation.

September 13–November 2, 1986
ALBRIGHT-KNOX ART GALLERY

December 11, 1986–February 8, 1987
SAN FRANCISCO MUSEUM OF MODERN ART

March 22–May 10, 1987
COLUMBUS MUSEUM OF ART

June 5–August 24, 1987
THE BROOKLYN MUSEUM

September 27–November 1, 1987
CENTER FOR THE FINE ARTS, MIAMI

Designers: Alex and Caroline Castro, Hollowpress, Baltimore

Editors: Georgette Hasiotis, Albright-Knox Art Gallery
Alan Axelrod, Abbeville Press

Production supervisor: Hope Koturo

Inquiries should be addressed to Abbeville Press, Inc., 505 Park Avenue, New York 10022.

Printed and bound in Japan.
First Edition

Library of Congress Cataloging-in-Publication Data

Krauss, Rosalind E.
 Beverly Pepper.
 Published in conjunction with a major exhibition of the Albright-Knox Art Gallery from Sept. 1986–Jan. 1987.
 Bibliography: p.
 Includes index.
 1. Pepper, Beverly—Exhibitions. I. Pepper, Beverly. II. Albright-Knox Art Gallery. III. Title.
NB237.P38A4 1986 730'.92'4 86-7931
ISBN 0-89659-667-2
ISBN 0-89659-671-0 (pbk.)

Cover: Detail, *Basalt Ritual,* 1985–86
Opening illustrations:
Pages 2–3: View of the artist's studio
Pages 4–5: Interior of the artist's studio
Opposite title page: *Damiano Wedge,* 1978

CONTENTS

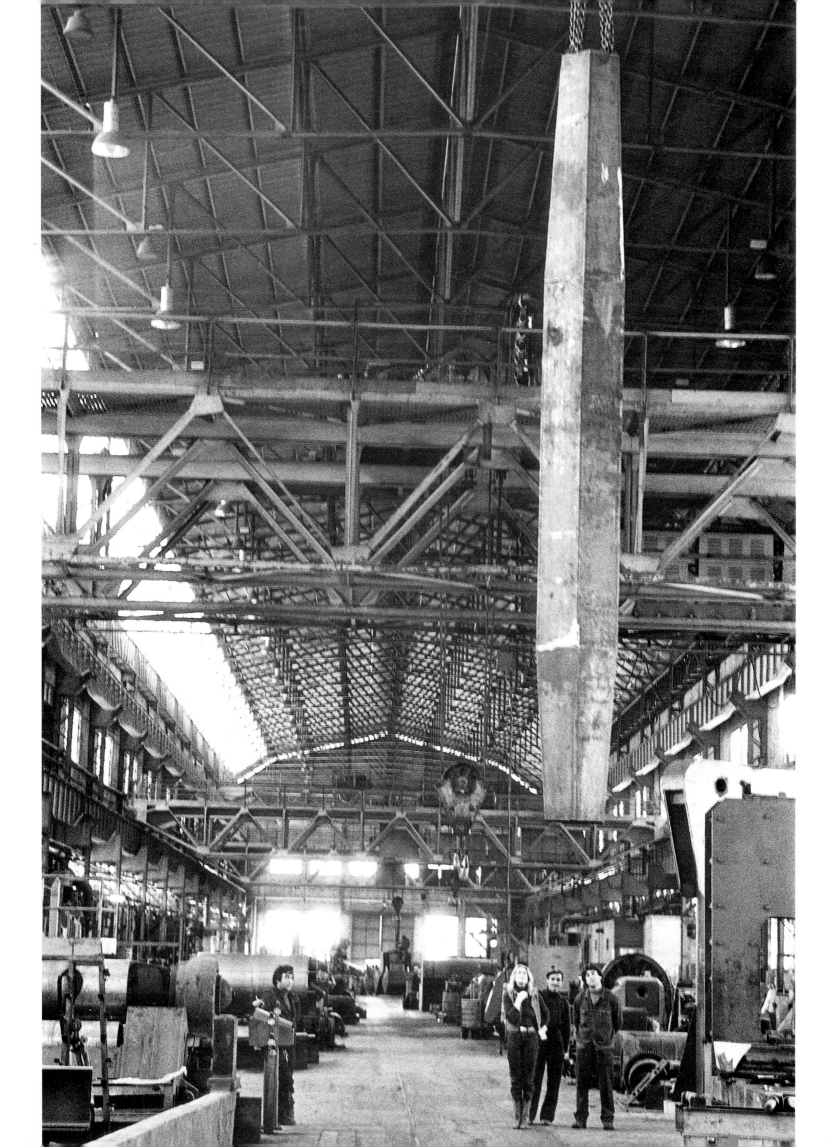

PREFACE

The exhibition on which this book is based, "Beverly Pepper: Sculpture in Place," provides a comprehensive view of the artist's work from 1965 to the present. It has been organized over a four-year period, during which I made several visits to the artist's studios in New York and Todi. My continuing dialogue with Beverly Pepper and the direction of the exhibition have provided me with an opportunity to know her work closely, yet have enabled me to see it within a larger art-historical framework. There is a consistency of vision running throughout the artist's work, which is evident in the particular gathering of works for the exhibition. A thorough understanding, however, is possible only by viewing her entire oeuvre; for this reason, numerous early works as well as site-specific projects not included in the exhibition are presented in this volume.

Sculptures dating from before 1965 are of particular importance as supporting references to the text by Rosalind Krauss. Her essay establishes, in the most personal and engaging manner, the logical connections inherent in Pepper's seemingly random pursuits. Drawing on her long friendship with the artist and ongoing knowledge of her work, Professor Krauss has analyzed the infrastructure of her work, giving the reader a unique view of Beverly Pepper's strong aesthetic concerns.

Although almost every piece in the exhibition is illustrated here, the number of works in this book far exceeds the number in the exhibition. This is as much due to the monumental scale of many of her sculptures—which poses sometimes insurmountable difficulties for transport—as to the site-specific nature of her environmental works. The physical limitations of space for an exhibition have also been a factor. However, to everyone who has been involved in the project, it seems appropriate that the book and the exhibition should differ: a focused exhibition and a general survey volume complement and support each other. Together they make possible the most comprehensive understanding of the artist's work to date.

Douglas G. Schultz
Director, Albright-Knox Art Gallery

The artist at work on Piazza di Todi columns in the Terninoss Steel Mill, Terni, Italy, 1979

11

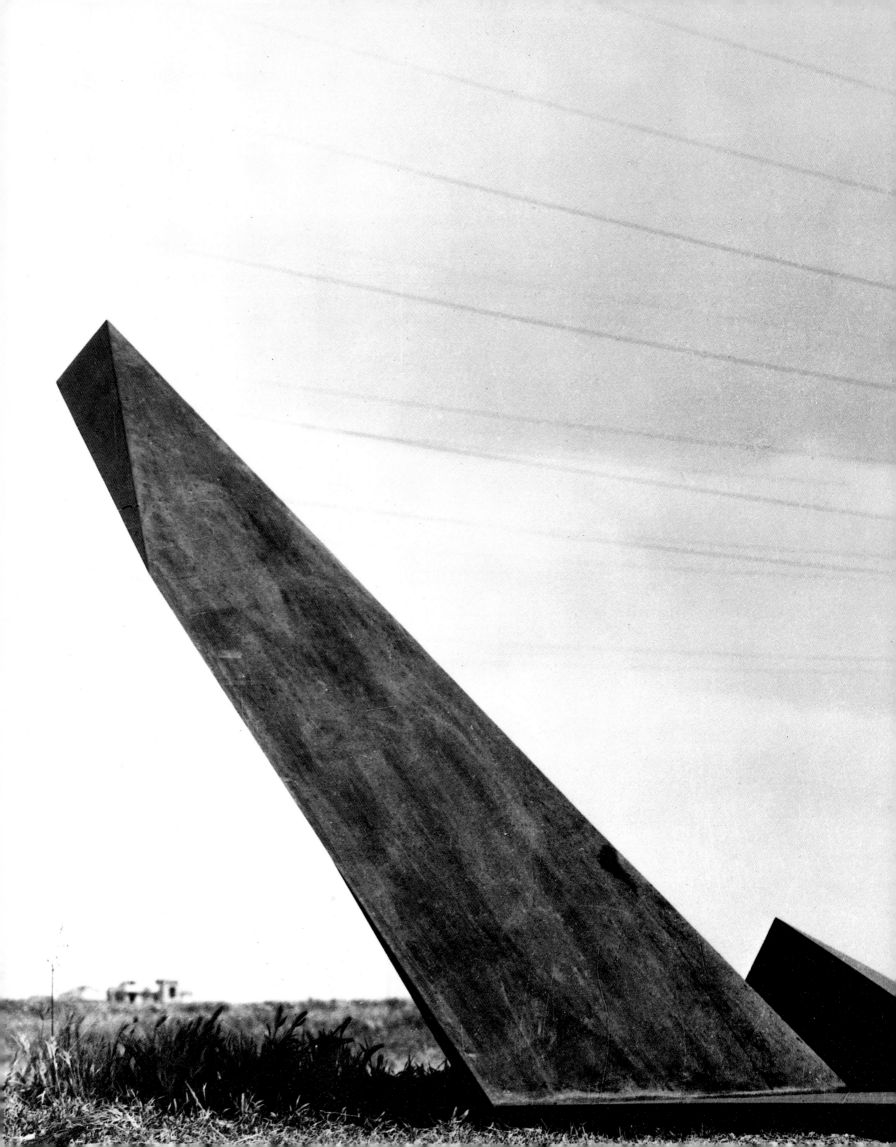

INTRODUCTION

The abstract language of form that I have chosen has become a way to explore an interior life of feeling I wish to make an object that has a powerful presence, but is at the same time inwardly turned, seeming capable of intense self-absorption.[1]

Beverly Pepper

Although based on the artist's experiences over the years 1960–75, this statement actually declares the goals that Pepper is seeking in her work right up to the present.

In the late '50s, Pepper, who had been trained as a painter, began to experiment with sculpture, producing expressive wood carvings that embodied figurative connotations but were nevertheless abstract. The emotive power of sculpture became even more evident to the artist after a 1960 visit to Angkor Wat. Two years later, she was among the artists invited to create a sculpture for the *Festival dei due mondi* at Spoleto, an occasion that hastened her direct participation in factory production and also involved her with the work of fellow Festival artists David Smith and Alexander Calder. By the mid '60s, Pepper had evolved a sculptural vocabulary of strong geometric forms, was confident of the direction of her aesthetics, and had developed a good working relationship with the fabricators and the factories necessary to the realization of her sculpture. She experimented with many large-scale sculptures that engaged the space around them, and she continued to challenge herself by inventing new relationships within her vocabulary of form and by mastering new technologies with which to create

Dallas Pyramid, 1971

13

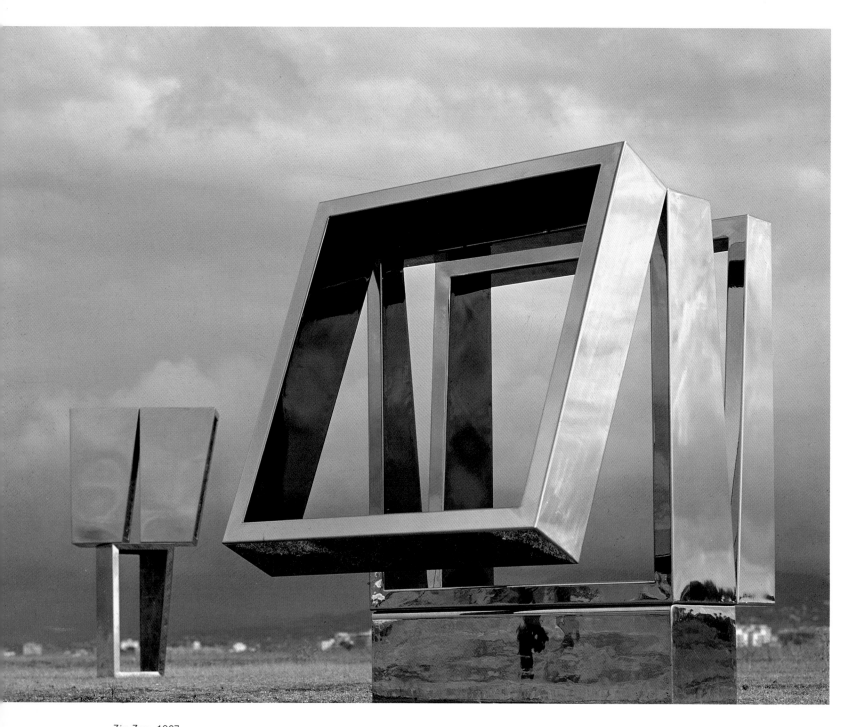

Zig Zag, 1967

the degree of monumentality and physical presence her psyche required.

By the late '60s, Pepper was using highly polished stainless-steel exteriors with painted interior planes, so that the works reflected the surrounding environment, and their voids became an integral part of the composition. The reflective quality of the material permitted the sculpture to "dissolve," allowing the earth and sky around it to become an extension of the work's physical presence.

Pepper's drive toward monumentality, however, was limited by the scale of even these constructions. As a result, she vastly enlarged her works and their relationship to the environment in a series of earthbound geometric sculptures completed in the 1970s. And she explored other creative possibilities, using shifting planes to create effects of perspective that result in the apparent perception of constantly changing configurations of form. She also cantalevered her work into space: massive geometric shapes, primarily triangular, conduct the sculpture's dialogue with its surroundings.

A 1977 variation on earlier themes appeared in a series of weblike constructions in which the artist stripped bare the defining planes of the sculpture and exposed its vulnerable substructure—thus engaging the viewer in a work that initially seems unstable in relation to its static surroundings. This movement toward a more linear quality in her sculpture implied connection to the burgeoning compositions of the early '60s, mainly in bands of metal welded together. Later, linearity would be explored further in totemic sculptures composed of strong elemental shapes akin to her work of 1971 to 1975.

Damiano Wedge (1978) and *Goliath Wedge* (1978) are small and intimate. Composed of primal forms, made of forged steel, their shape and surface finish seem to have been inspired by ancient artifacts. Their proportions possess a votive quality reminiscent of ceremonial and ritual objects, and they foreshadow the powerful contemplative quality of the large-scale columns she would create over the next two years. Pepper redefined these forms, creating taller, slimmer, more elongated columns and, later, monolithic "urban altars." As with the statuary and edifices she saw at Angkor Wat, her sculptures invested their surroundings with a sacred aura. Made of cast iron and rising up to ten feet, such works as *Claudio Column* (1979–80) and *Normanno*

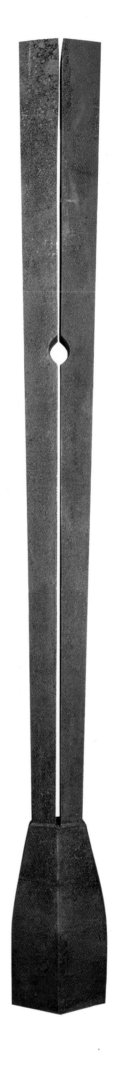

Normanno Column, 1979–80

15

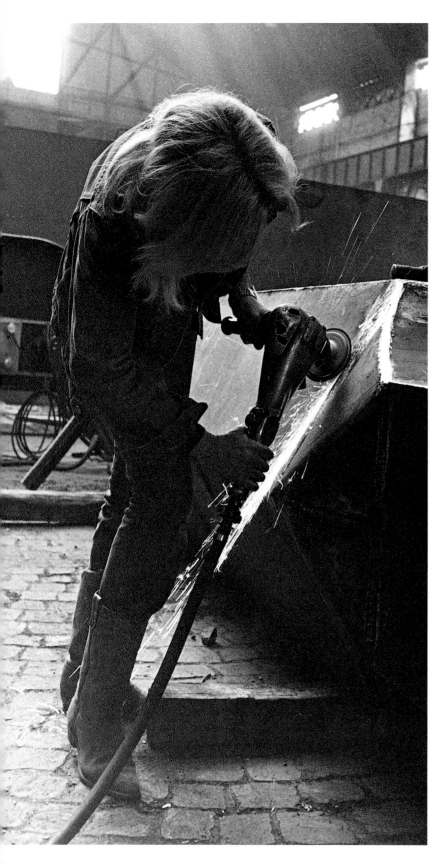

The artist at work in the Terninoss Steel Mill, Terni, Italy, 1979

Column (1979–80) function as markers or sentinels, evoking sacred powers and a sense of ceremony. Various elements work together, often in tripartite configurations, to emphasize the weight of each piece and its strong, even majestic physical presence. At the same time, the artist created works with long narrow slits and/or bored holes, compositions capable of dialogue among form, light, and the defined spaces. The artist's exquisite mastery of proportion and the interplay of forms resulted in vertical compositions of great grace and nobility.

In 1981, Pepper began working single columns into groupings, such as *Ursalan Plaza*, and she continued to make monolithic structures like *Mute Metaphor*. In a continuing refinement of this theme, her more recent works place greater emphasis on machine-tooled precise fabrication and on surface qualities. For example, *Solitary Messenger* (1982) manifests her affinity for industrial machinery, stemming from years spent in factories, fabricating her own sculpture. The use of patinated and expressionistic polychrome surfaces and the addition of carved and polished wood elements increased the primitive, exotic quality of works like *Tranquil Messenger* (1983), in which materials and shapes become more organic and suggestive of nature in a rooted abstract presence.

Pepper has most recently concentrated on a series of "urban altars," works composed of archetypal forms that extend, both literally and figuratively, the 1975 statement—quoted above—about monumental presence. Although she considers *Ternana Wedge* (1980) to be the first in this series, the basis of these new works was actually present in the small votive objects she made in 1977–78. A larger archetypal form, such as *Janus Agri-Altar* (1985–86), is evocative of a massive shovel form—its commanding presence created out of the simplicity of an ageless tool. This work is emblematic of Pepper's enduring ability to create a sense of monumentality through concept, as opposed to scale alone. As in her oeuvre of the past twenty years, Pepper creates a sense of archaeological minimalism through simple forms and surfaces.

Apart from those sources, conscious and unconscious, that are a part of every artist's development, Pepper has worked within the context of modernist sculptural development, drawing on such movements as Constructivism, Assemblage, and Minimalism. *The Messenger* (1982–83) and

Normanno Wedge, 1980; *Ternana Wedge,* 1980

16

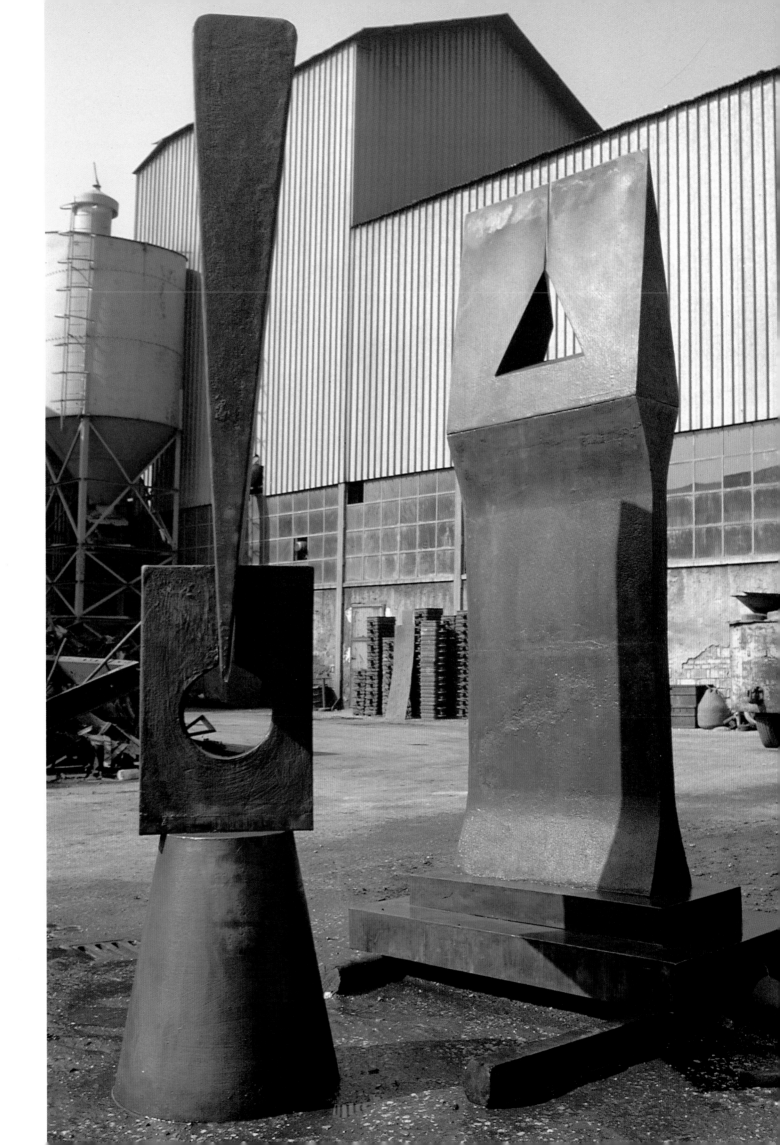

Philemon, 1983–84; *Aristo*, 1983–84; *Gaia*, 1983–84

Santoni (1983–84) series have an affinity with the Assemblage movement: various hand-tooled elements, such as exotic woods, brass, and other metals, are fitted into a unified whole. Many of the forms are inspired by industrial products—ranging from a nineteenth-century Italian cast-iron lamppost to everyday machine tools. Yet, unlike Arman or Chamberlain, both of whom epitomize Assemblage by their use of the waste products or found objects of industrial society, Pepper transforms and recreates new forms from the old.

Her work has often been analyzed within the context of Constructivism, generally regarded as an aesthetic movement based on logic, structure, abstraction, geometry, and forms in which voids are vitally important. Superficially at least, all of these qualities are present in Pepper's sculpture, but her handling of surface—whether reflective, as in *Zig Zag* (1967), heavily textured, as in *Dallas Pyramid* (1971), or grooved and scored, as in *Sentinel Marker* (1981) and *Coupled Column* (1981)—is essentially expressionistic, the constant presence of the artist's hand having little in common with the precise, machinelike elements so closely associated with Constructivism.

The artist also has been identified with Minimalism occasionally. And here again, it is possible to isolate formal qualities of her work that conform to its aesthetics: simplicity, nonreferential forms, unitary modules, factory fabrication. *Dunes* (1971) and *Exodus* (1972) are suitable examples; however, even these sculptures, unlike the works of such leading exponents of Minimalism as Carl Andre and Sol LeWitt, are not entirely devoid of symbolic content.

Having lived for many years in Italy, a country rich in monumental historical and cultural references—Roman ruins, cathedrals, piazzas, medieval towers that preside over hilltowns, and the austere ceremonial edifices of buildings from the Fascist era—Pepper is ever mindful of history. Almost without exception, her sculptures may be read as timeless references that nevertheless maintain a vital dialogue between past and present, between primary sculptural forms—whether geometric or organic—and the antecedents of ceremonial architecture. Like the builders of the pyramids, ancient temples, and other heroic monuments and memor-

Janus Agri-Altar, 1985–86

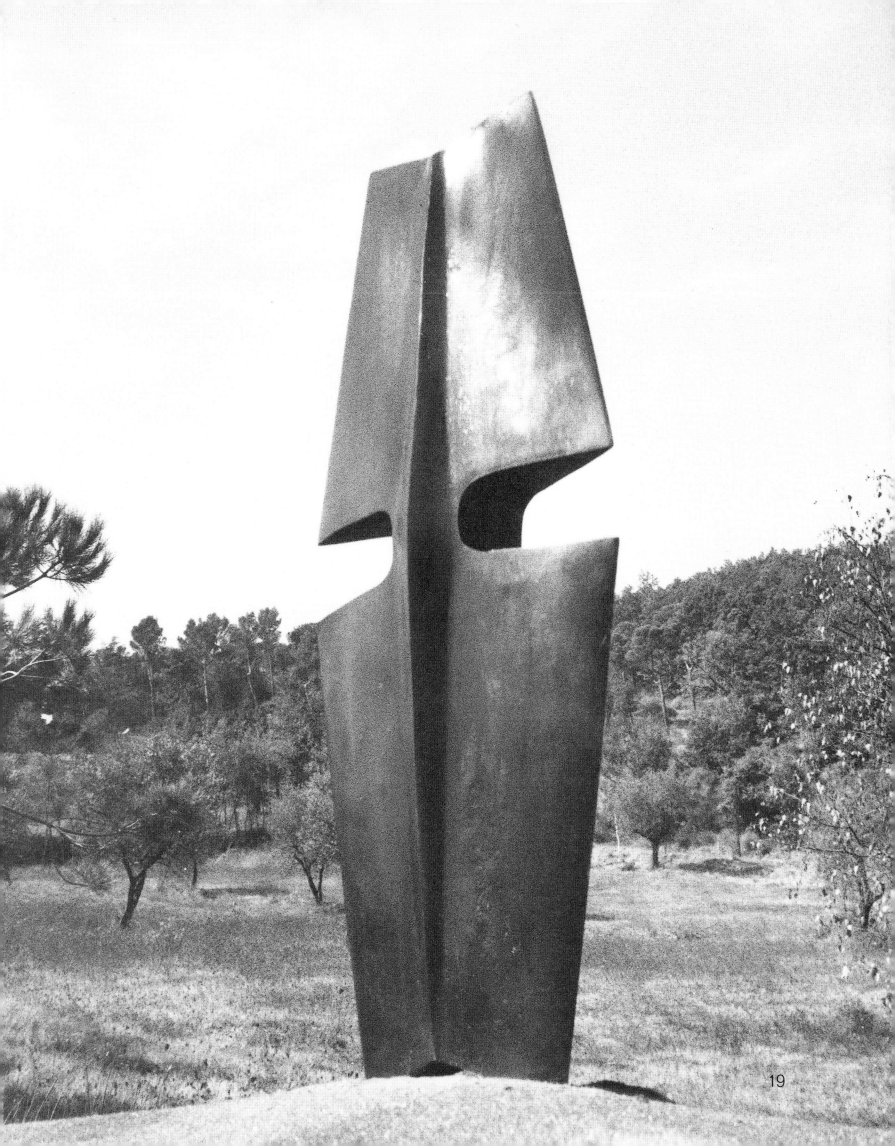

19

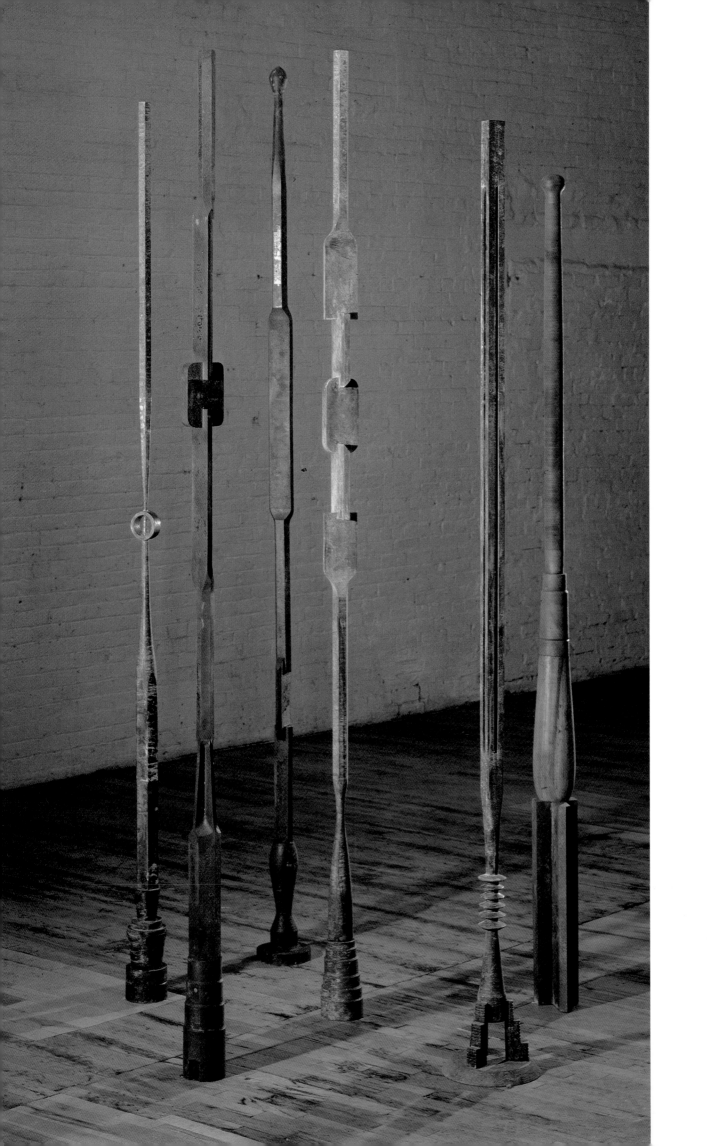

ials of the past, Pepper invests the pastoral and urban spaces of contemporary society with a ritual and spiritual aura.

In her work of the past twenty years, it is clear that the artist—while conscious of aesthetic movements, particularly those of twentieth-century sculpture—has followed her own instincts. She has reflected on her technical and artistic achievements and created an abstract yet spiritual body of work that realizes the potential emotional power in three-dimensional form.

Douglas G. Schultz

1. Quoted in "Statements by Sculptors," *Art Journal* (New York), XXXV, no. 2 (Winter 1975–76), p. 127.

Checkmate Diad: Nefetari Column and *Rameses Column*, 1985

Opposite: *Atavist Messenger*, 1982; *Archetypal Messenger*, 1982; *Stalwart Messenger*, 1982; *Solitary Messenger*, 1982; *Vestigial Messenger*, 1982; *Cryptic Messenger*, 1982

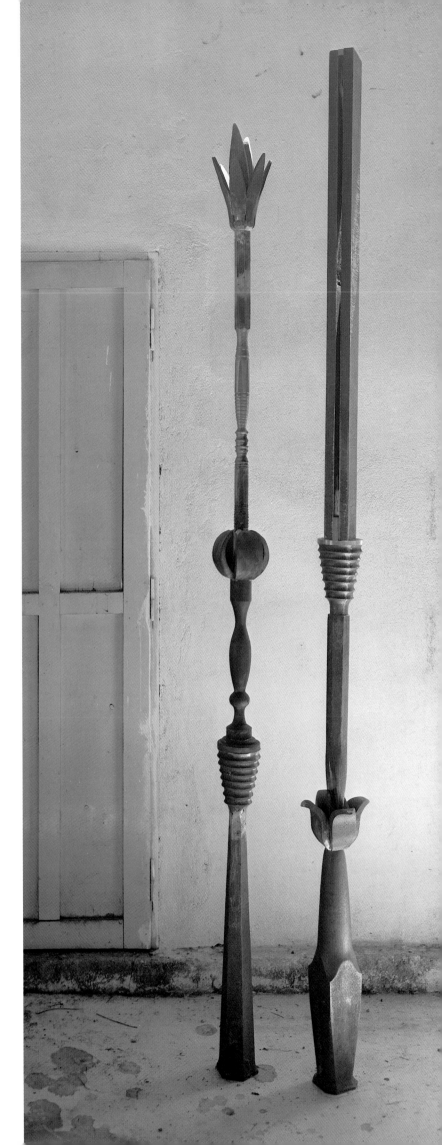

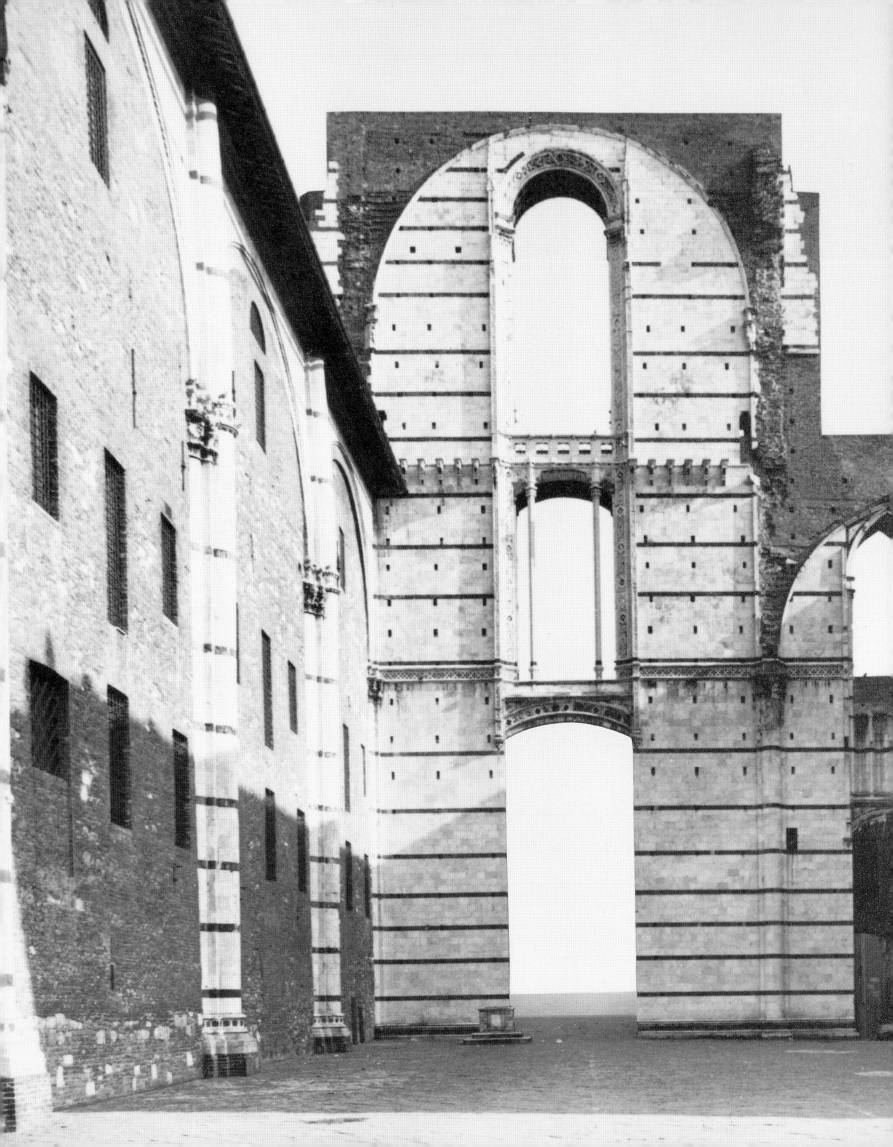

BEVERLY PEPPER
IN SUN AND SHADE

It was a brilliant July day in 1980, and Beverly Pepper was in Siena, with friends. During the thirty years that she had lived in Italy she had constantly returned to Siena, to feel the majestic security of its campo, to renew the shock of insistent ferocity of its cathedral, striated everywhere—on columns, on piers, on the walls of the nave—with running bands of black and white that seemed to armor the building's interior, to sheath its stones as though for battle, to give to their clustered mass a crystalline sharpness and clarity so that each pillar, each architectural profile, seemed to leave the imprint of its weight on the brain.

That day she had approached the Duomo from its eastern end, where early in the fourteenth century the city fathers had built a baptistry below the church to serve as the foundation for an enlarged and glorified apse for the already finished cathedral. It was necessary, then, to mount from the site of the baptistry to the plane of the Piazza del Duomo and enter the cathedral square through a deeply shaded archway. Anticipating the authoritative mass of the building on her right, its glittering right angles articulated in the linear black-and-white idiom of the Tuscan Romanesque, she looked left for a moment and saw what she had seen dozens and dozens of times without really concentrating on. So that that day she saw it as though for the first time.

It was a huge perforation, a giant architectural lacuna, stretching in exquisitely useless perfection across the press-

Wall in Siena, Italy

23

ing blueness of the sky. It was something that was nothing. It was monumental. It was glorious.

It had derived from a plan of preposterous grandiosity born of Siena's rivalry with Florence and its desire to best Orvieto. A new cathedral was to have been built using the old one as its short, crossing arms. The new one was to more than double the volume of the earlier building and to rise to twice its height. All that materialized of this scheme is a portion of the front wall of the never-realized nave. Isolated, meaningless, it rises above the other buildings that flank the piazza, as though it were an elegant partition in an immense, unbuilt room. Faced with white marble sparingly striped in black, it is defined simultaneously as a rectangular plane and a semicircular arch, for its pale surface comes to an abrupt end where the structure of the vaulting was to have extended forward into space, leaving the darkened trace of incompletion like an oval mat that vignettes the upper corners of the plane. And as if to emphasize the leap toward nothing of the archlike shape that concludes this wall, its surface is pierced by a large Gothic window that almost breaks through the summit of the dark profile of the uppermost border of the arch/plane.

Two sets of impossible contradictions come together in the image of this enormous, useless screen. It is at once an inside and an outside surface; and it is a structure working to support nothing.

On the piazza swarming with tourists heading toward the Duomo, Beverly Pepper stood facing the other way, stunned by the vision of this huge, derelict remnant, effortlessly transcending gravity in front of the impassive witness of the sky.

"One day," she said, "one day, I will use this extraordinary thing."

☐

Model, with photomontage, *Pontiac Fountain,* 1982
Pages 26–27: Model, *Pontiac Fountain,* 1982

24

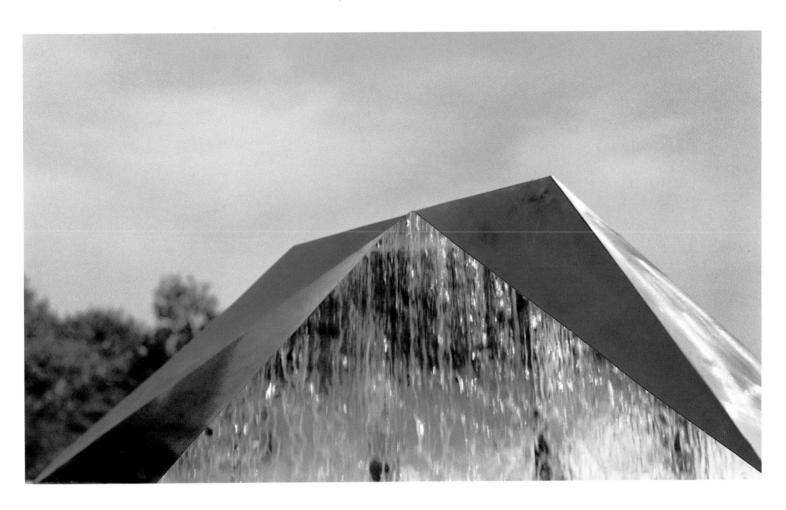

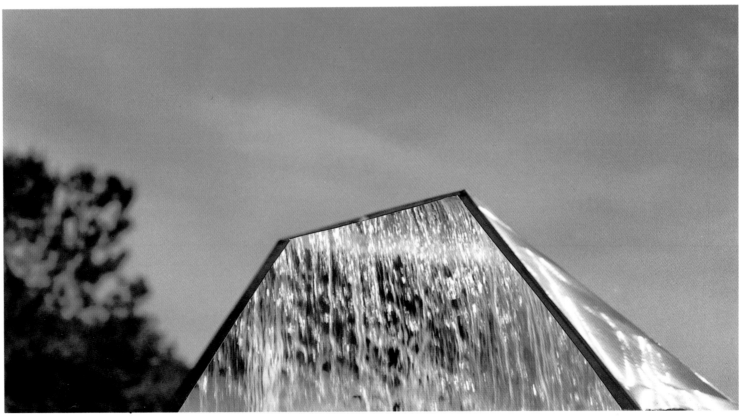

Why then, you may ask, does she show the Michelangelo when she gives her talk about the fountain?

The fountain, designed by Pepper for Pontiac, Michigan, is an apparent arch. Across a span of seventy feet, two stainless-steel prisms stretch thirty feet into the air and incline toward each other, almost touching at the inner points of their upward reach. At once enormous and seemingly fragile, each prism is poised on the ground along one edge only, while its entire volume moves skyward, as if to balance against its mirror element high in the air. That the two prisms do not touch and therefore seem deprived of any means of support, and that the extremely abrupt contrast of light and shadow from one face of the prism to another produces an experience of the volumes in terms of silhouette, allows one visually to reduce the mass of the work to nothing more substantial than the illusory "image" of an arch. The two-dimensionality of this "image" is then the visual support for the fountain's wall of water, a vertical sheet that appears to hang from the upper edges of the form.

From certain angles the water appears to close the work, to function as the side of a trapezoidal solid, one face of which is formed by this vigorous, liquid screen. From that view the fountain conveys a sense of volume, the inner depths of which one will reach by lifting the veil of water. From the other side, where the veil *is* lifted, the water falls as background behind the image of the two prisms as they reach, silhouettes falling through space, to catch each other in the stabilizing embrace of the wholly fictional "arch."

She was putting away a tray of slides that she had used for a lecture on her work. In the part about the fountain there had been a slide of the Sistine ceiling. It was a detail from the Creation of Adam panel, a blow-up of that image we almost cannot bear to look at any longer: that arch of life that is about to be built when the erectile forefinger of God touches the lax hand of Man. "You will hate me," she said, "for comparing this to the fountain."

In that vast catalogue of images that each of us carries in his brain—the catalogues of some stuffed fuller than those of others—those two fingers, almost touching, could certainly be related to the silhouette formed by a wall almost eroded by the arch of a window erected to support nothing in the heart of Siena. Why not? The only thing wrong with the Michelangelo image is that it is not, strictly speaking, how she got to the fountain. So it avoids the inner logic of the analogies that drive art, that cause someone at one time and not another to stand, transfixed, in front of a soaring, useless wall.

□

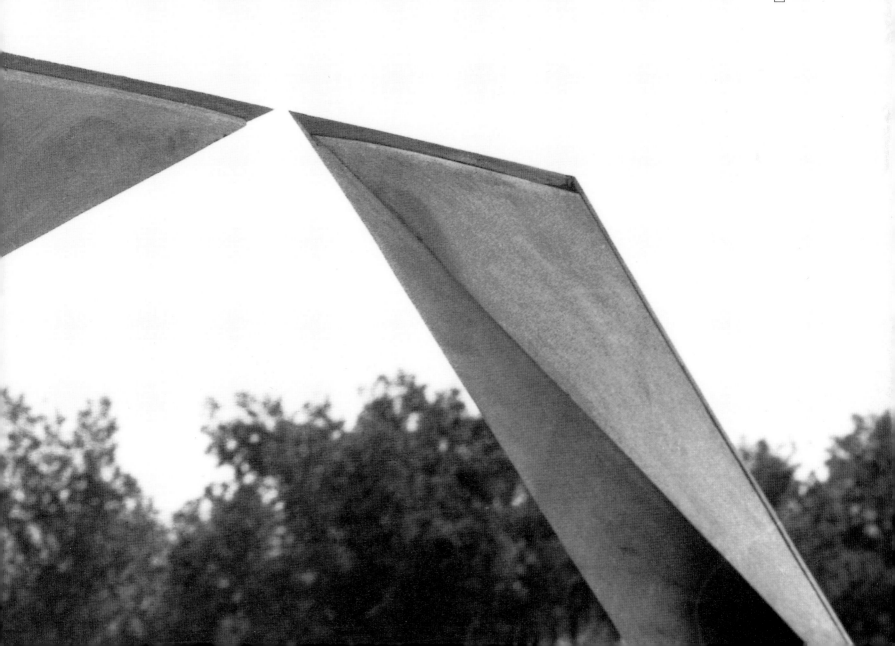

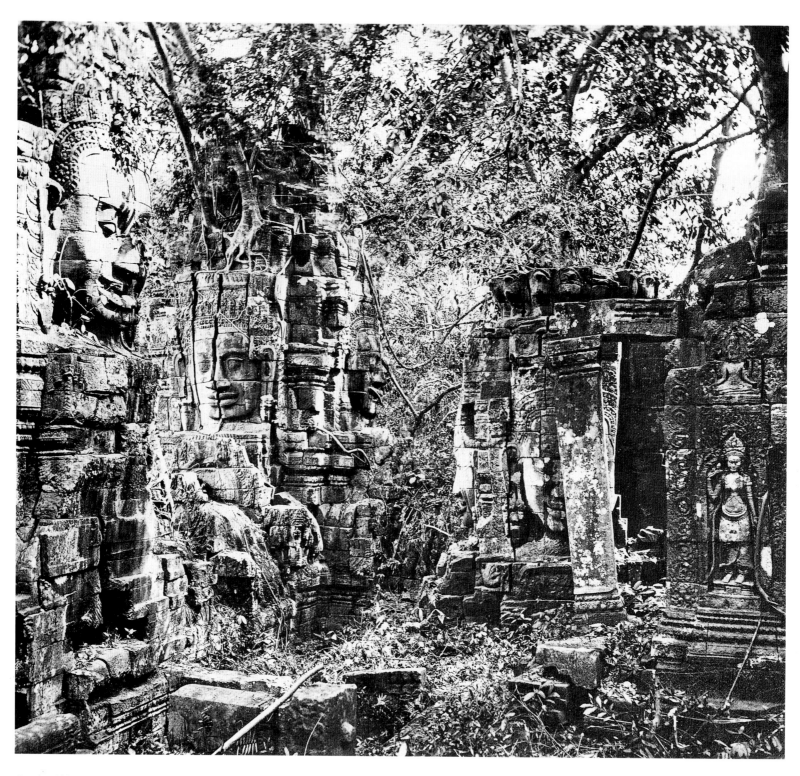

Angkor Wat

For example, what does it mean to say, as she once did, "In 1960, I walked into Angkor Wat a painter and I left a sculptor"?[2]

Conversions, sudden conversions, are frequent in the biographies of artists, you might reply. And particularly for an artist developing in the 1950s, in the shadow of the rampant success of Abstract Expressionism. In the talk that surrounded '50s Action Painting—the talk of critics like Harold Rosenberg—conversion was thought to be necessary to the *vocation* of artist, a kind of baptismal event through which one passed into art: "the saving moment," as Rosenberg reflected on these painters' careers, "in *his* [we now add for him, *her*] story."[3]

But this moment that Pepper names is precise, as specific as another particular day in July in the Piazza del Duomo. And the conversion is from one medium to another. So the question is what did she see, and with what logic did it mesh? For it is not self-evident how the ruins at Angkor open onto what a modernist artist will experience as *sculpture*.

The carving at Angkor Wat is a profusion of relief. Figures swarm over the outer walls of temples and the inner ones of corridors; figures are set into shallow niches and are squeezed, teeming, into narrow, decorative bands. Profiles in parallel formation ridge the walls with waves of echoing curves. Every interstice is crossed with the sinuous, ropey lines of limbs or vines or snakes. Human anatomies are articulated by bands of ornament, faces are completed by the cosmetic of a seemingly etched-on smile. The energy is astonishing; but it seems very far from the formal purity, even puritanism, of the modern plastic imagination. For that imagination shuns drawing, avoids relief.

The architecture, then: the great stepped towers that rise over the temple complexes, pyramidal in form. But carving erodes the tiers of these immense cupolas, fraying their silhouettes, pocketing their volumes, developing them as gigantic stone ornaments, like inverted chandeliers. As

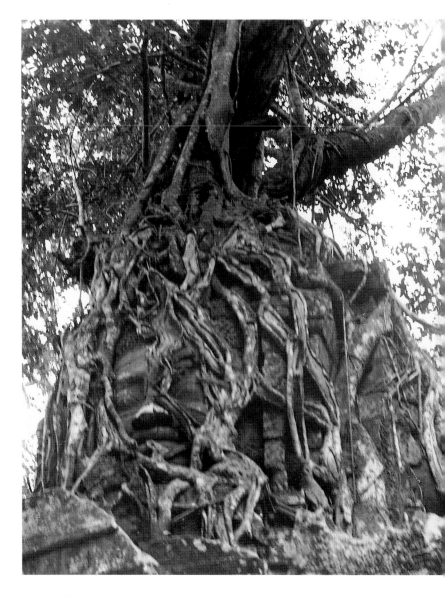

Angkor Wat

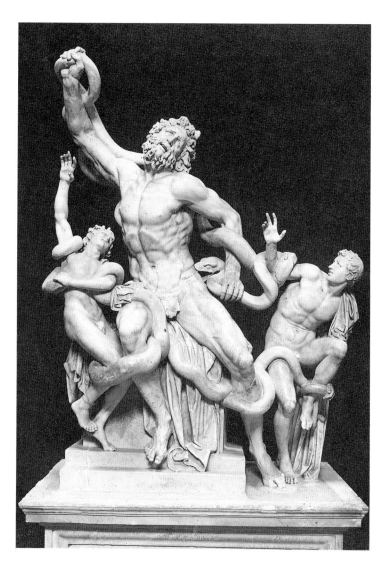

Laocoön, ca. 42–21 B.C., by Agesander, Polydorus, and Athenodrus. Collection Museo Vaticano, Rome.

extraordinary and overpowering as Angkor is, it is not immediately obvious how, in 1960, someone would enter there a painter and emerge a sculptor.

"Most tourists flew into Angkor in the morning," she wrote, "and they flew out in the afternoon. I stayed two weeks—the enclosed photos show the banyan trees growing over the statuary—and I think there is some reference to this in the *Laocoön.*"

Not the sculpture itself, then, nor the architecture alone, but these *and* the trees, those huge complexes of roots that descend like massive, leathery serpents to crawl over the temple walls, perching on carved lintels before dropping to the ground to obscure whole ranges of masonry, wrapping gateways and colonnades in their boa-constrictor embrace, churning up centuries of waiting stone in a kind of vitalist death.

It was 1960. Would it have been possible to witness this spectacle of vegetable indifference without relating it to one of the most famous images of the decade just past, the decade that had grasped for something to steady itself and had found Existentialism? What about that great, elephantine root of the chestnut tree in the Public Garden of Bouville? The one that oozes toward Antoine Roquentin, the narrator of Sartre's *Nausea,* to reveal "existence" to him in all its monstrous, contingent, excessive meaninglessness—its "absurdity," a characterization that was to determine the aesthetics of a generation.

The chestnut tree of *Nausea* is the book's culminating example and its most impressive, durable image. Of course, the tree itself is directly relatable—within the book—to the banyans at Angkor and to Khmer statuary. Sartre's hero associates the experience of something with soft, squishy, undifferentiable insides both with the example of Cambodian sculpture that he remarks in an Indochinese office and with a sense of the flaccid meaninglessness of colonial bureaucratic culture, and these in turn are related to an abandoned, pullulating, vegetal abundance, a rampant multiplication of jungle growth—here he names the banyan roots at Angkor—in which things are born in endless, insistent serial replication, without reason.[4]

A circle, Sartre argues, has an explanation that it carries inside itself like a mathematical law through which it is articulated. It cannot be born; it cannot die; chance cannot disturb its course. But for that very reason, circles don't

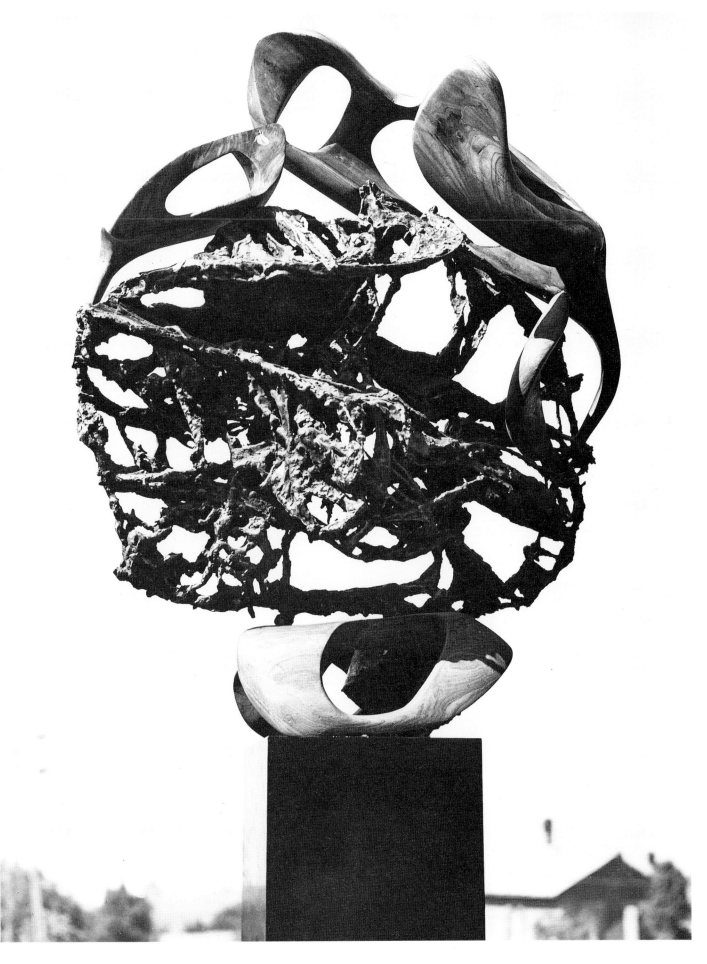

Laocoön, 1961

Sketchbook studies for *Woman and Child*, 1960

exist: they *are*. The root, on the other hand, is pure abundance, existence taken to the very limit of its obscene non-necessity. Absurdity means just this irreducibility, this lack of explanation. "Faced with this great wrinkled paw," Roquentin writes of the tree root in the park, "neither ignorance nor knowledge was important: the world of explanations and reasons is not the world of existence. A circle is not absurd, it is clearly explained by the rotation of a straight segment around one of its extremities. But neither does a circle exist. This root, on the other hand, existed in such a way that I could not explain it. Knotty, inert, nameless, it fascinated me, filled my eyes, brought me back unceasingly to its own existence" (p. 174). Other descriptions constantly return to this sense of explanation as something that inheres in *form*, with meaninglessness a function of the inchoate. The root is associated with "puffiness," with "bloat" and "mold," with "soft, monstrous, disordered masses." Never articulated or structured, its viscous insides simply reproduce by fission.

Whatever the conclusions this nausea in the face of existence might suggest regarding human freedom or political responsibility, there is an immediate lesson to be extrapolated from the image of the tree root for the domain of sculpture, particularly in the light of early modernism. For much of early modernist sculpture had proceeded according to a very different chestnut tree: Yeats's "great rooted blossomer," in which essence and existence each are understood to be a function of the other. "Are you the root, the blossom, or the bole?" Yeats muses, before moving toward that final luminous couple, the indissolubility of "the dancer from the dance."

Early modernist sculpture, of the kind that allied itself with natural elements as the manifestation of natural law (the series that includes Brancusi, Arp, Moore), was, we could say, the celebration of this unity of dancer and dance, of form and material; it was a three-dimensional hymn to the auto-explanatory condition of matter: the grain in wood an inscription of the logic of growth, the tidal ripples in sand an index of cosmic wave mechanics, the forms of boulders a record of geological time. The laws of growth and change were thought of as acting inside material elements to produce external forms, not unlike Sartre's circle—the result of a segment's rotation about a point. The coherence of inside and outside that Sartre grants to mathematical models

but denies to the stumps of trees had been fashioned as a sculptural argument by artists in the opening decades of this century either in extremely simple organic shapes or in volumes pierced to allow a channel of vision that enables recognition of the way the outer surfaces of the object are exfoliations of its central core. Primitive carving, with its own formal obedience to the growth patterns of the material of which it is made, had always served as a model for this kind of sculpture, a reinforcement of the modernist sculptor's ideas about "organic law."

But another generation had come to view this as organic anarchy, as disorder, as chaos. A world war, among other things, had destroyed their simple faith in the reality of appearances. Faced with existent things, there is no constructive, reasoned relationship between outside and inside. Sartre's narrator scratches the surface of the root to excavate beyond its black exterior, but behind that surface he finds only more blackness. This lack of differentiation between surface and depth is symptomatic of the indistinctness that qualities themselves—like "black"—take on in the grip of existence. Instead of a true black or a true red, a true odor of almond or of violet—and the comfortable sense of a world founded on these stable, locatable qualities—there comes a deep malaise.

"Colors, tastes, and smells were never real," Roquentin discovers, "never themselves and nothing but themselves. The simplest, most indefinable quality had too much content, in relation to itself, in its heart" (p. 176). It is this surfeit of sense, in which one thing oozes beyond its boundaries to join with something else so that no black is "itself," that produces the nausea.

□

That same year in Rome, some large trees near her garden were cut down; thus the materials for sculpture literally fell into her hands and, with them, the possibility of realizing something of what she had seen at Angkor, of leaving the domain of painting for something else.

A first series of sculptures resulted in 1961. She told an interviewer about her struggle with the material, about how the traditional craft of carving was closed to her and how she attacked these logs with electric drills and saws.[6] Nonetheless, the series involves a certain recapitulation of the history of early modernist carving, which the undulant volume of a work like *Homage to Lachaise* (1960) admits through both the condition of its form and the acknowledgment of its name. A calmer, more geometric tradition is called forth as well, with references in some of the other works to Moore, Hepworth, and Bill.

But the violations of that tradition are just as insistent, particularly in the work titled *Laocoön* (1961). Like many of the other works in the series, it is a combination of carving and casting, the ropey web of hewn elm merging visually with an open, heavy mesh of bronze. This mixing of two materials, and even more important, of two material *logics*—the subtractive procedure of carving with the additive build-up of matter from which one casts—violates the rules of modernist carved sculpture, with its credo "truth to materials." If a material—wood or stone—has *its* truth, the one to which the chisel excavates, that truth can only be contaminated by the introduction of a foreign body, with its quite different "truth." This interruption of one "truth" by another, this overwhelming or overrunning of the pure by the vegetable abundance of existence, is of course exactly what Sartre had posited as unavoidable about matter—to excavate to the center of an existent thing is not to find its core, its truth, its law, but instead to find something else.

Laocoön violates the carving tradition not only by mixing materials, but by so corroding and perforating the center of the form that the distinction between inside and outside becomes blurred, nugatory. So that the logic of the relation

34

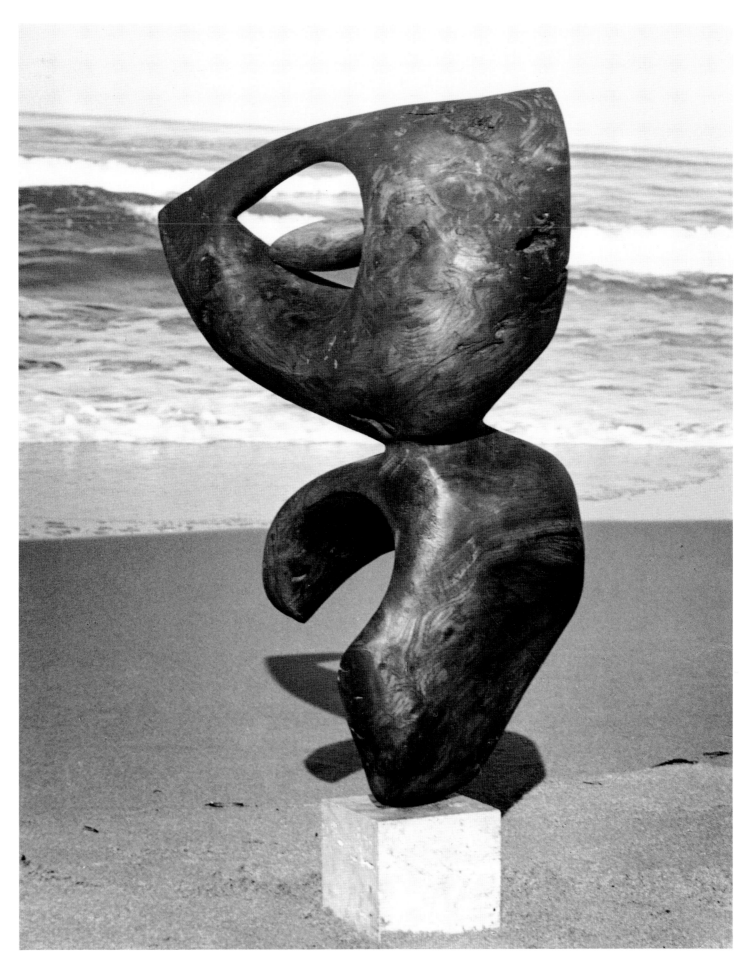

Homage to Lachaise, 1960

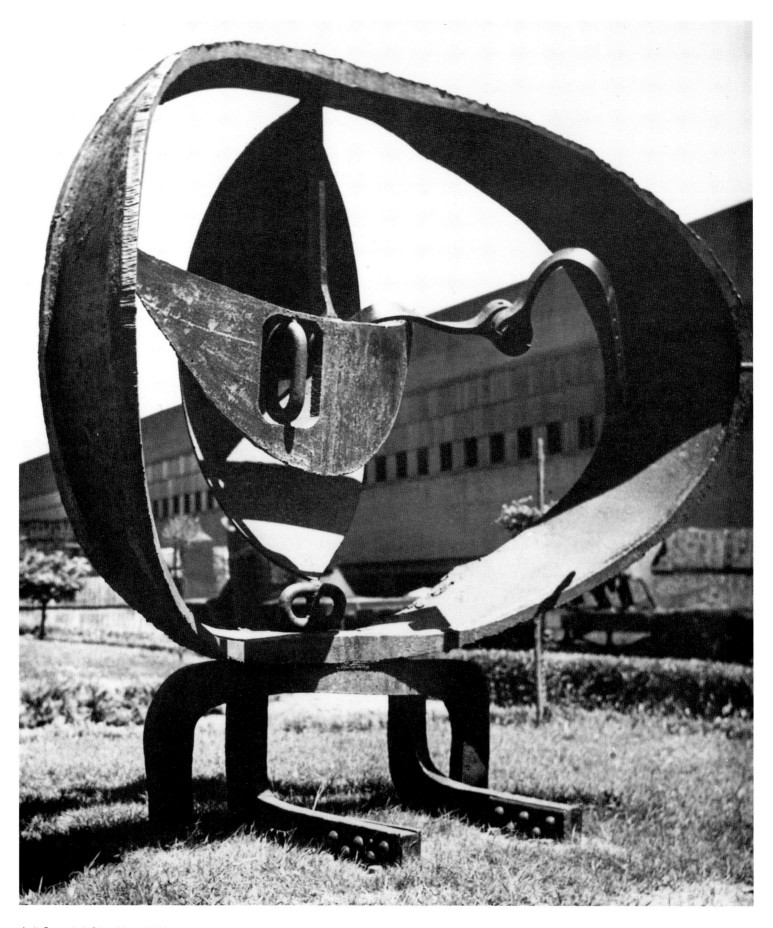

Agli Operai di Piombino, 1962

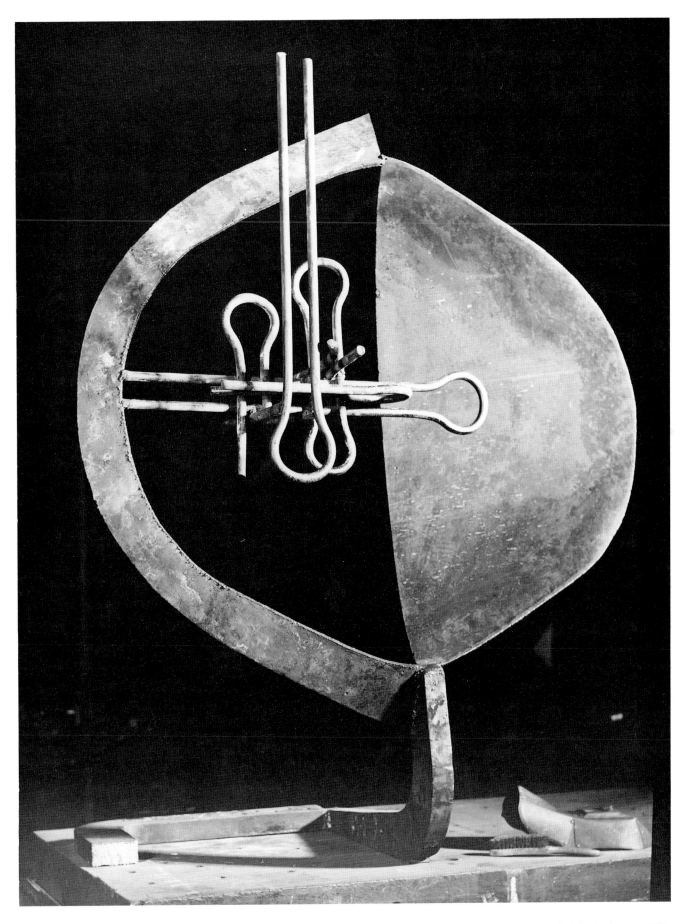

Salute to Genoa, 1962

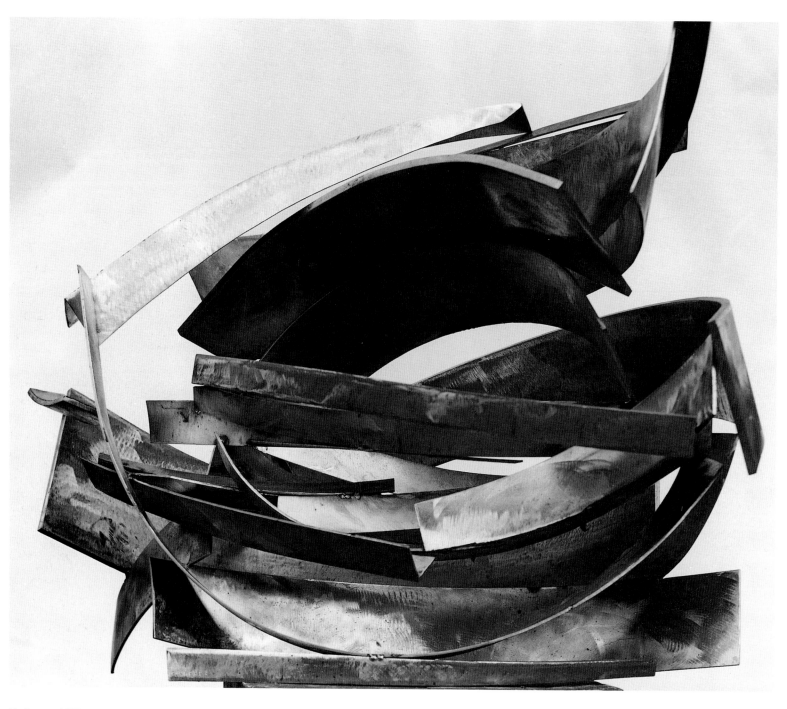

Embrace, 1963

between inside and outside no longer functions. This bizarre mixing, this crushing of the logic of relations happens at Angkor when the long coils of banyan roots snake over the stone orders below them, to adulterate, churn up, disorder the organism of aesthetic sense. "I think," she had written of the effect of this impression on her own work, "there is some reference to this in the *Laocoön*." □

The drama of contemporary sculpture is that it is at war with its own nature.[7]

Jean-Paul Sartre, "Sculpture à *n* dimensions"

And when Clement Greenberg wrote "Towards a Newer Laocoon" he was both celebrating the old one and correcting it, chastising it, purging it of error.[8] Lessing's *Laocoön*, the original one, the treatise from the eighteenth century, had posed the question: What is unique to each of the arts—what separates painting and sculpture from poetry, from drama, from writing? That part was fine, was progressive, was modernist, and a newer *Laocoönizing* treatise could be founded on it, one that would drive ever deeper into the territory of "truth"—the true black, the true odor of almond, the true sculpture as opposed to the true painting. Greenberg approved the Kantian moment in Lessing.

The question of narrative is the appalling part. Lessing does not research only the pure thing: what is essential, unique, to sculpture; what is essential to poetry. He wants instead to know the grounds—particular to each form—on which each tells its *story*. Poetry tells it sequentially; sculpture, on the other hand, has nothing more than a moment to tell it in: the space, we might say, of a blink of the eye. However, for Greenberg, modernism will go on to understand any story, indeed the very fact of narrative, as an impurity, a corruption of the "truth" of space, space understood as distinct from time. The blink of an eye cannot be divided into sub-moments: past, present, future. The blink of an eye is as indivisible as true black, true almond, the circle—a moment that *is*.

In Greenberg's view of modernism, Lessing's very example is an index of his error, his confusion. *Laocoön*, the antique sculpture Lessing uses to set up his problem, is in and of itself an impurity, a mixture of classical and baroque, a Hellenizing delight in confounding differences, a classicism

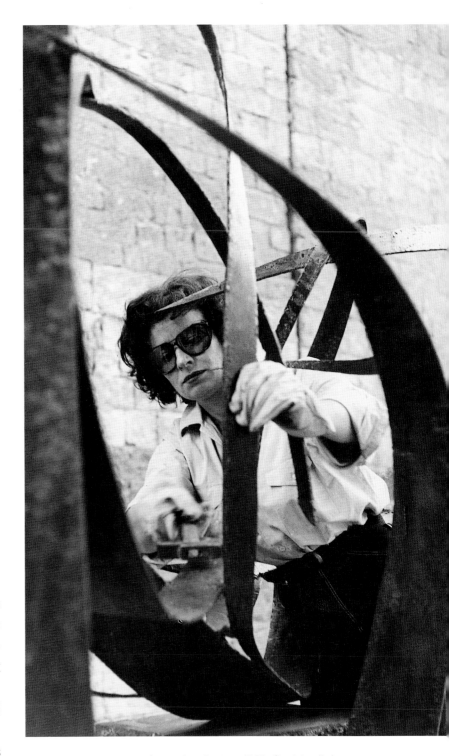

The artist at work on *Spring Landscape*, 1962, Spoleto, Italy

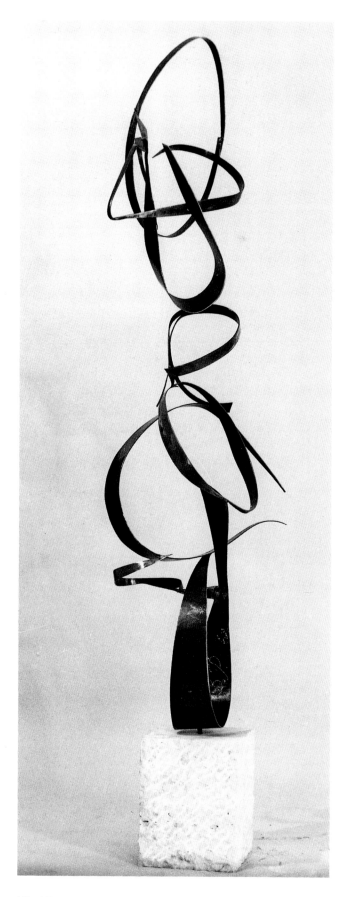

Wind Totem, 1962

too open, too perforated, too pleased with the possible blurring of the qualities of stone and cloth and flesh. The snakes that coil around Laocoön and his sons, to crush them, are the very symbol of the obliteration of just those oppositions on which the classical paradigm is built: solid as distinct from void, straight as distinct from curved, hard from soft, inside from outside, vertical from horizontal. "Towards a Newer Laocoon" makes clear that modernist aesthetics seeks a world of distinctions, a paradigm world, x versus y, a world of true blacks and of circles.

□

The desire for "purity" works, as I have indicated, to put an ever higher premium on sheer visibility and an ever lower one on the tactile and its associations, which include that of weight as well as of impermeability.[9]

Clement Greenberg, "The New Sculpture"

If a circle, or black, or almond *is*, it does not belong to history. Here, you will point out, is the giant inconsistency of Greenberg's *Laocoönizing* of sculpture. In the eyes of modernist aesthetics, sculpture *is*. But at the same time it, sculpture, is seen to join history in the form of technology. Steel, Greenberg argues, is more progressive than stone; open construction (the imperative of steel techtonics) is truer than closed; the transparent is more beautiful than the solid.[10]

This historicizing view of sculpture placed the carvers—Arp, Moore, Hepworth—in the back seat and left the driving to Construction—Picasso, González, Gabo, Pevsner. By the mid 1950s, Greenberg had discovered a major heir to this progressive wing of modernist sculpture in the figure of David Smith, a sculptor who follows the logic of steel techtonics and therefore "draws in space"; a sculptor who pushes the tensile strength of his material into a whole vocabulary of illusionisms. Never mind how much this confuses the paradigm so that sculpture now is not opposed to drawing, to illusion, to pictorial forms, but somehow, in a mysterious reversal of logic, conflated with them. We will overlook the degree to which the snake of history is coiling around the core of what sculpture *is*. By 1962 Greenberg's was the most powerful voice in the critical discourse surrounding the new American art, a voice that was carrying as far as Berlin, Paris, London, Tokyo, Rome.

Contrappunto, 1963

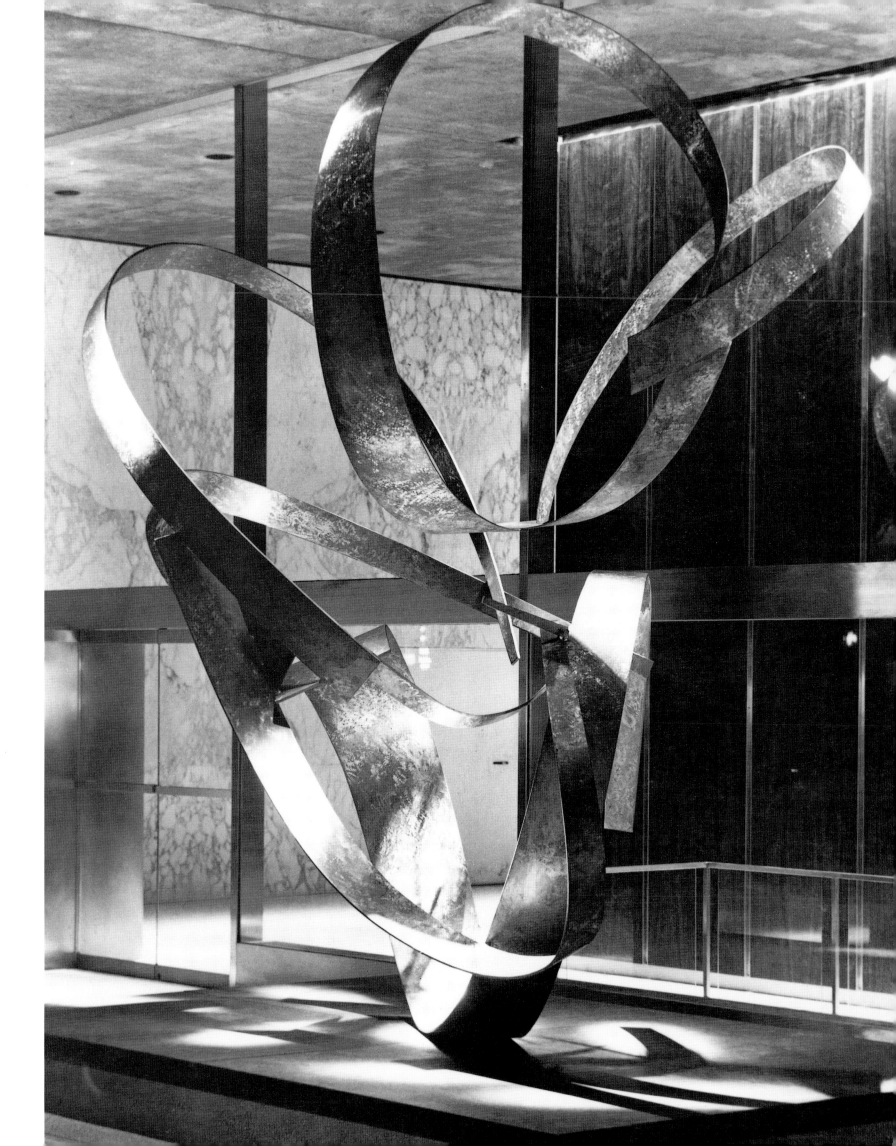

In Rome, Giovanni Carandente was dreaming up a sculptural event for the Spoleto Festival in 1962; what he arrived at was something of a second wave of Italian Futurist thinking. The future is in the steel mills, in industry, he said. The past is in the huge outdoor museum of Italy's Classical, Gothic, Renaissance past. "Sculpture nella città," was to be a modernist explosion in the medieval walled town of Spoleto, with an international band of sculptors serving as shock troops. Carandente had made his arrangements with Italsider, the semi-national steel company with mills spread throughout Italy. With their aid in materials, equipment, and crews, he could invite ten or so sculptors to Italy to work in factories-turned-studios. Afterward, what they had made would be installed in Spoleto for its first *Festival dei due mondi*. From America he asked David Smith and Alexander Calder, from England he invited Lynn Chadwick. The artists who would join from Italy were Arnoldo Pomodoro, Nino Franchina, Pietro Consagra, and Beverly Pepper.

□

I am slightly pleased when I see rust on stainless material, the soft acid stain which denotes either contamination of iron from the grinding wheel or lack of balance in the alloy, or possibly it states philosophically that the stainless is not wholly pure and has a susceptibility as do humans, to the stain of avowed purpose to the actual.[11]

David Smith

"When Giovanni Carandente, organizer of the sculpture section of the festival, asked if I knew how to weld, I didn't say yes and I didn't say no. I asked why. He said David Smith and Calder were going to be there, and he would like to have another American welder, preferably a woman. The show was to be in April. It was then September. Yes, I said, I could weld. And immediately I went out and apprenticed myself to the nearest ironmonger."[12]

Another conversion then. And a baptism, this time by fire. Pepper had half a year to get ready to climb into the front seat, to equip herself to join an international men's club of welders and forgers, a kind of Society of Vulcan. By the time she was sent in April to the mills in Piombino she was enough in control of stainless steel to "draw" with it in space, to treat ribbons of metal as though they were

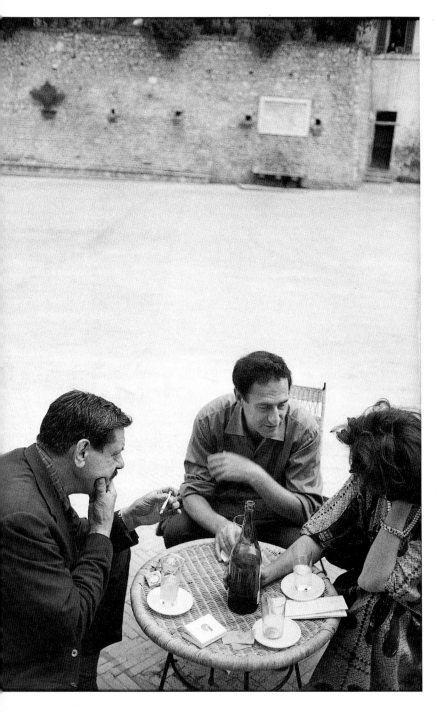

David Smith, Gian Carlo Menotti, Beverly Pepper, Spoleto, Italy, 1962

Gift of Icarus, 1962

42

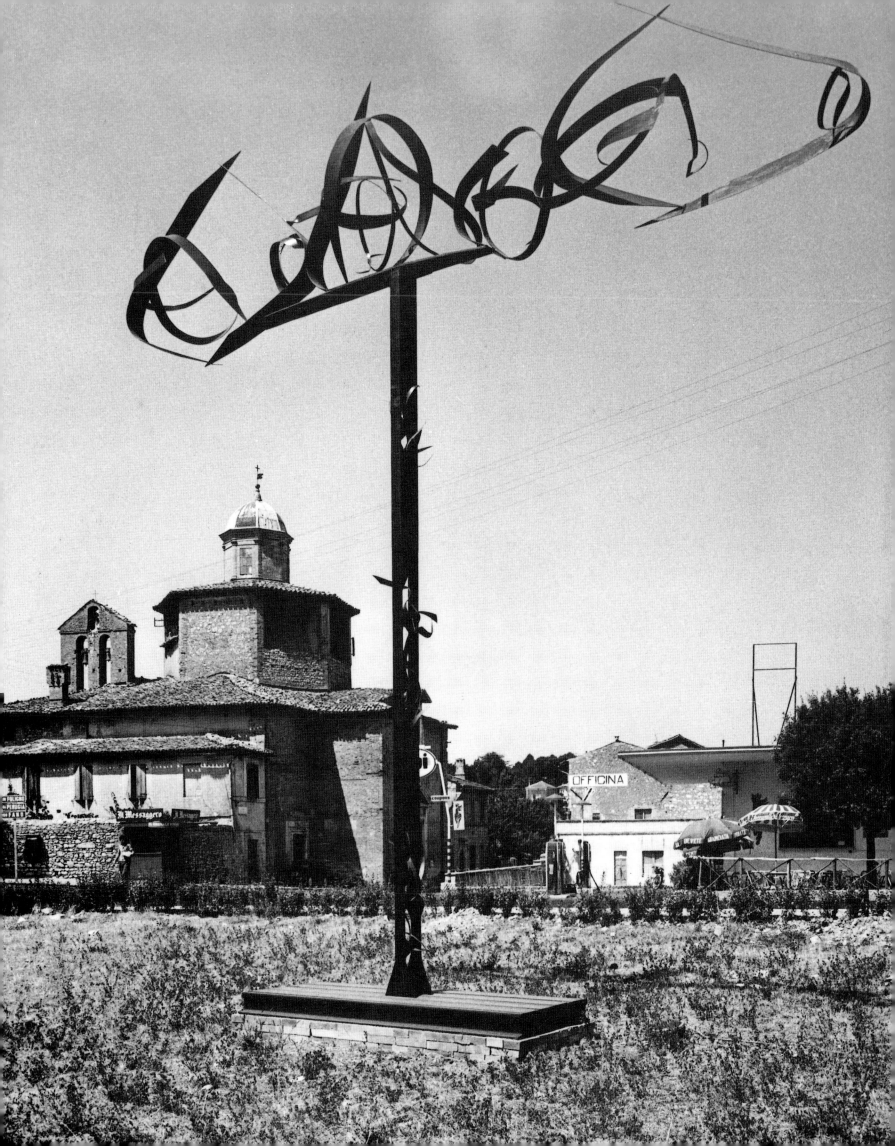

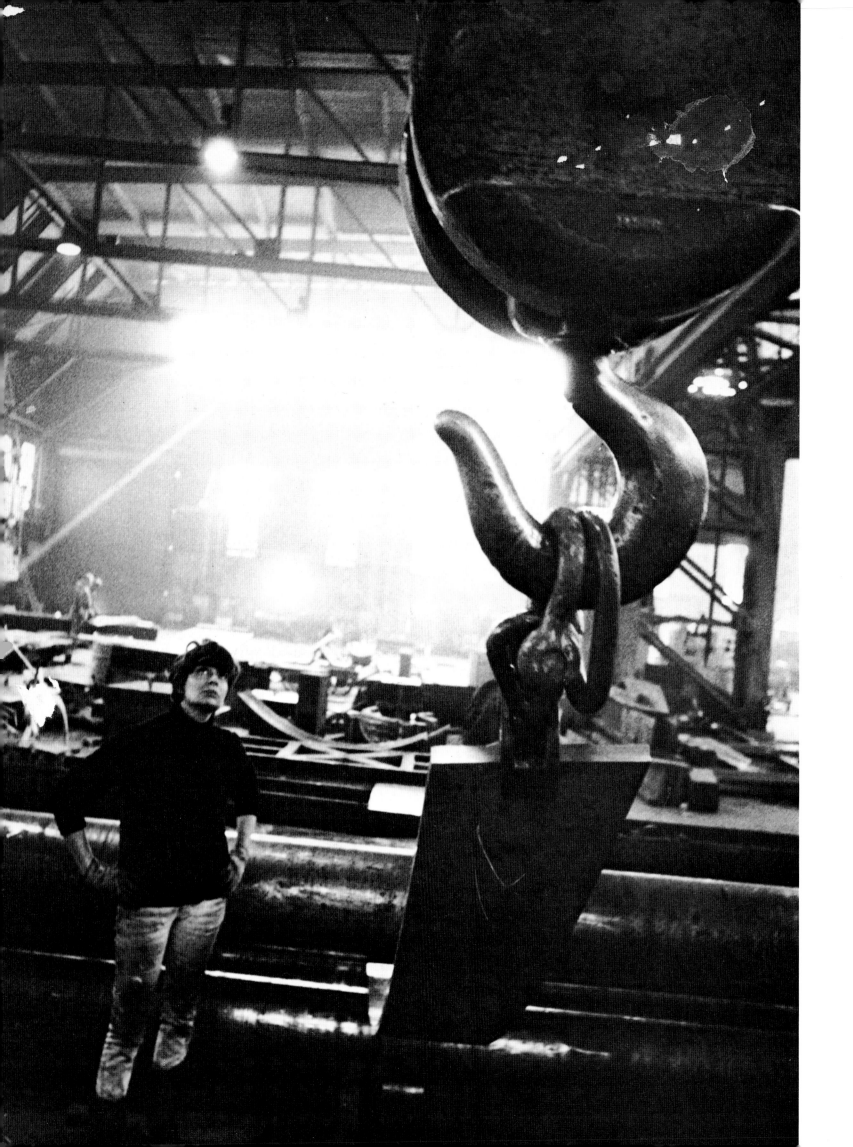

weightless strokes of a brush but nonetheless to leave within the work a trace of the technics of construction. *Wind Totem*, over six feet high, captures the quality of careless, improvisatory posture of Julio González's *Woman Combing Her Hair*; *Gift of Icarus*, almost twenty feet long, achieves the horizontal abandon of David Smith's *Royal Bird* or *Agricola IX*. And in these works, too, there is that kind of special assurance that undergirds the work of the apprentice who knows that very soon the master will be left behind, an aggressive authority, only barely held at bay, that most teachers have learned to recognize.

The lessons of spring 1962 were various. She worked day after day at hard labor in a mill, running a crew of men over two long shifts that had begun each morning at six, turned inward on the job at hand and the difficulties of doing it. Though they were spread as far apart as Genoa and Naples, she felt the connections to the other members of the network drawing her into the chain of an international modernist circle and a historical mission. She watched with the others as David Smith performed his incredible feat at the Voltri factories near Genoa, making twenty-seven sculptures in a month, twenty of them at a scale large enough to "people" the amphitheater at Spoleto. One of the smaller works (it did not go to Spoleto) was a "doll" that Smith made for Jorie, Pepper's daughter. Smith and Pepper had become friends in Italy. He found her serious and, what was more important, hard-driving, with the same kind of relentless will to master something that for thirty years had pushed him. He would call her long-distance from Genoa late at night. From bars. From whorehouses. He liked to talk.

The ribbon works, clusters and sheaths and bundles of bent steel, developed for two more years. Then came a far more geometrical series of open-faced stainless boxes, their edges violated by the abusive fire of torch cutting. David Smith had once confided to his private notebooks that he liked to see rust on stainless steel, to witness impurities beginning to attack the metal. This wink of sadism toward the medium he held "in high respect" and in which all his efforts were grounded manifests a certain ambivalence.[13] The destructive mark of the torch on these 1965 works by Pepper partakes in this instinct of pleasure at the idea of undermining the strength of steel: construction open to the terms of its own destruction. The attack on material was of course available within the terms of Italian modernism,

David Smith's studio

The artist working at the Steel and Alloy Tank Company, Newark, New Jersey

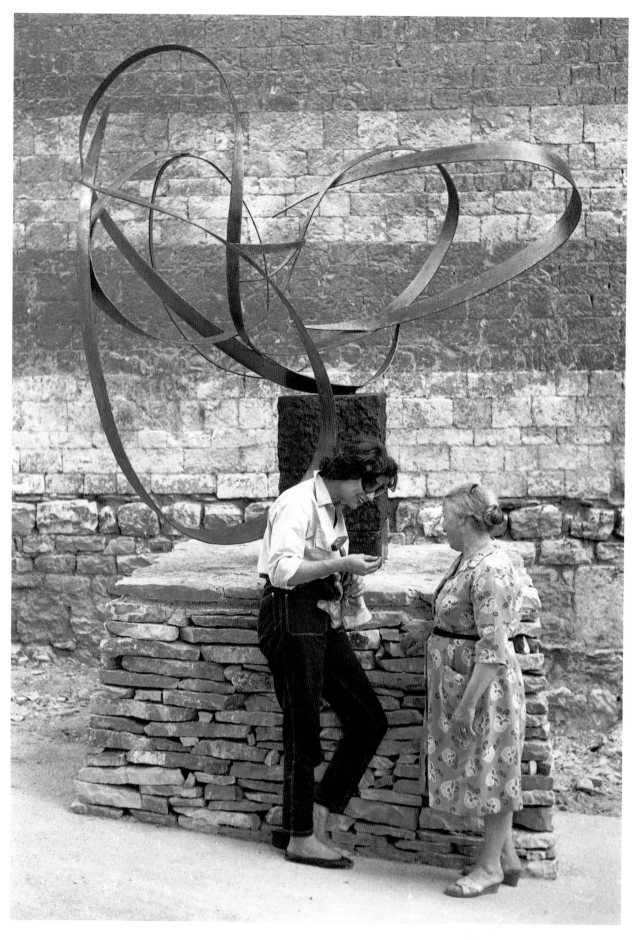

Spring Landscape, 1962

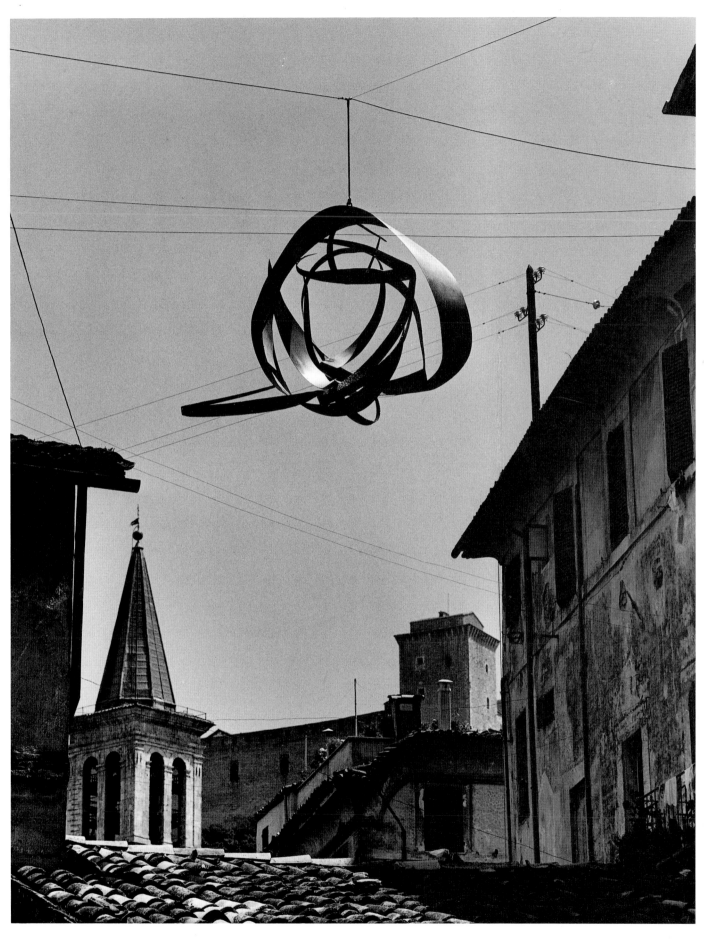

Leda, 1962

47

Passage of Night, 1965

Strands of Mirror, 1965

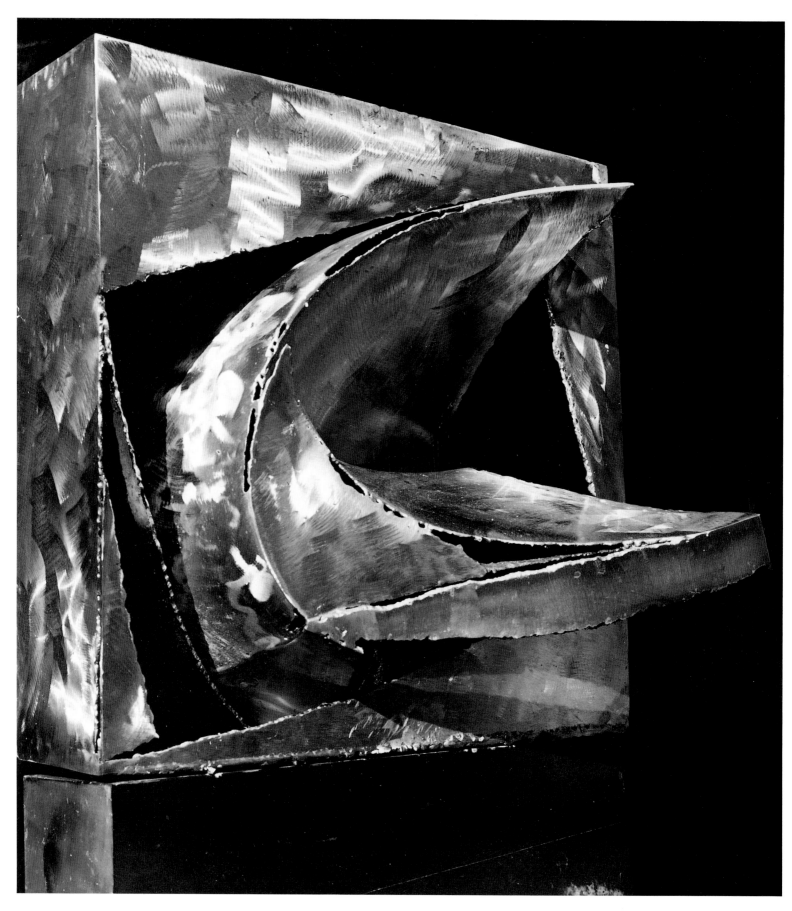

The Vast European Continent, 1965

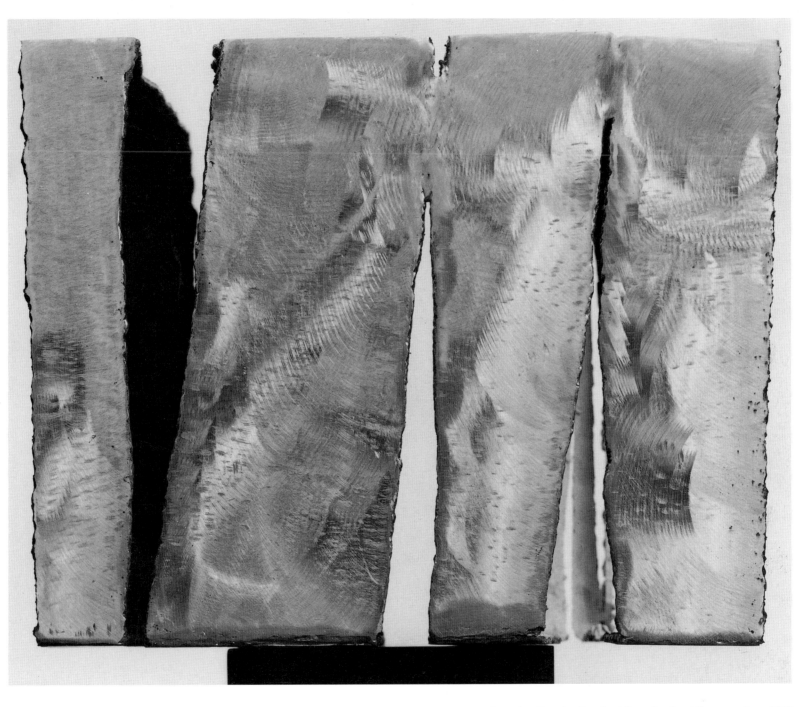

Seeming Eventuality of a Misunderstood Conversation, 1965

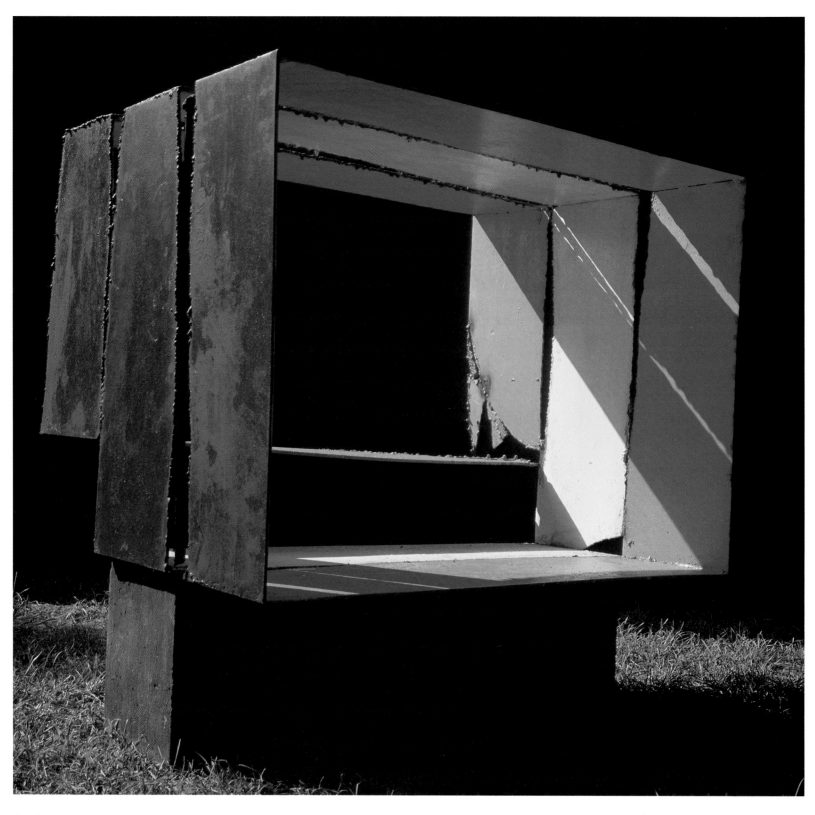

Cor-Ten Viewpoint, 1965

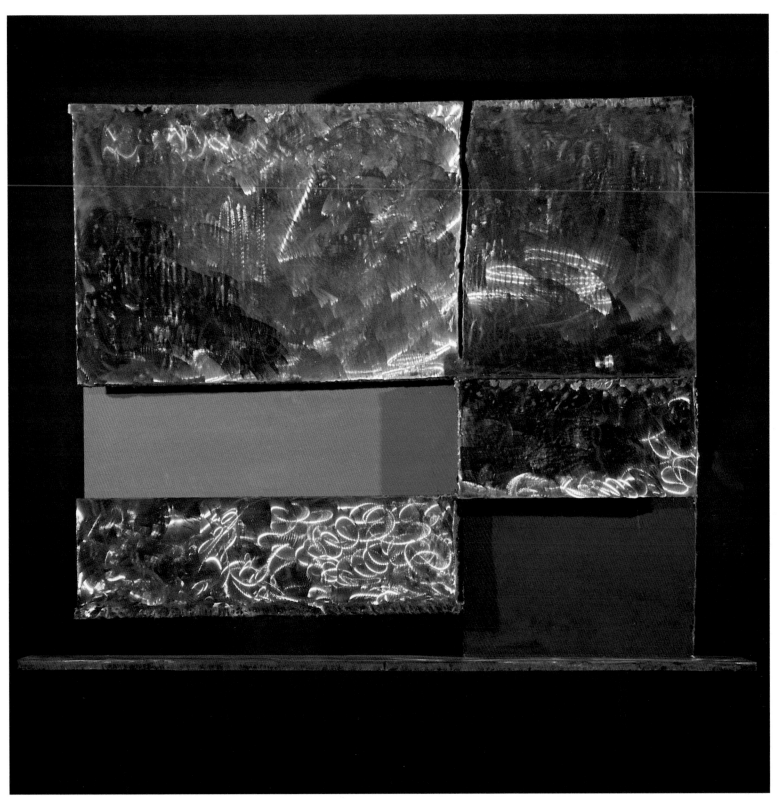

Homage to Piet, 1966

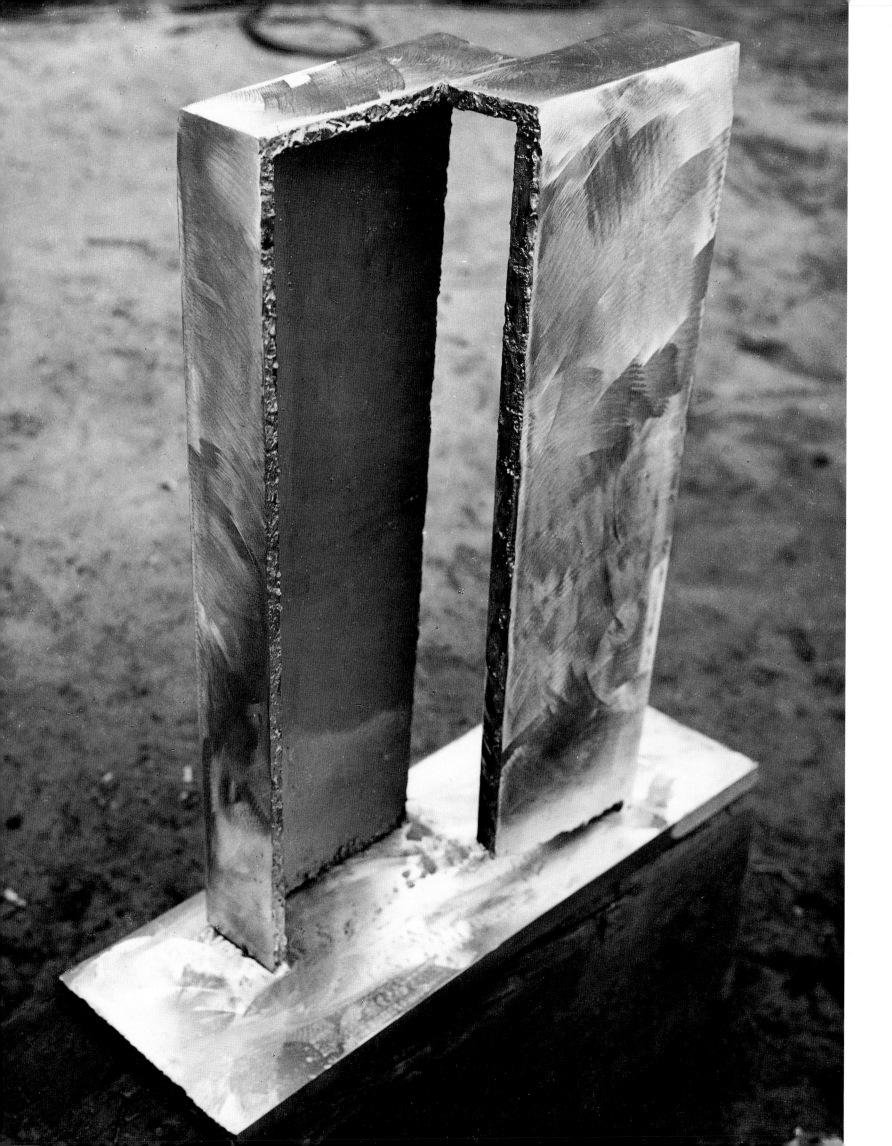

particularly in the slashed canvases and gouged ceramics of Lucio Fontana. But since 1962 Pepper had been following out a particular logic in the development of metal sculpture. That development pushes the paradox of the "newer Laocoön" as far as it will go, it takes pleasure in the crack that appears in the surface of the logic, like the puddle of rust that spreads on stainless steel. It thwarts the paradigm.

Beverly Pepper became a sculptor who was on her own and speaking in her own voice that moment when she found a way, with both directness and simplicity, to thwart the paradigm. The sculptures in which this happens date from 1967 and form a series that continues through 1969. Their medium is stainless steel, polished to the reflective consistency of a mirror. Their form is the constructed box, its back and front removed, its sides pared and narrowed to the dimensions of a frame. The inner surfaces of these works are lined with dark blue baked enamel.

To speak of the way these works thwart the paradigm: First there is the modernist, *Laocoönist* paradigm to unravel—painting versus sculpture. Unlike the sculptural solid, the mirror welcomes everything into its field: colors, shapes, images. It is a surface made transparent by the depth it reflects, and made pictorial by the panorama of vision it entertains. As a function of the mirror, sculpture yields to painting.

Then there is the Kantian paradigm that sheers art from non-art, or art from objects. Within the domain of the visual arts this operates to distinguish sculpture from its base or painting from its frame. The painting is what counts as the work of art. The frame is what is not yet art, what is haphazard, what is objectlike. In giving the polished surfaces the character of frames, this distinction is thwarted; for it is the frame that carries the image, while the space inside the bounding surface is empty. Another way of saying this is that here the frame exists as the field of illusion while the inside of the frame opens onto the space of the object world.

Finally there are the paradigms that operate the formal language of sculpture itself: the distinctions between surface and center, outside and in, which the classical sculptor articulates through the connections of necessity that link one to the other, like the outer curve of the circle linked by causality to its inner, geometrical law. Not only modernist carvers, but modernist constructors depended on this paradigm, viewing it as the operator of sculptural meaning.

Walk Through II, 1966

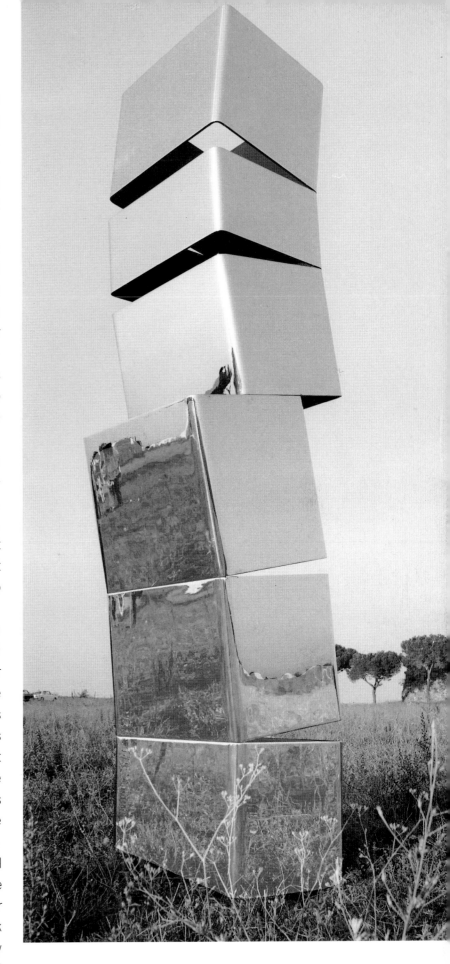

Square Sentinel, 1968

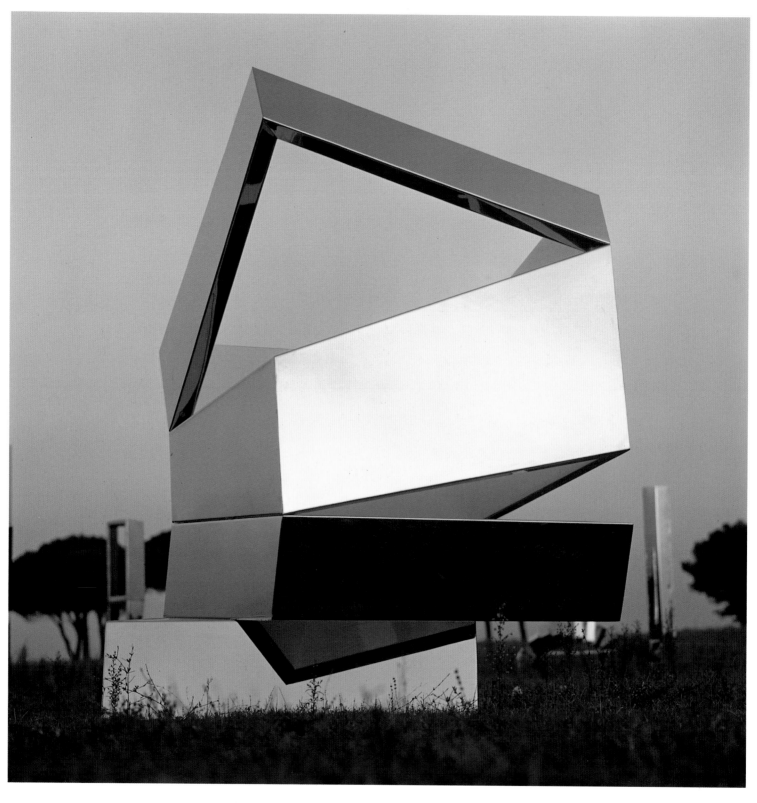

Excathedra, 1968

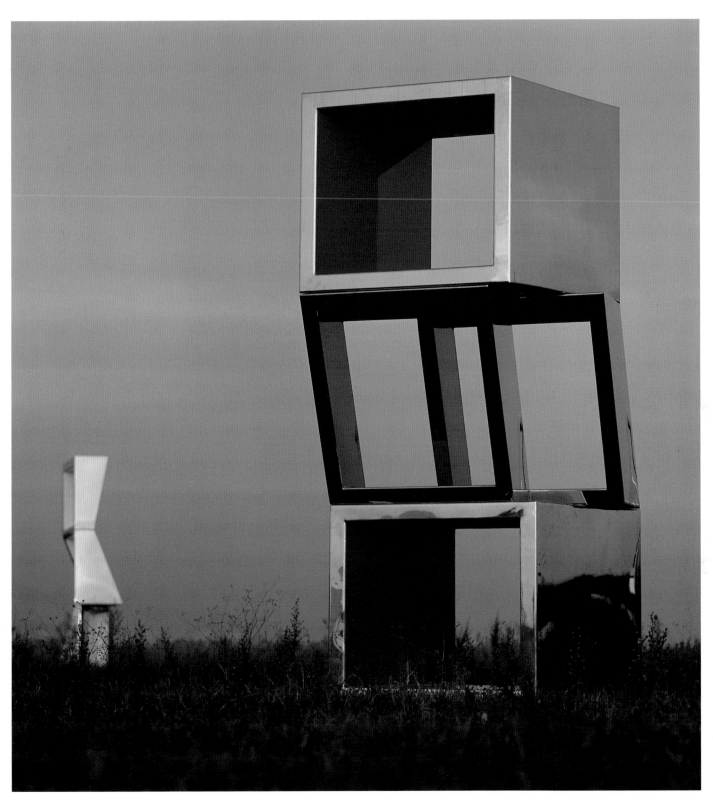

Diagonal Campo, 1969

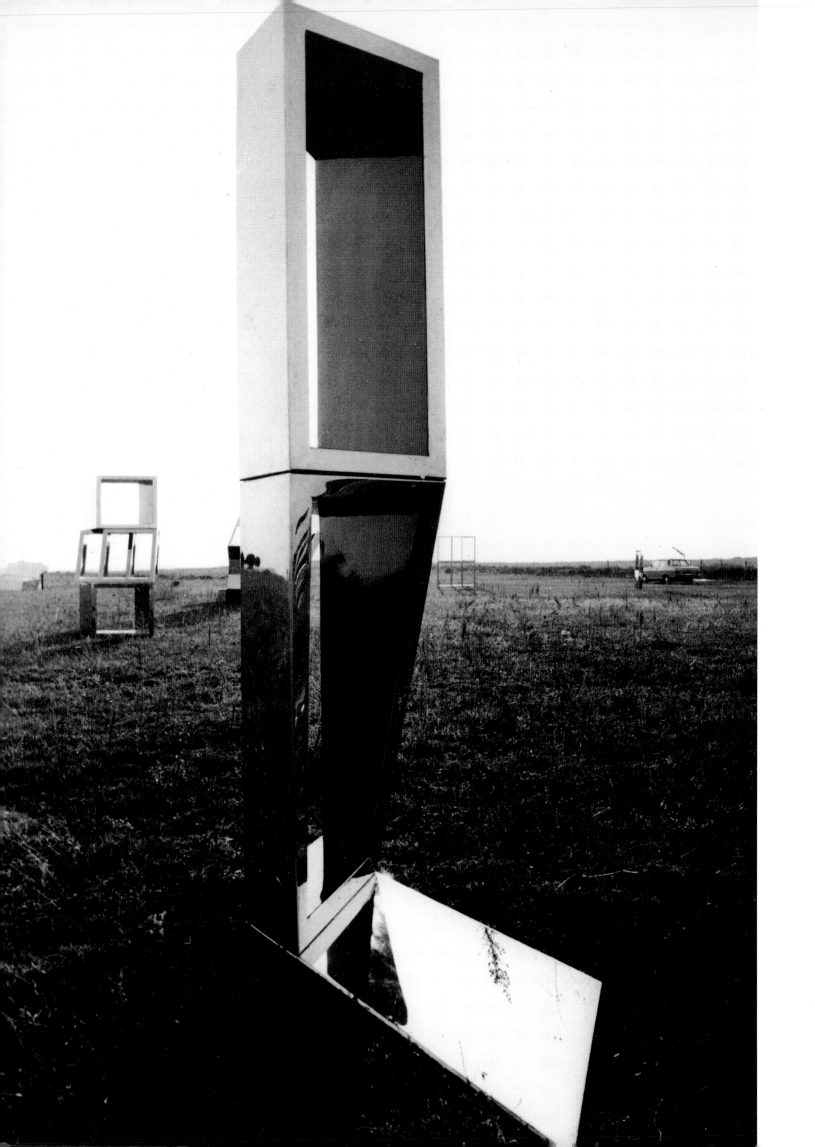

But the relationship between the solid blue insides of the frames and the mirrored outsides is an arbitrary, unstable one, the mirrors multiplying and displacing one's sense of the inner surfaces, causing them to appear at times as exteriors, not of the same, but of different, sculptures.

The most successful of these works are ones like *Excathedra* (1968), *Zig Zag* (1967), *Diagonal Campo* (1969), *Venezia Blu* (1968), where the frames themselves seem to be pulling apart from one another, opening the overall volume of the work ever farther, to accept more and more impurities into the sculptural center of art.

That was the problem, Sartre had written, about the black inside of the chestnut root. "It *looked* like a color but also . . . like a bruise or a secretion, like an oozing—and something else, an odor for example, it melted into the odor of wet earth, warm, moist wood, into a black odor that spread like varnish over this sensitive wood, in a flavor of chewed, sweet fiber. I did not simply *see* this black: sight is an abstract invention, a simplified idea, one of man's ideas. That black, amorphous, weakly presence far surpassed sight, smell, and taste" (p. 176).

One has here, then, the lesson of the banyan trees translated far away from the imitative language of coils of wood or curving webs of metal. Seven years after Angkor Wat and just six years into the vocation of sculptor, Pepper had mastered abstraction. So that it was not necessary to call on the image of the priest Laocoön to figure forth this idea of the implosion of realms, the overflow from one place, one condition into another, the dizzying transparency of illusion. One could do this thing with economy, even severity. Just a few shining frames and the idea of something parting.

□

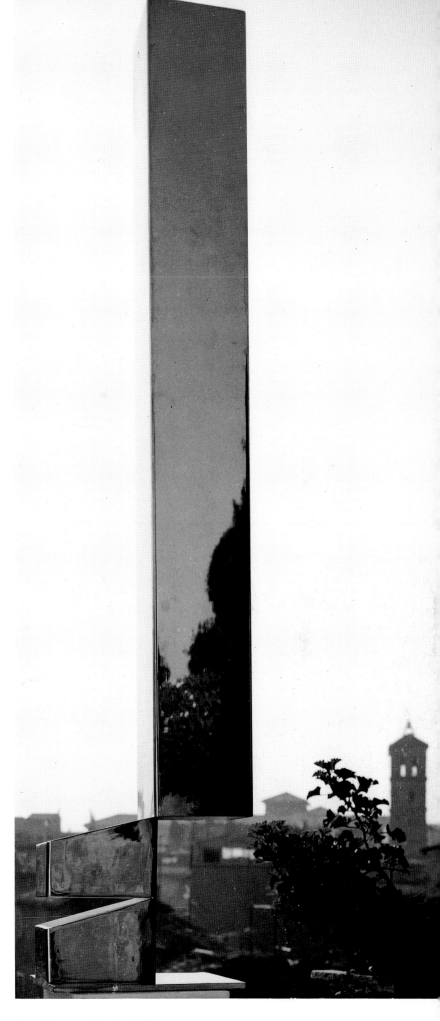

Virgo II, 1968

Torre Pieno nel Vuoto, 1969

59

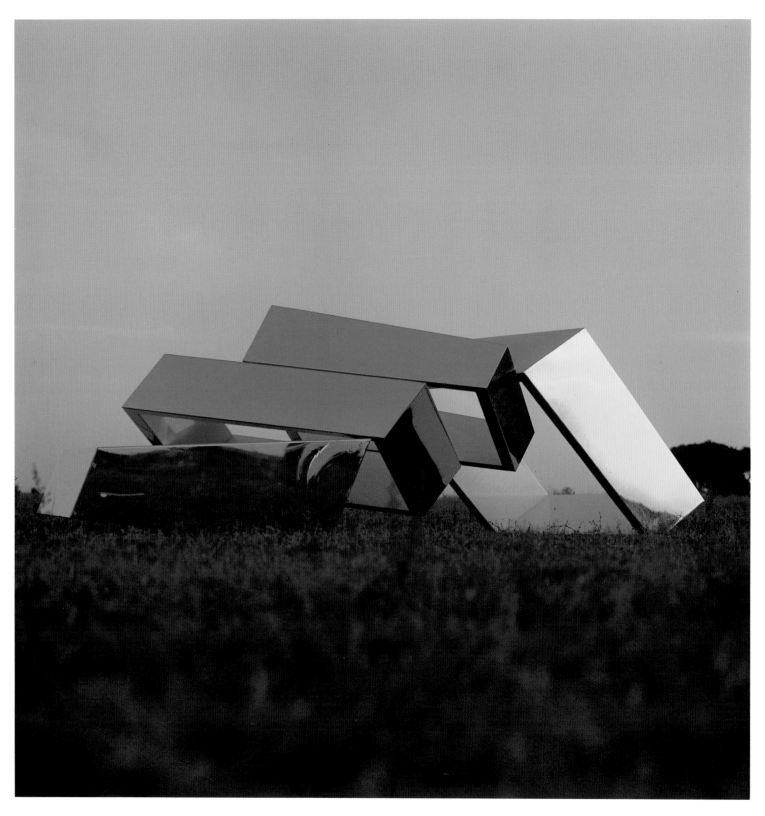

Fallen Sky, 1967

Venezia Blu, 1968

Prisms II, 1967

Every material has its own individual qualities. It is only when the sculptor works direct, when there is an active relationship with his material, that the material can take its part in the shaping of an idea.[14]

Henry Moore

They came to her studio that cold, glittery day in early 1968, to talk about her sculptures: the painter Piero Dorazio, the poet Giuseppe Ungaretti. They spoke both to her and into a tape recorder. Mostly, Ungaretti spoke.[15]

He felt the vertigo: "Intersections of surroundings through a play of fixed voids, causing light and luminous reflections which produce a slight dizziness."

He saw how difference came to be neutralized (the paradigm thwarted) by the apparent fluctuations (between figure and ground, solid and void, open and closed): "So we have in these forms an optical impression of both disjoining and suspension. . . . Like hands which grasp each other or like enchained spaces. Or better, voids which enchain each other; or even better still: voids in chains."

He waxed eloquent about these things: "Ah, the mirror feeling! That dizziness, the sensation of a mirror that turns, that turns, that turns, that returns, that empties, that fills, that deceives, that deceives and then is nothing, is nothing, and actually gives the sense that everything in life is an illusion. It's terrible, it's true, everything is only an illusion."

He spoke of the absurd as a counter to the rational and the "gift of liberty" this bestows.

Nonetheless, he returned to the organicist model of sculptural "truth" in which the surface reveals the logic of the inner core. That had been his first impression: "They resemble mineralogical and crystallographic models," he began. "Mineralogists construct similar models, taken from the structure of rocks and geological strata. Everything here is in steel?"

"Stainless steel," she answered, "polished to a mirror finish. The idea is that from whatever angle you view it, the voids seem filled and the solids seem empty."

So the conversation had veered away from the models and into the operations of these forms and these materials on experience, on illusion eating away at the fabric of "truth." But it returned to the models in the end. He spoke of her work as "searching for the innermost reasons for the creation of the world. In short," he added, "a universal significance."

Excathedra, 1968

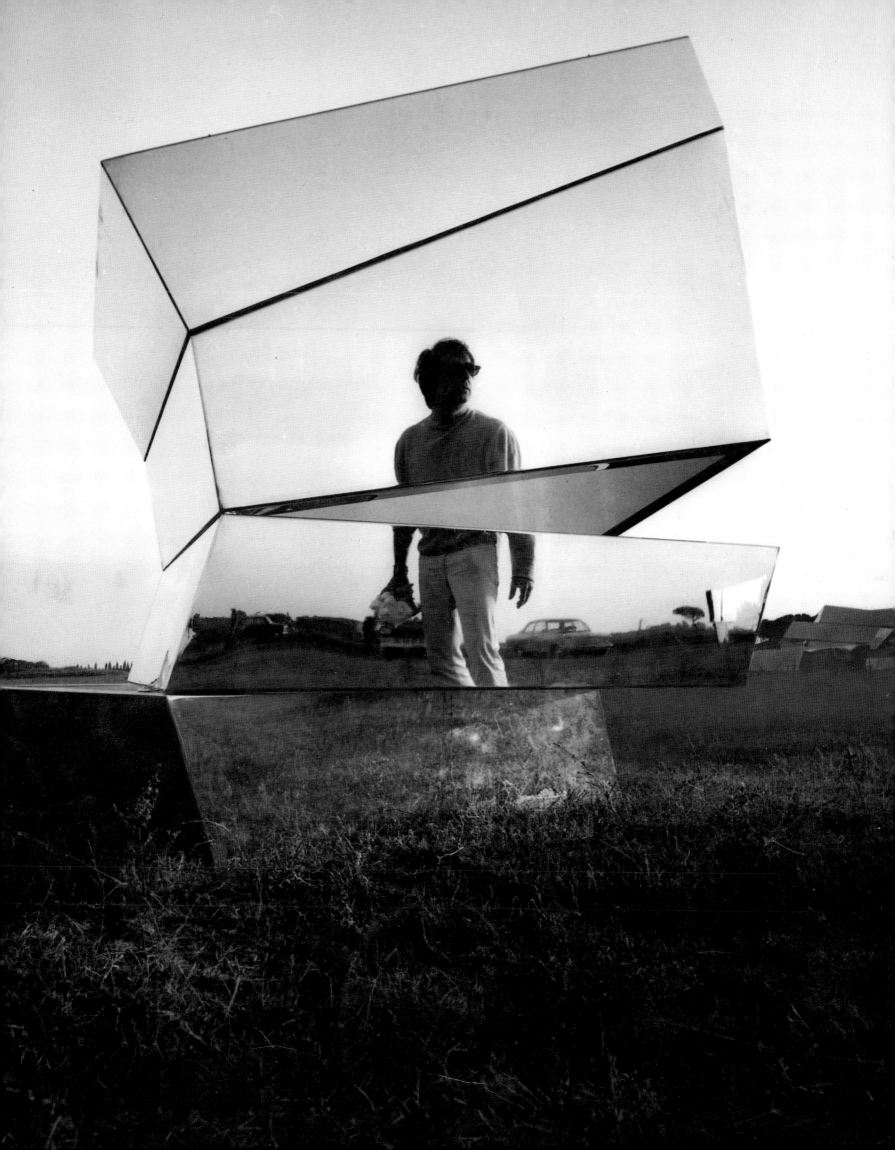

The circle, which *is*, has a universal significance. But caught in a labyrinth, a play of mirrors, its arcs become multiple, its center fissions, it gets taken up by seriality, repetition, time. The paradigm that holds opposites apart is thwarted when this happens. The paradigm is unraveled. There is significance, but it is not universal. It is too canny for that.

<p style="text-align:right">☐</p>

Sketchbook studies, 1968

The helicopter maneuvered the sun's reflection through the Spiral Jetty until it reached the center. The water functioned as a vast thermal mirror. . . . Et in Utah ego.[16]

<p style="text-align:right">Robert Smithson, "The Spiral Jetty"</p>

Besides the opposition of inside/outside, there is the opposition of sculpture/base, which is another way of saying vertical/horizontal. Classically, sculpture has been a vertical marker, a monument, rising above the undifferentiated spread of the ground. It relates to this ground, this horizontal continuum of the real, both by opposing it—in its own existence as vertical, delimited, symbolic—and by defining it. The sculptural marker is a representation of the meaning of the place above which it rises: battlefield, government plaza, cemetery, public park. The bronze general on his horse, the soaring obelisk, the allegorical figures supporting the fountain hover in a virtual, symbolic space above the real ground to which their representation gives definition. The operations of the paradigm set them apart from this ground, this reality, this limitless horizon, and through that very opposition produce the possibilities of definition, of what *is*: victory, power, faith, knowledge.

The sculptural revolution of the 1960s had attacked that part of the paradigm with all its force. Those idealities—victory, power, faith—were viewed as so many aesthetic vanities, which early modernist sculpture in its quest for "truth" was seen as having continued, in its own way, to pursue. Minimalism, therefore, chased sculpture off its pedestal, dumping it into real space and onto the ground. The sculptural event now became the passage of real light as the sun shifted overhead, and the play of real perspectives as the simple geometries of the work were flattened or sharpened by the vagaries of happenstance points of view.

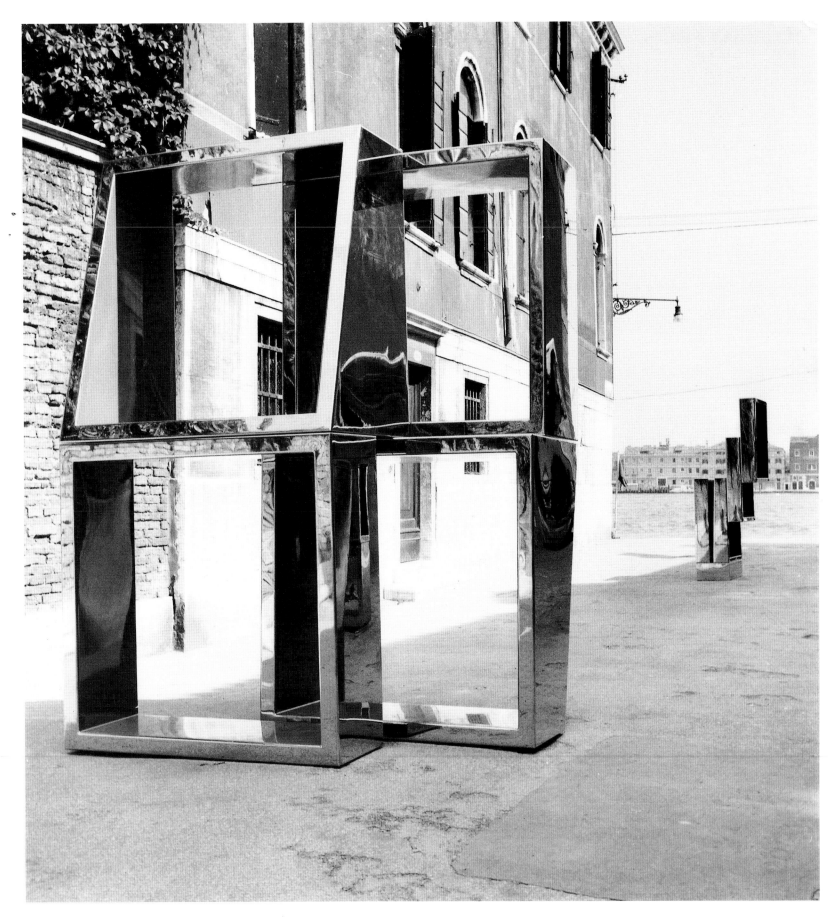

Venezia Blu, 1968 (foreground)

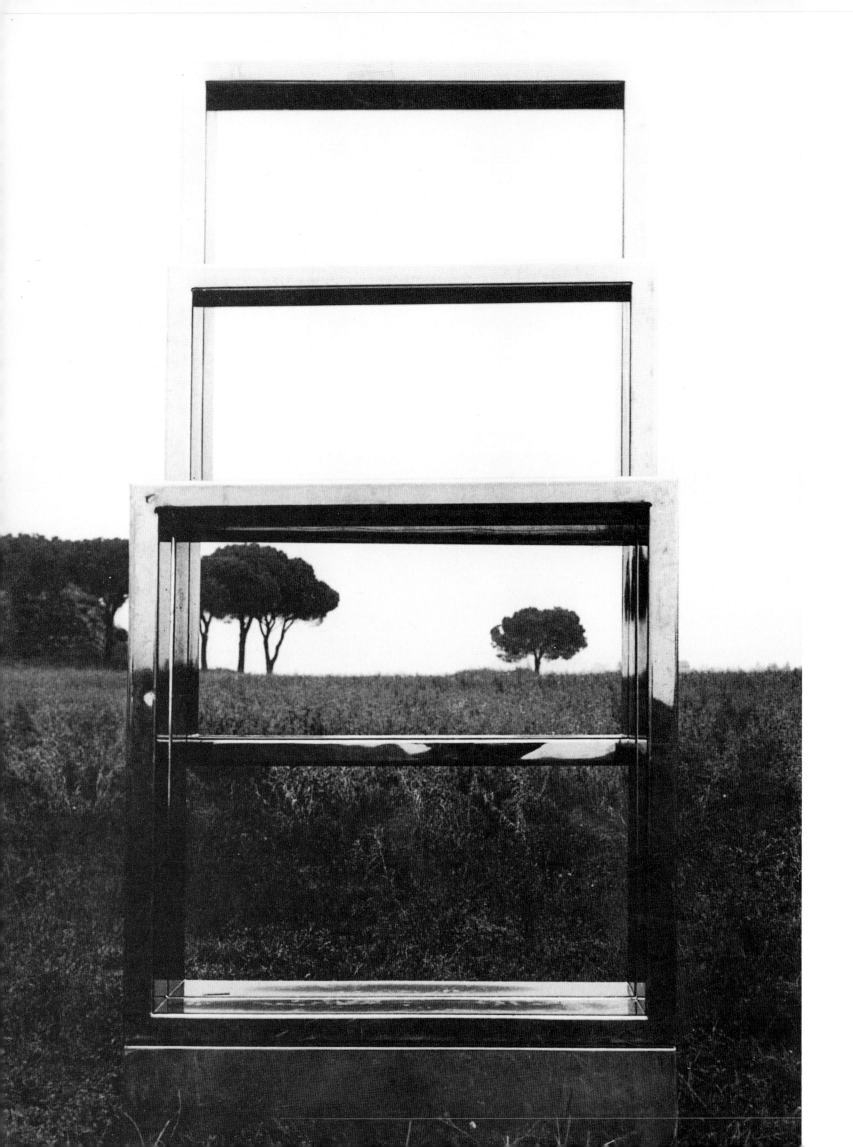

Coming to life only in relation to its viewer's body, this work stressed the dimension that it shared with that body, namely, an existence dependent on the support of the ground. This was visible in the matte metal boxes of Robert Morris, Donald Judd, and Sol LeWitt, in the floor-bound prisms of Tony Smith, in the "rugs" of Carl Andre.

It was in these last that the horizontal made its most definitive, most absolute statement, leading past the Minimalist resistance to the operations of the vertical/horizontal paradigm and into a new kind of model. Andre's rugs were made of the repetition of a single unit—firebricks, say, or tiles of a specific metal—each joined to its neighbor by the simple fact of contiguity, one element merely abutting the next. Andre had explained that he wished to avoid a kind of procedural idealism by which a given set of real things would be unified or given form by the application of a "law" of juncture. Welding would be such a law, or casting. These procedures would act inside the finished form to make it cohere, to institute its unity from the center, as it were, outward. In the rugs, each unit "adhered" simply through the gravitational attraction to the ground that it shared with every other element. The rugs were not, therefore, forms that had been fixed or cemented by the application of a law of unity. They were provisional. They cohered in real time as gravity acted upon the members of the work, all of which were open to being realigned, shifted, or changed. As Andre concentrated more and more on this temporal ribbon of provisionality that visibly/invisibly wove its way through his sets, he became involved with the logic of process: with counting, melting, tearing, dropping.

Process opened for a generation of younger sculptors. This was a paradigm that wrested sculptural meaning from the opposition of form/non-form, that sought to balance the work on the narrowest, most breathtaking margin of difference between a something and a nothing, between the formed and the formless. The opposition between vertical and horizontal that had operated for the sculptural paradigm, and within which Minimalism's embrace of the horizontality of real space had made powerful sense, no longer had the same kind of signifying force for process art, in which the horizontal field of real action would now become the *only* medium.

□

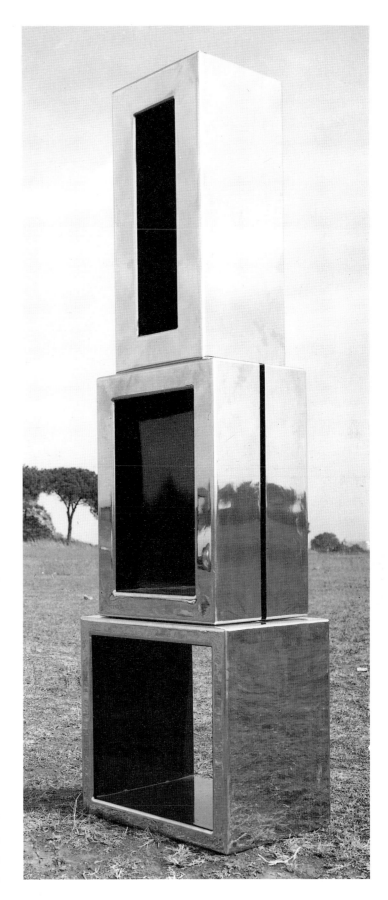

Alert, 1967

Quadro Vuoto, 1968

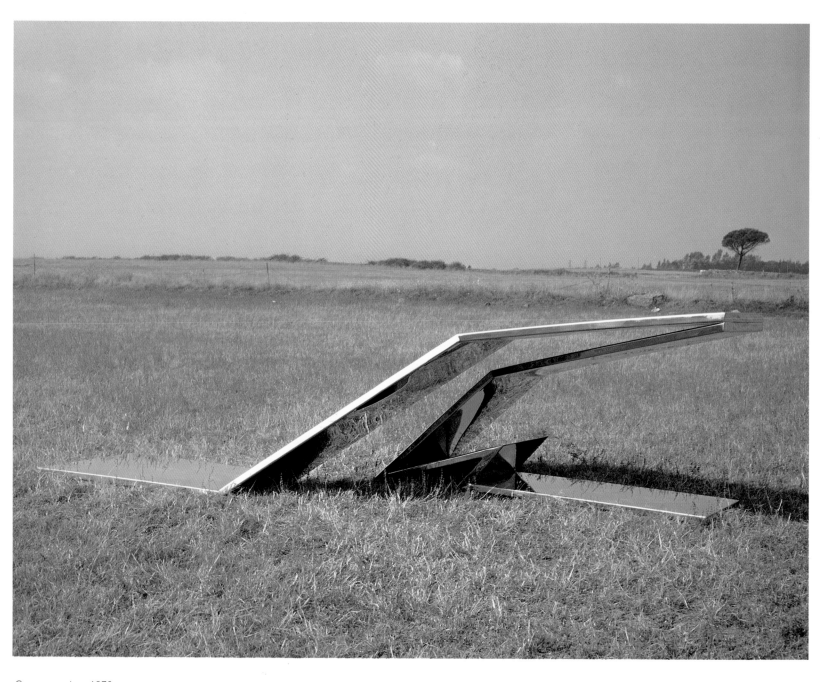

Camponastro, 1970

Camposimp, 1970

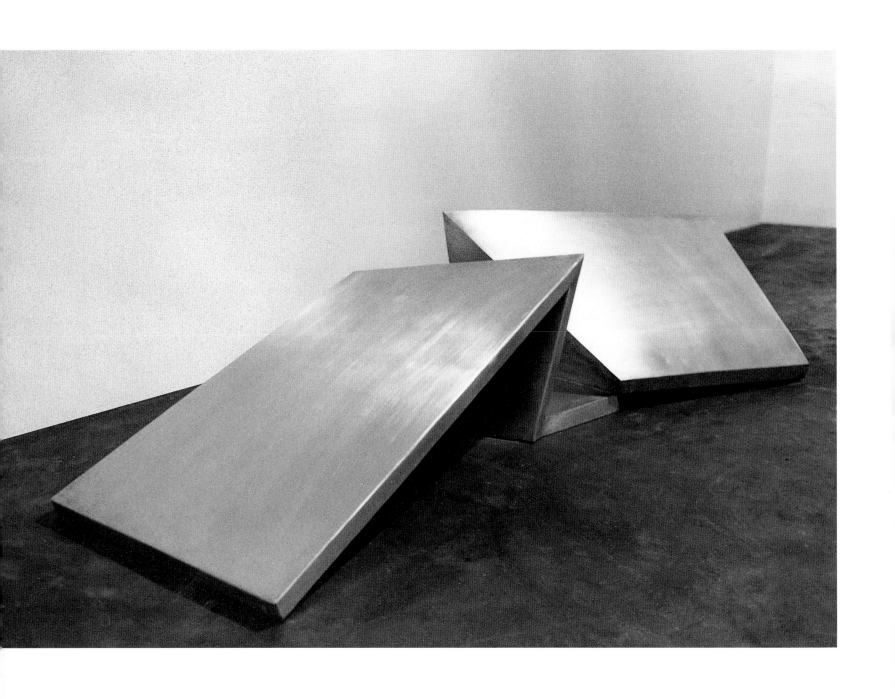

Odescalchi Series, 1970 (foreground); *Campond Jr.,* 1973 (background)

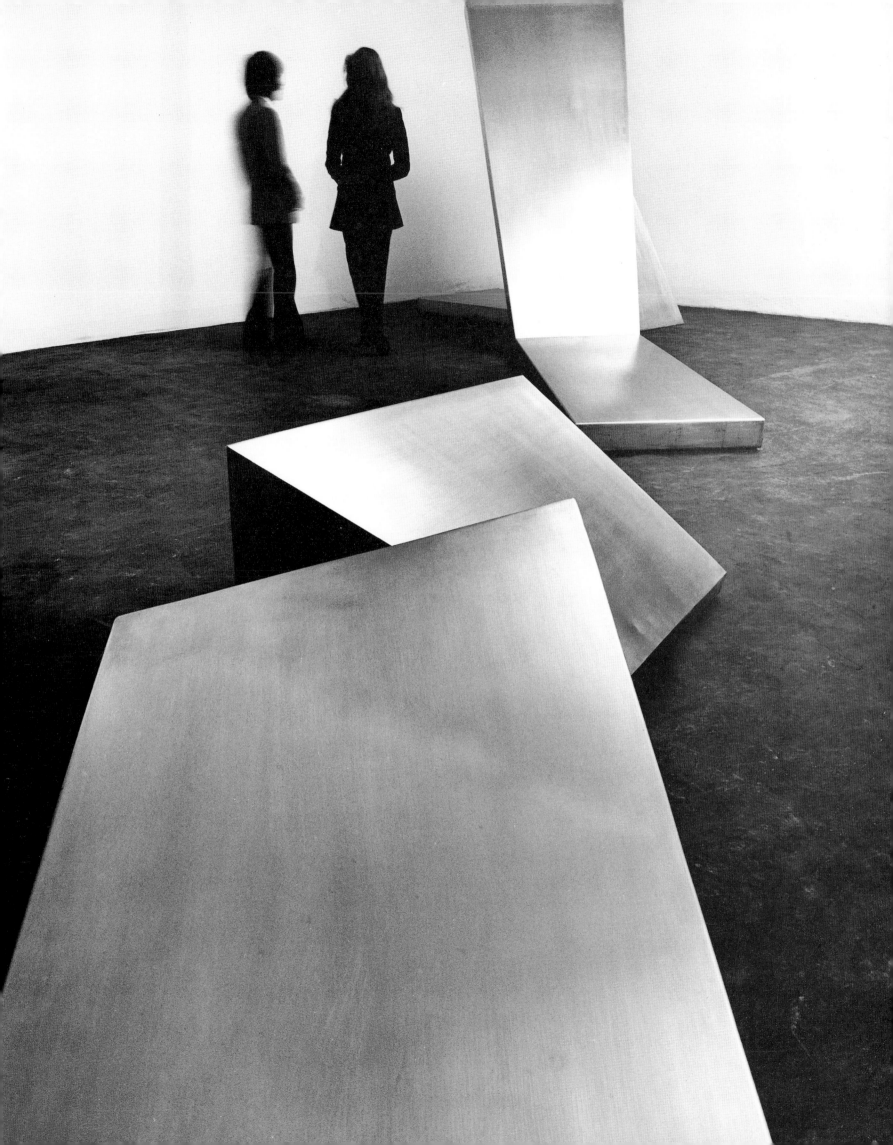

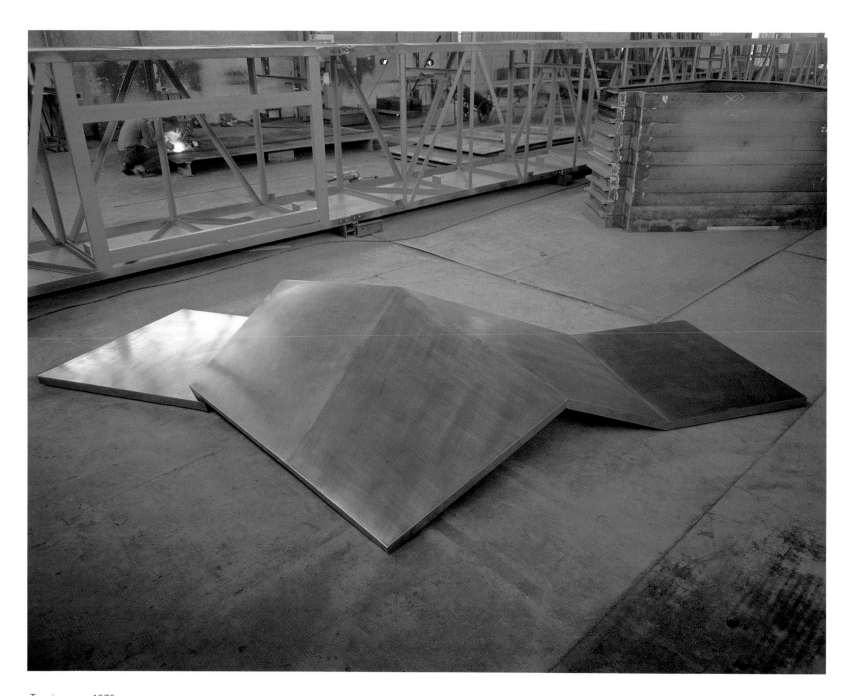

Trevignano, 1970

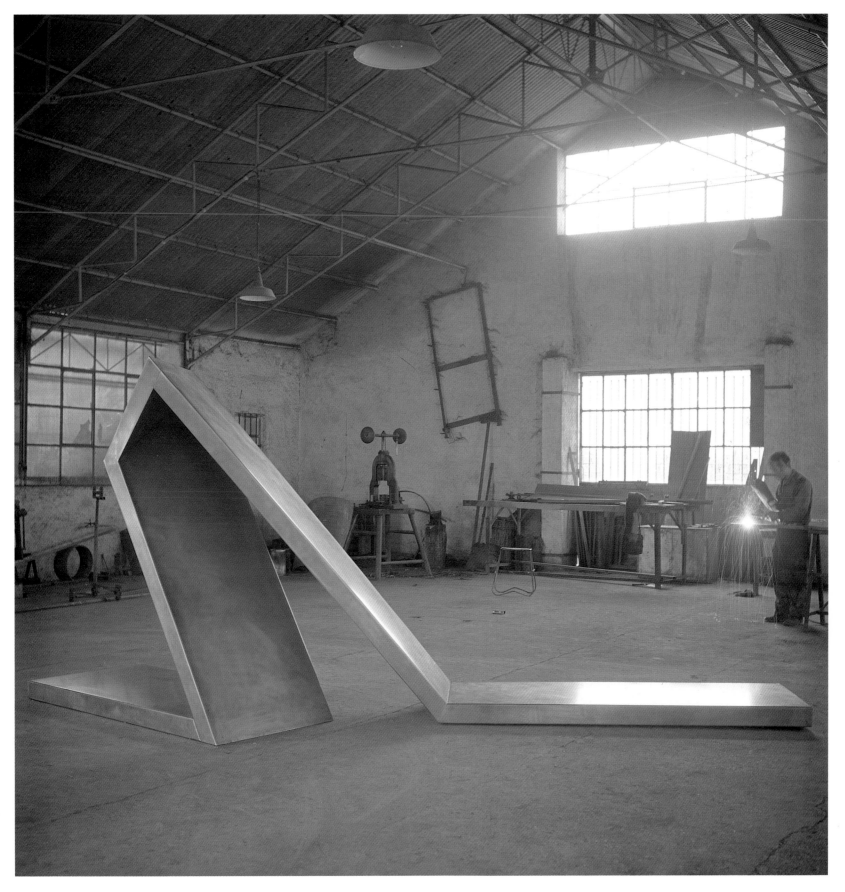

Campond, 1973

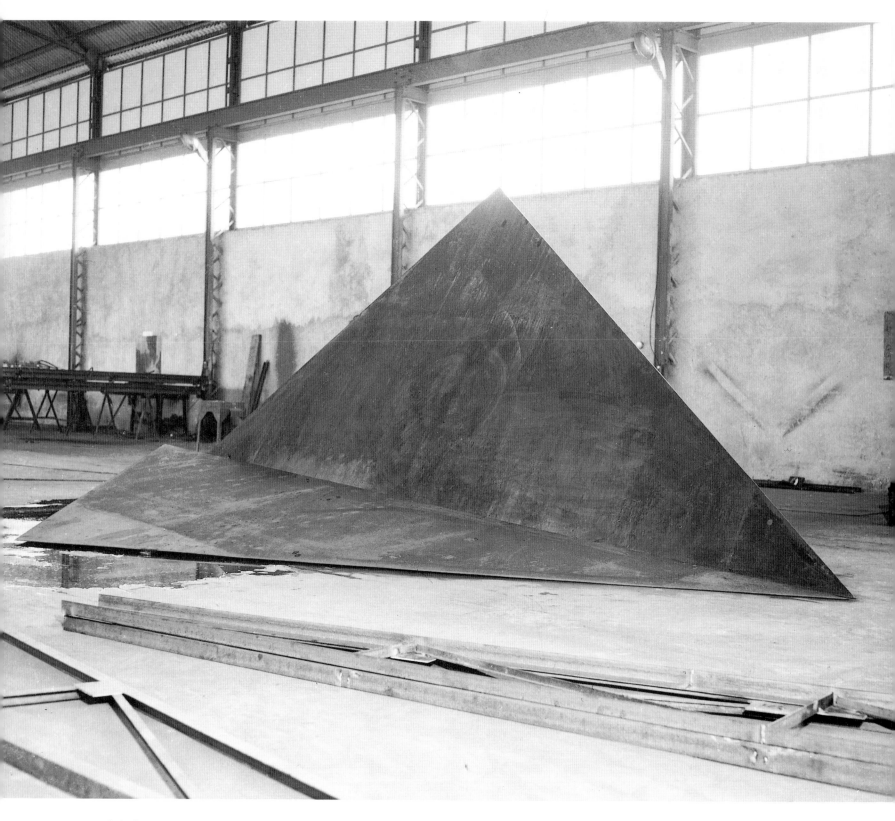

Split Pyramid, 1971

When in 1970 her work sought the ground, it did so first in planes of shining stainless that seemed to collect in geometrical pools on the floor, only to mound briefly upward at a shallow angle (*Odescalchi* [1970]), or in heavy flat plates of Cor-Ten interrupted by diagonal ripples like mammoth serpents moving over unseen protruberances in the earth (*Camposimp* [1970], *Trevignano* [1970]). Her horizontality was, in this way, always conditioned by what appeared to be a change in *grade* in the ground itself, a horizontality that could not be absolute because it seemed to be articulating a subterranean struggle pitting one direction against the other.

It is in this sense that the modernist sculptural paradigm is activated by being invoked—called to mind—and then strangely displaced or neutralized in these sculptures. These horizontal works oppose the idealism of the vertical representation that separates itself from the place it defines. Instead, although they remain representations, they represent the earth's amorphous spread, its chthonic darkness, the movement through it of tunnels. They do not mark a transcendence over horizontality but the fact of horizontality itself. And part of this fact is that the horizontal—the earth—has an inside, a depth.

The sculpture of "truth"—early modernist sculpture—carried that universal law as the meaning secreted within itself, at its core. The labor of the sculptor had been to organize the work's external form in such a way that it would appear as the result of that truth, the outcome of an inner axiom or rule.

These works by Pepper are deflected or displaced vis-à-vis the sculptural relation of inside to outside as they were vis-à-vis the opposition between vertical and horizontal. For they describe or represent or report an inside. Only, the inside they describe is not their own. It is the inside that is the earth's, an inside that has no formal truth and that sculptural form cannot master. It is an inside far more like the black beneath the carapace of the chestnut root at Bouville, a disorganization that sculptural form can bring into view as both surfeit and magisterial indifference.

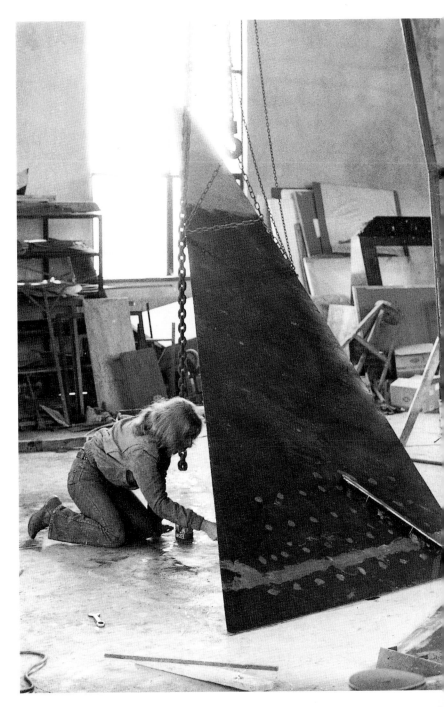

The artist at work in her studio, 1970

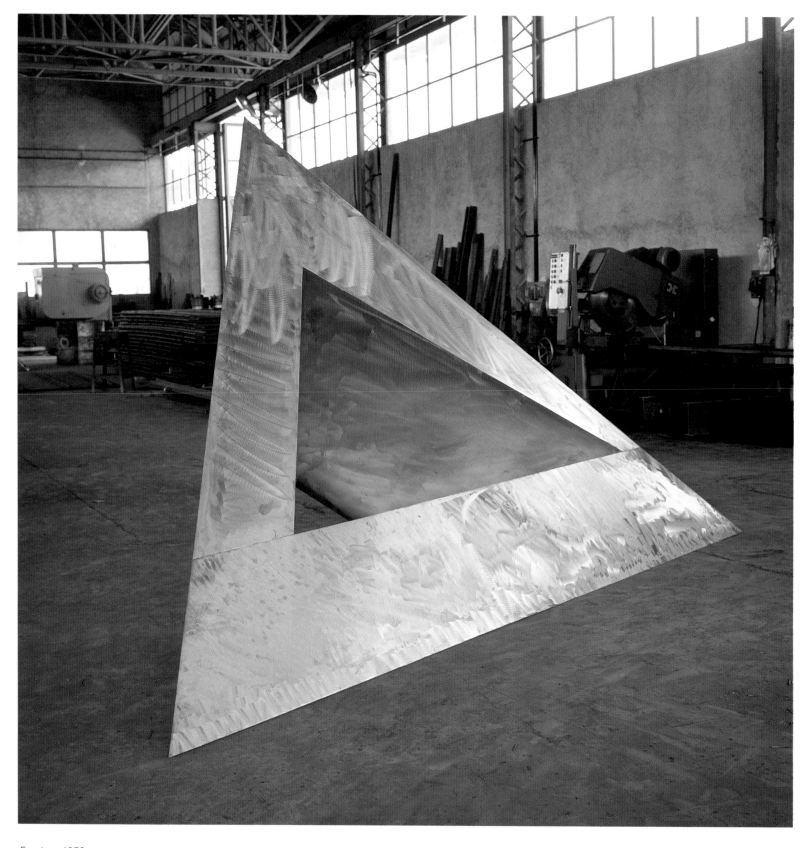

Exodus, 1972

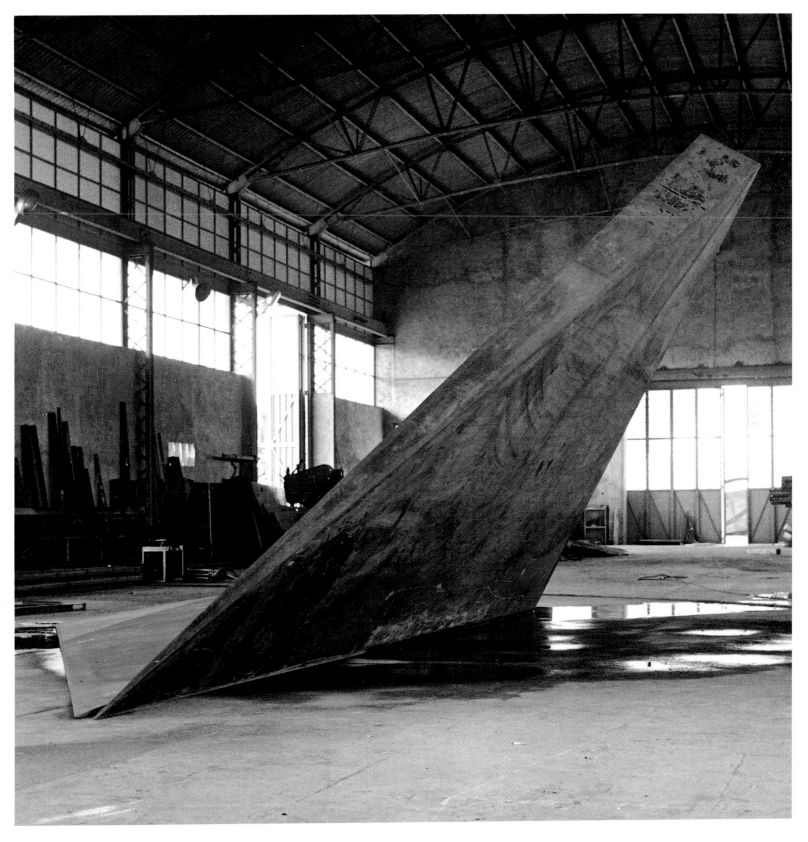

Split Pyramid No. 3, 1971

Pages 78–79: The artist in her studio, 1970

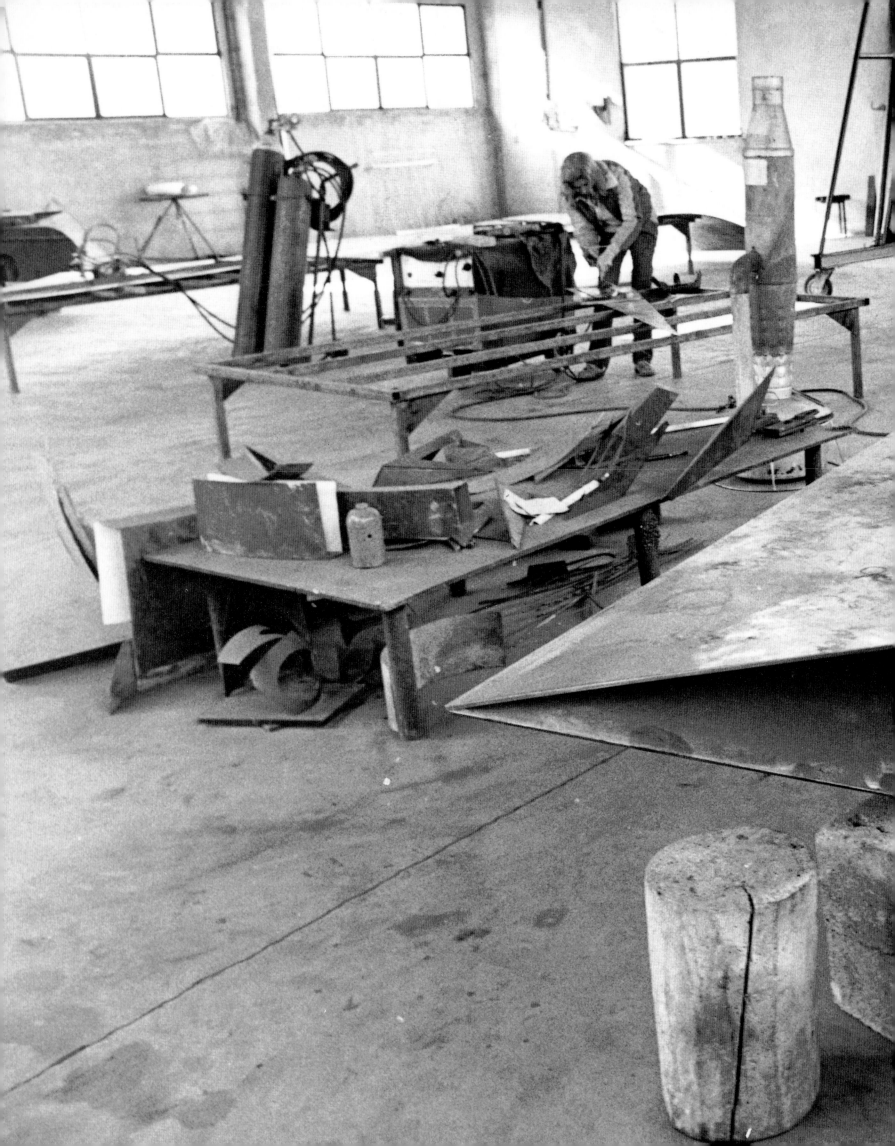

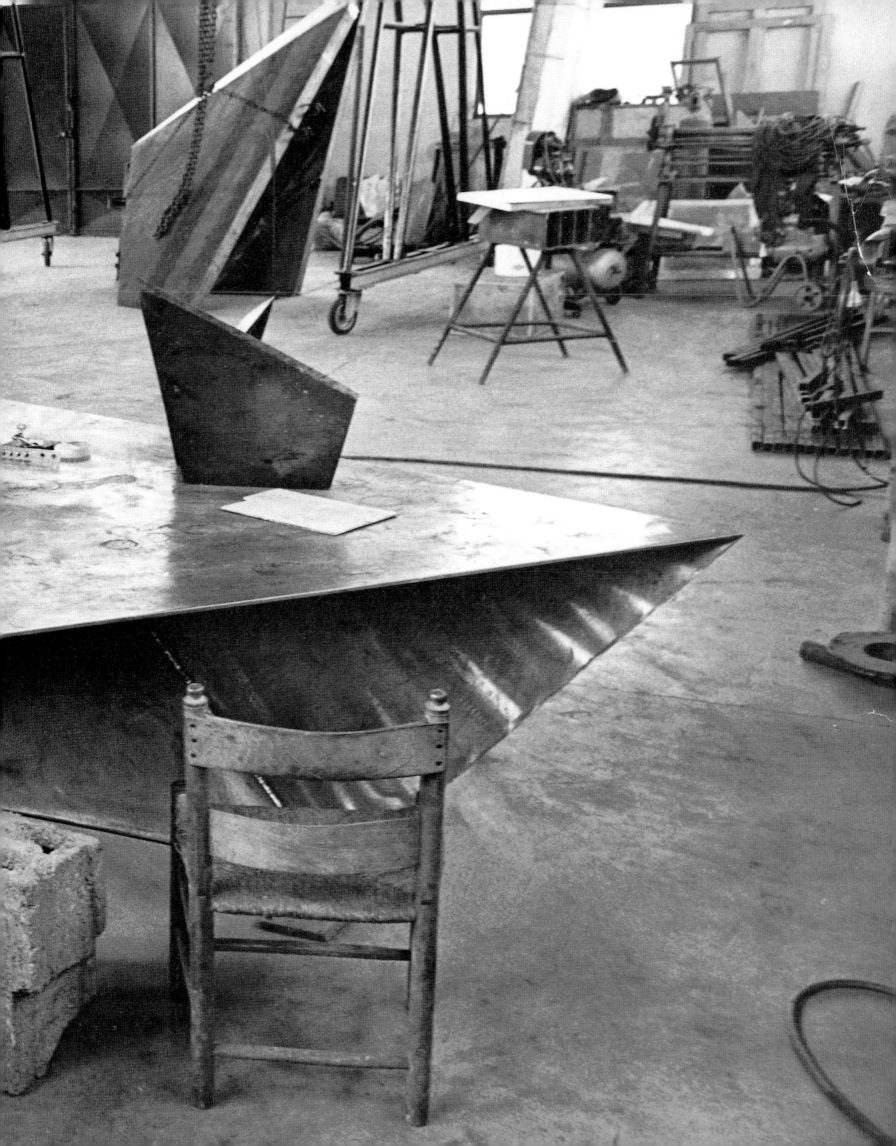

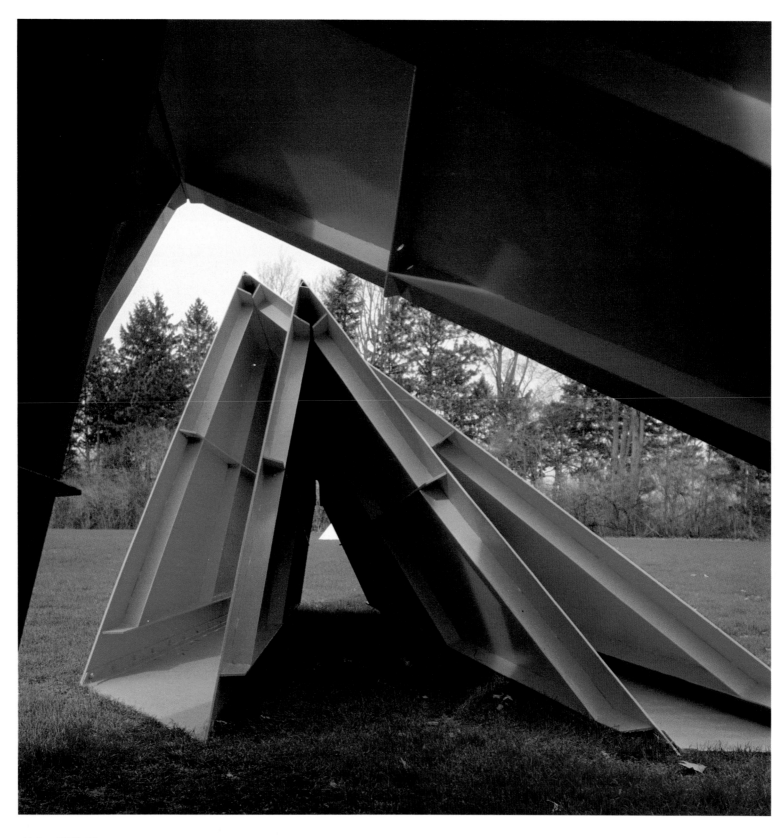

Alpha, 1973–75

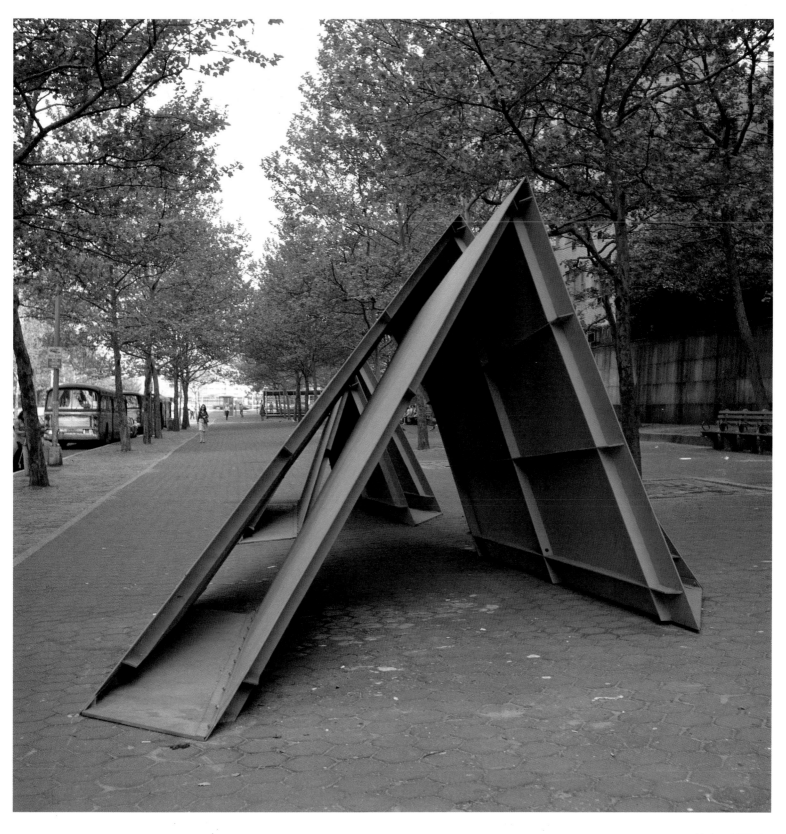

Alpha, 1973–75

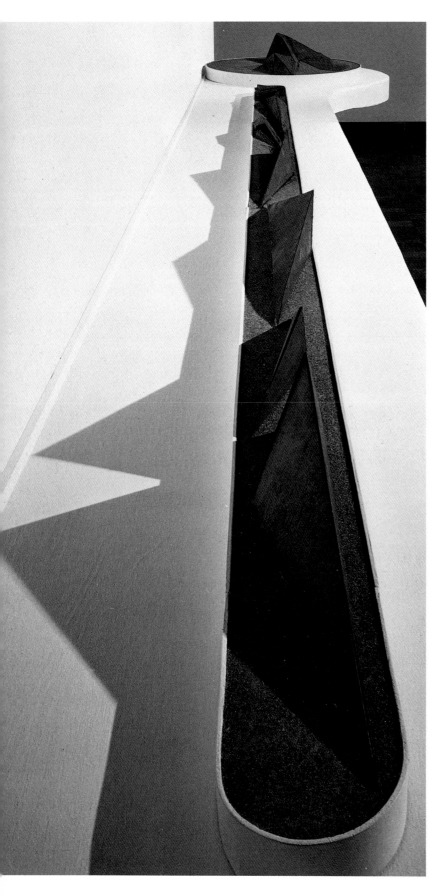

Maquette of *Dallas Land Canal and Hillside,* 1971

Here are some earthen insides whose depths she began in the early 1970s to poke or prod or test:

—A shallow "land canal" in Dallas, which runs for three-hundred feet, a ribbonlike trench nearly six feet wide, which occasionally sounds a depth of about five feet.

—The sand mass of a beach projected as the site for a work that is part tunnel, part dike.

—The side of Mount Vesuvius, on which the terracing of vineyards would help to create a necropolis.

From certain angles and from a distance, the forms of the *Dallas Land Canal and Hillside* (1971–75) look like a long, low cluster of pyramids. At other angles, from above the trench, the wedge-shaped steel sides of the elements resemble plows excavating the green cover of sod. This relation between built, geometrical thing and the growth that mounds against it, partially covering it, could be seen to interpret in yet one more formal idiom that collision of culture and jungle in Cambodia, that rich but mortal fecundation of each by the other.

By the mid 1970s the idea of a sculpture that would describe excavation and grade, that would combine the built with the non-built, became less involved with a question of struggle, with images of tunneling or digging or interruption. *Amphisculpture* (1974–76), two-hundred feet in diameter, calls to mind the repose of the Classical amphitheater and nestles with relative serenity into the crest of the knoll whose "center" it cautiously sounds.

□

> *If it resembles something, it would no longer be the whole.* [18]
>
> Paul Valéry, "Eucalinos ou l'architecte"

The question of the inside, then, is summoned but displaced. For the work that works the earth excavates toward the "inside" of what is not itself. This strategy of summoning and displacing the terms of sculptural meaning came to function in the increasingly larger work of the middle 1970s. *Phaedrus* (1975–77) will serve as the extreme and perhaps best example. The terms it summons but neutralizes are the axial relations of vertical/horizontal.

Phaedrus is pyramidal. Its triangular face rises at a thirty-degree angle to the ground, a face whose geometry is underscored by the triangular void that punctures it, excavating backward into what appears to be the metallic depth

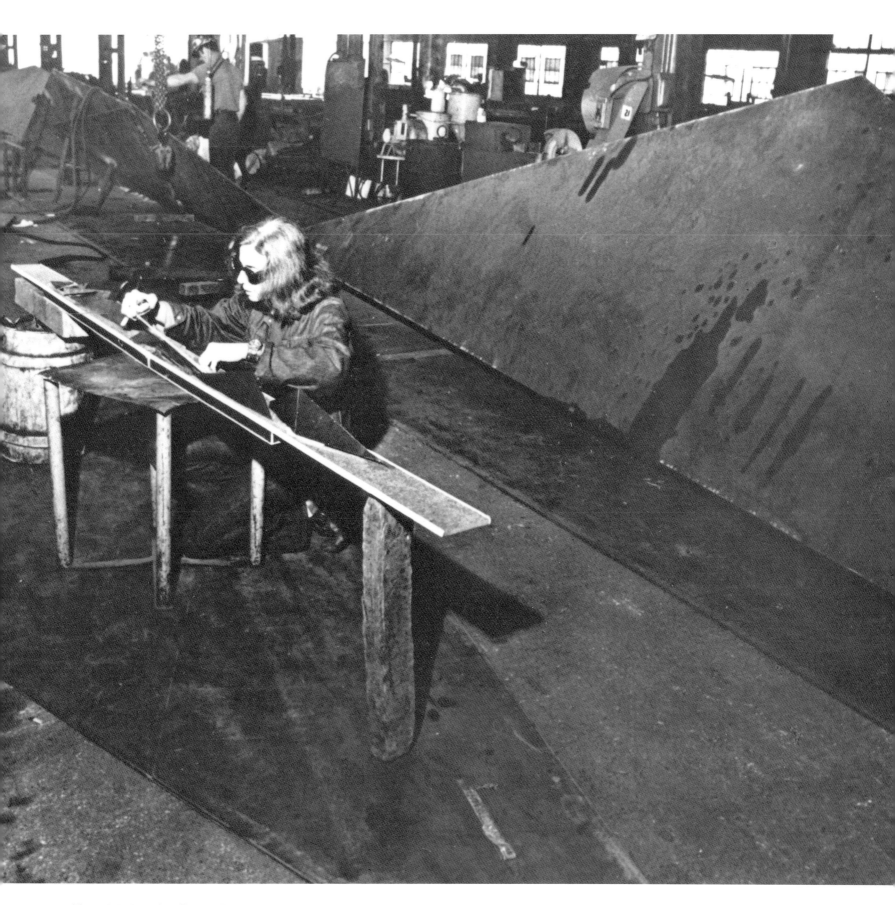

The artist at work in Dallas, Texas, 1970

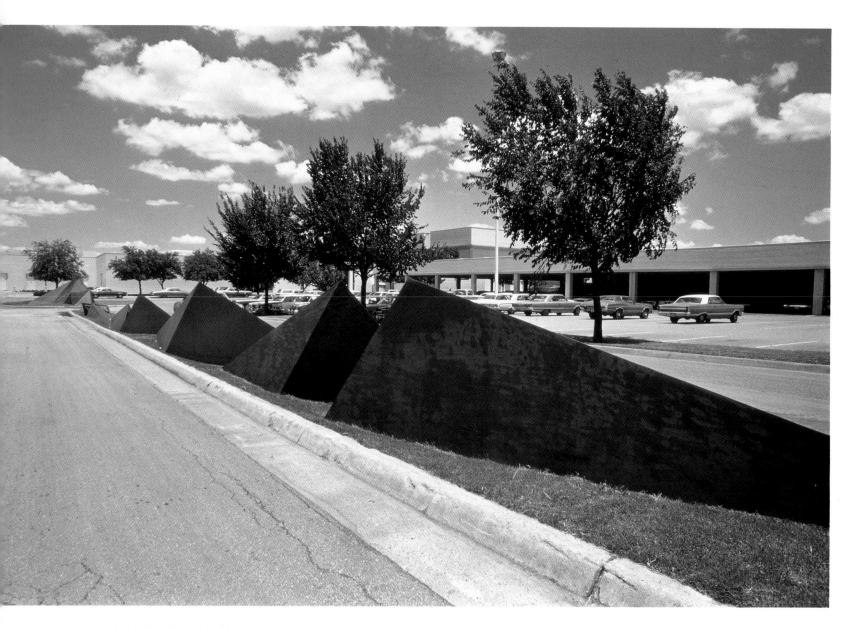

Dallas Land Canal and Hillside, 1971–75

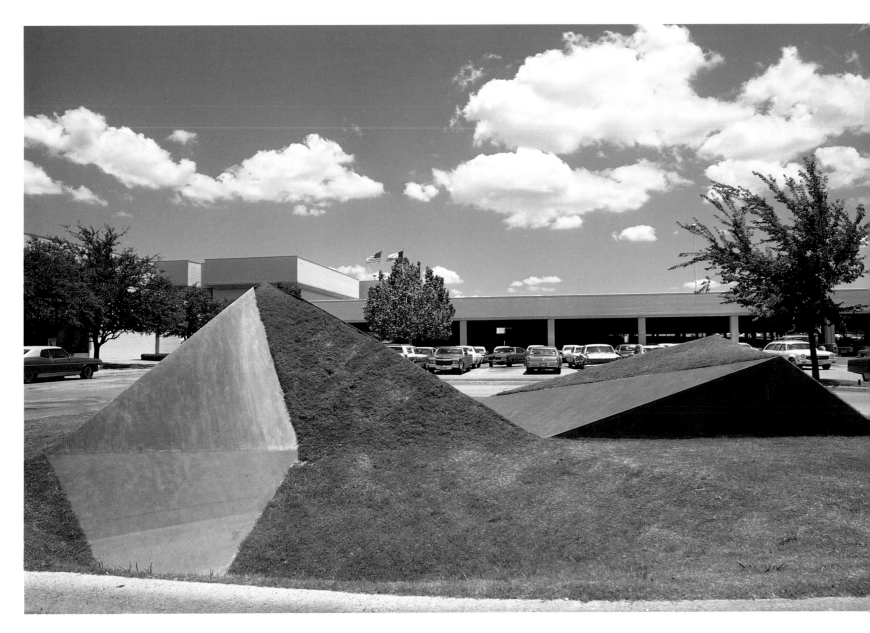

Dallas Land Canal and Hillside, 1971–75

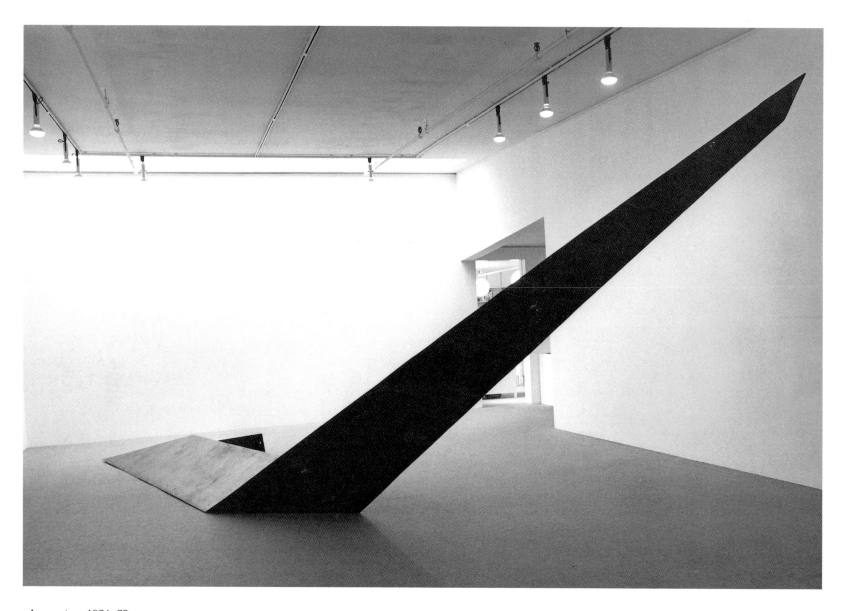

Ascension, 1974–75

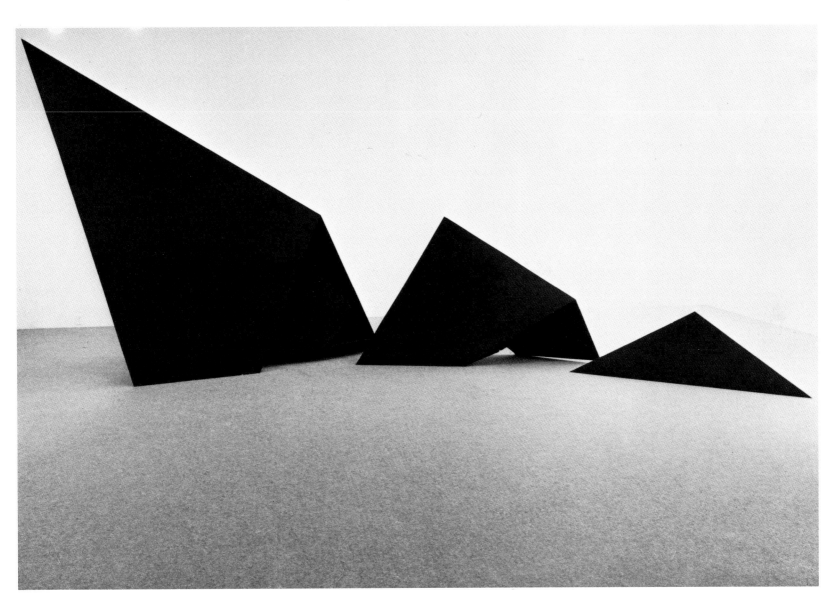

Pithom Revised, 1973–75

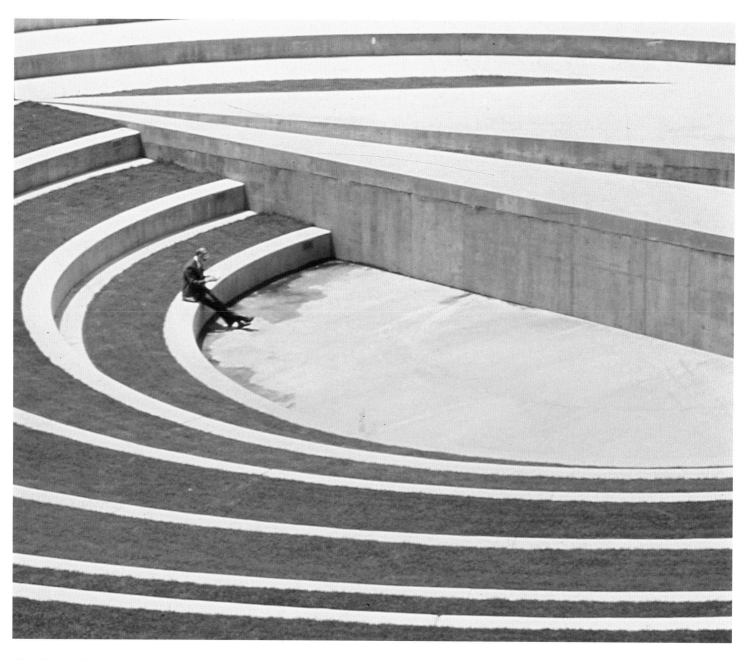

Detail, *Amphisculpture,* 1974–76

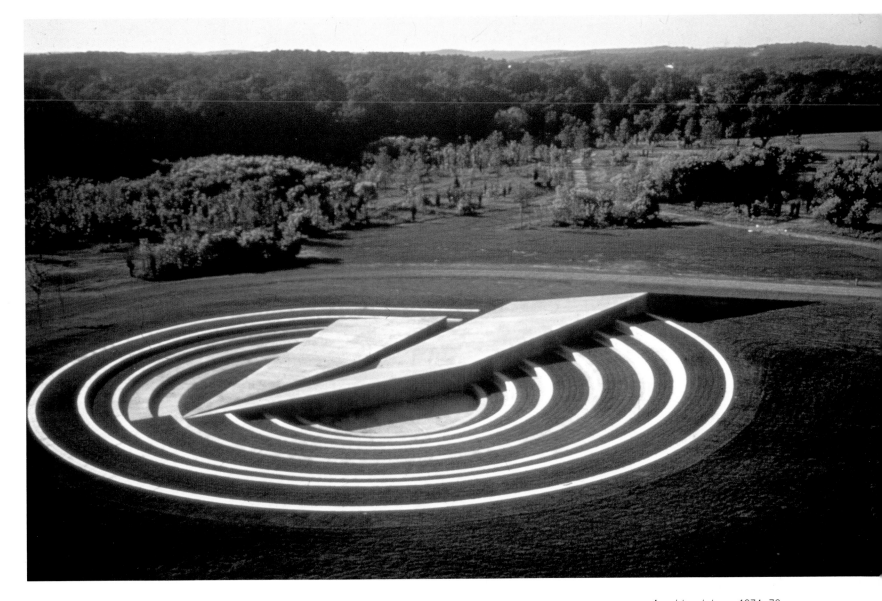

Amphisculpture, 1974–76

Pages 90–91: *Amphisculpture,* 1974–76

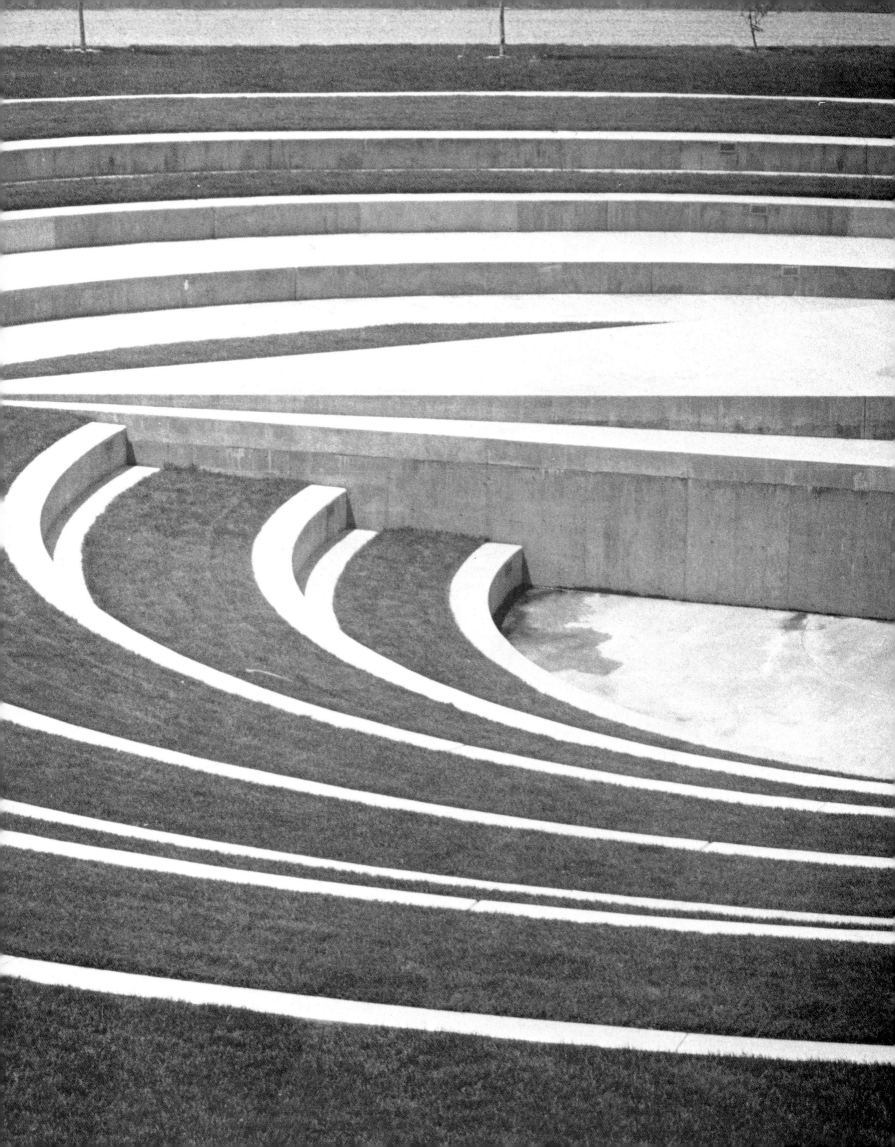

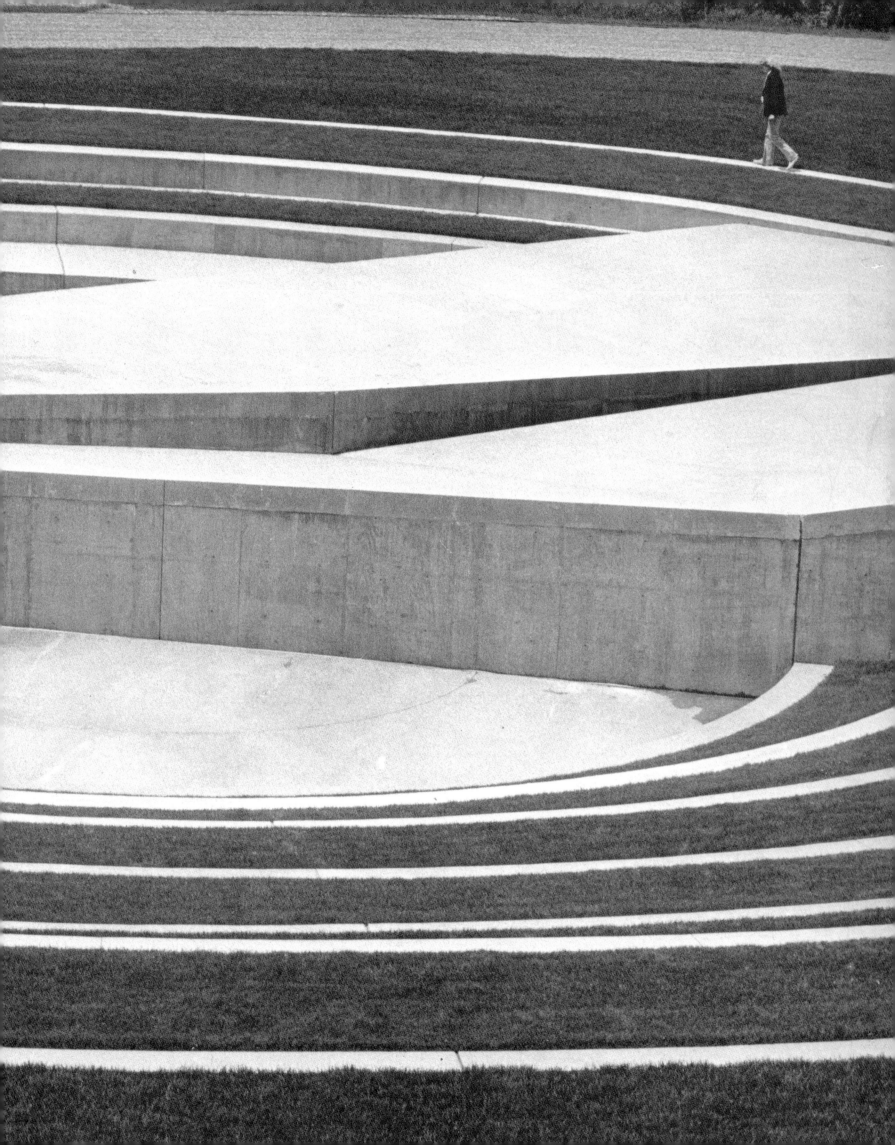

Thel in progress

of the form. Yet this pyramidal face is grounded in nothing but air. No further sides rise from the earth to fuse with it in geometrical stability, to complete that ideally durable volume in which three triangular sides each lean toward the other in a structure of mutual support. Instead, the "face" of this pyramid hovers between rising and falling, between vertical and horizontal, supported it would seem by nothing. The dimensions of solid and void, of vertical and horizontal, are called forth and neutralized so that in *Phaedrus* the experience of *something rising* is strangely cancelled by that of *nothing falling.*

This simultaneous rising and falling, through which the absolutes of the difference between vertical and horizontal are magically canceled, had been what compelled her attention in these years to the shape of the triangle, the object whose slope reads both ways. A work like *Ascension/Descension* (1974–75) names this experience of the geometry of the triangular prism, as does *Excalibur* (1975). In its apparent lack of any support, however, *Phaedrus* reaches for the extremes of balance between one condition and the other: neither vertical nor horizontal; neither/nor; difference suspended; conflict annulled.

The techtonics of this hovering narrow prism of metal, thirty feet from base to point and over fourteen feet wide, require an elaborate metal web inside the work, a frame or brace over which the skin of the volume is stretched, as though one were making something like the wing of an airplane or a tensegrity roof.[19] This structural inside or center had a beauty that began to obsess her.

In 1976–77 she made *Thel,* an earth sculpture that rose above and tunneled through a one-hundred-thirty-five-foot sweep of ground at Dartmouth College. The "inside" to which these grounded pyramidal volumes related as container to contained was, as in the case of the other horizontal works, the inside of the field: a spread and immensity that cannot be contained. But one of the elements, the largest (rising twelve feet), turned its back to the earth to reveal its own inner fabric: its web of white metal mesh.

The year that she finished *Thel* she worked on a group of large-scale web sculptures that fanned over the ground, both rising and falling in a display of nothing but structural principle. It was the seemingly wild randomness of these webs, their scatter of balance and tension, that gave them the quality of decentered center, of the hidden structural rationale of the earlier, sheathed works exposed as irrational and strange. □

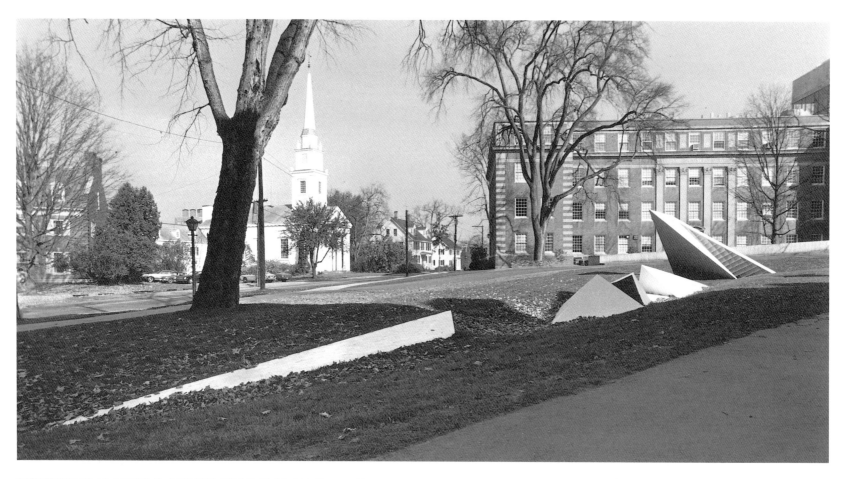

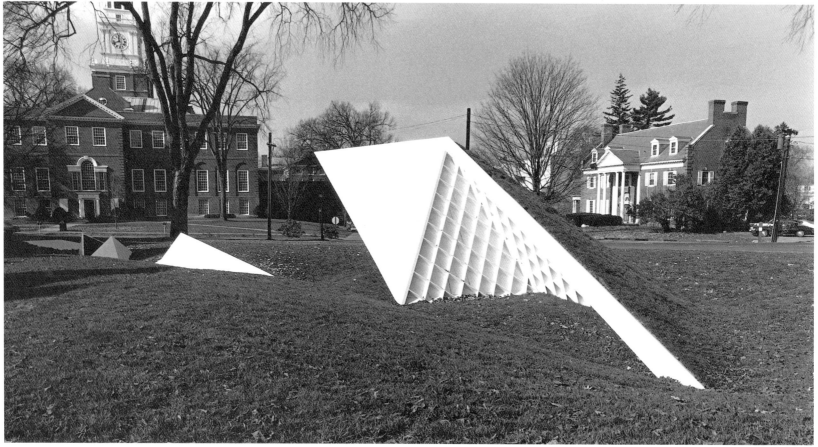

Thel, 1976–77

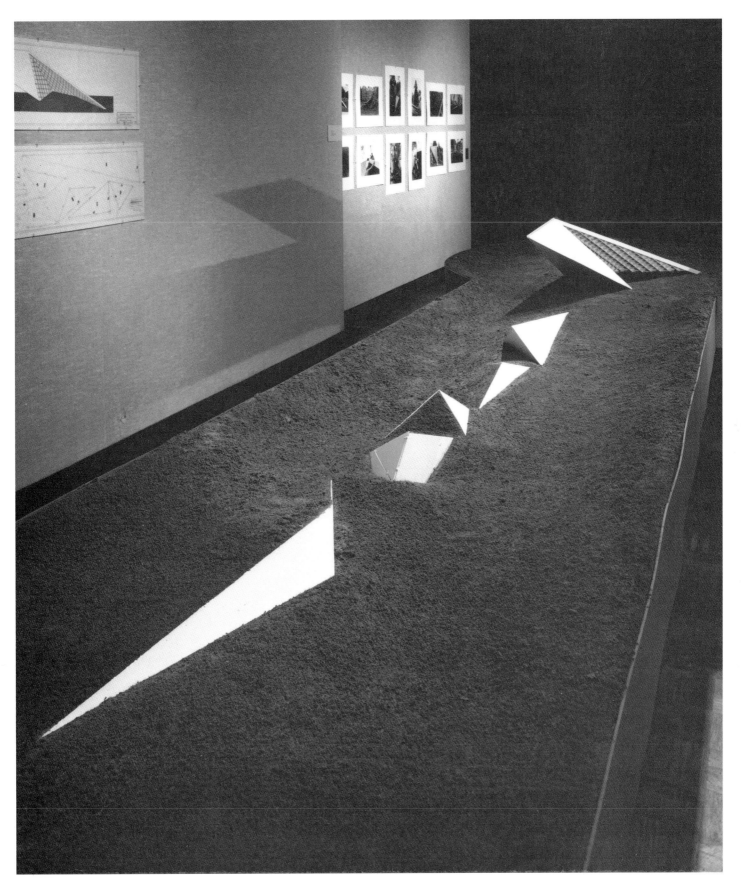

Model, *Thel*, 1976

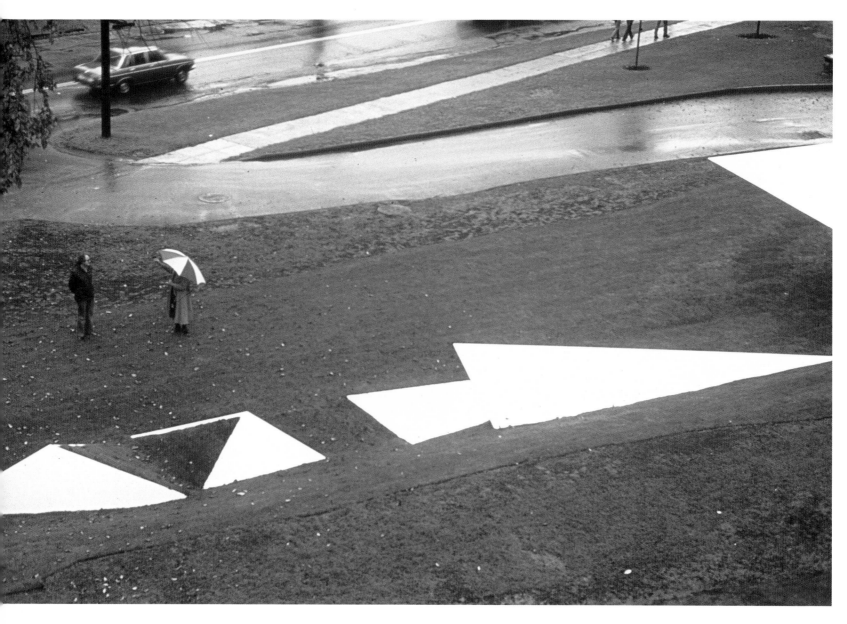

Thel, 1976–77

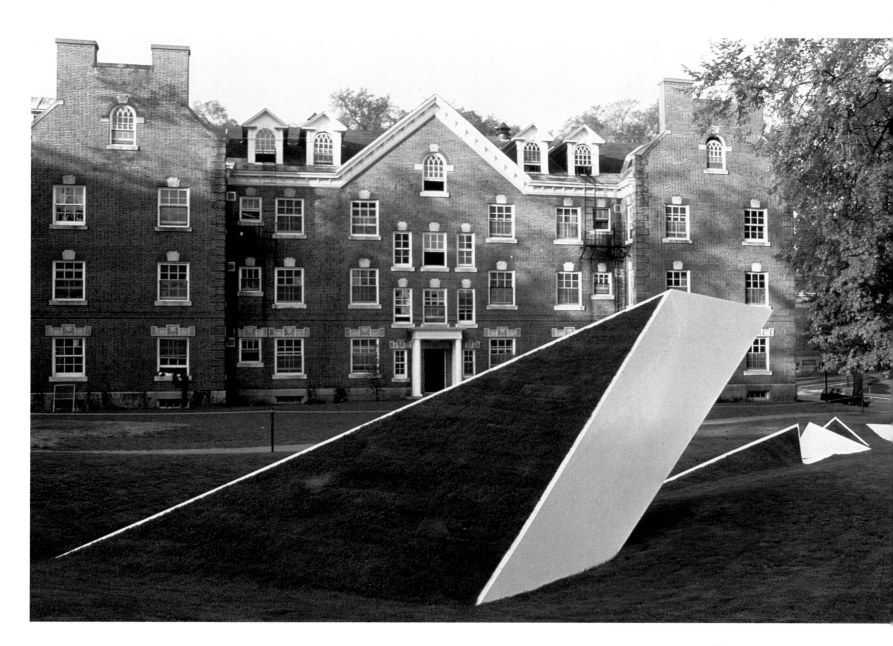

Thel, 1976–77

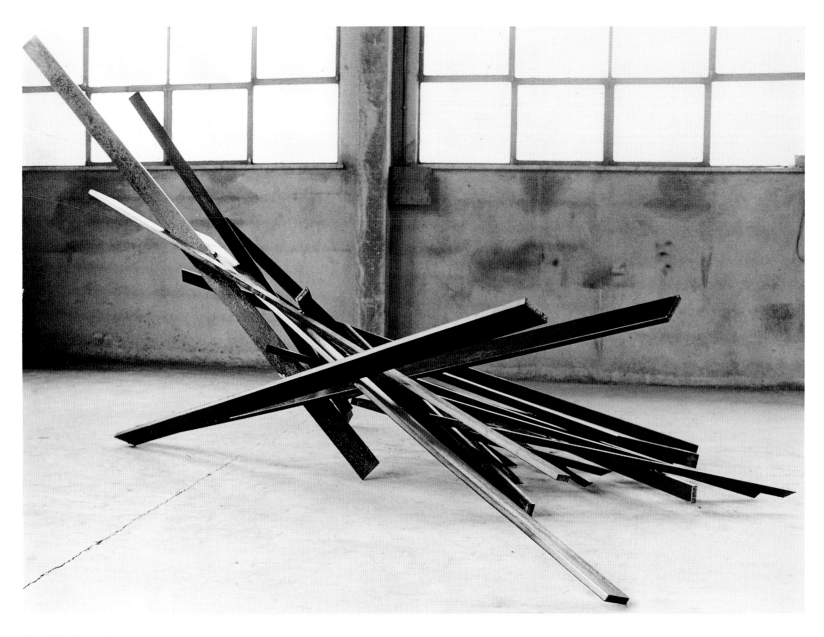

Rain Shadow, 1977

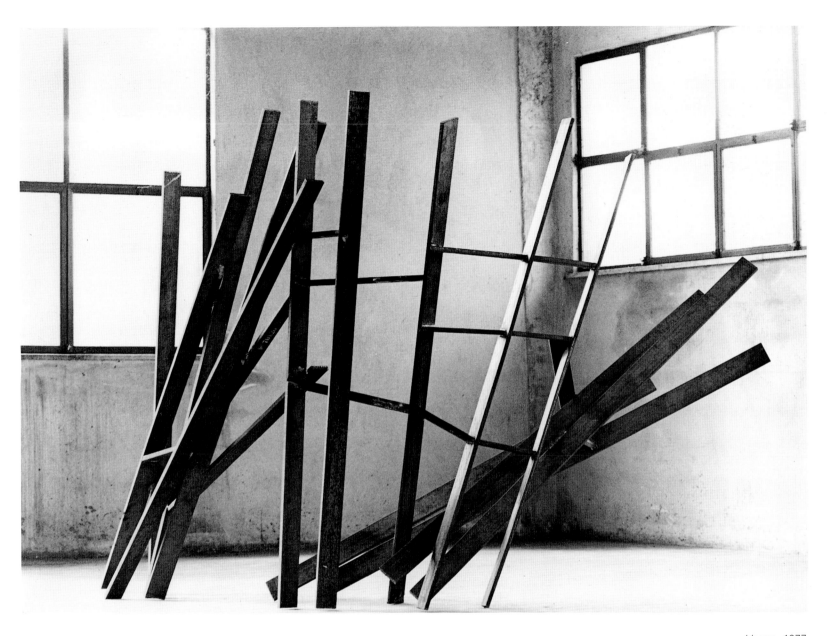

Hosea, 1977

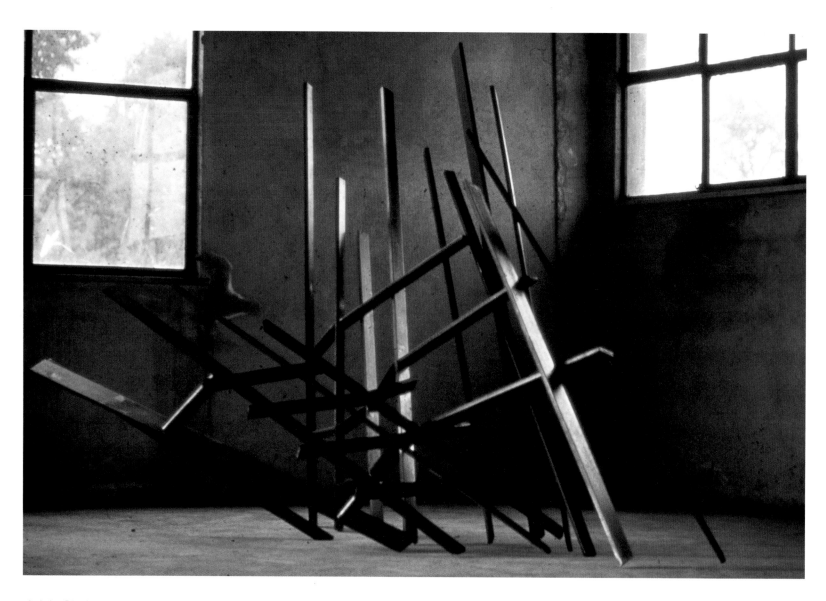

Astatic Black Web, 1977

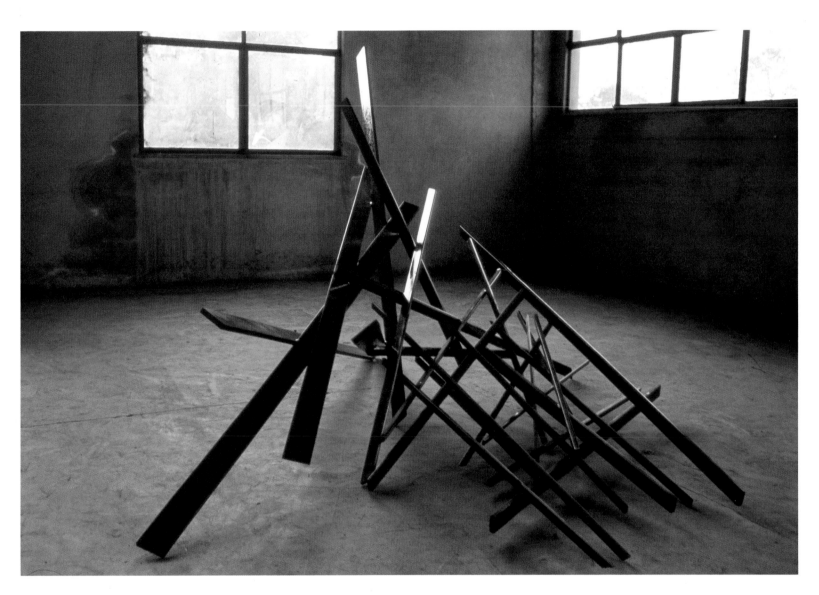

Shaddai, 1977

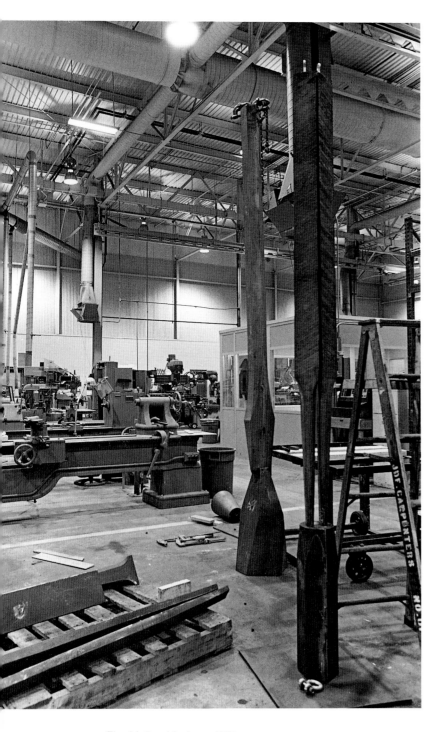

The Moline Markers, 1981

In 1962 his Italian crew at Voltri had helped him to gather up a group of extraordinary tools that were lying, old and disused, about the derelict factory buildings in which he had made his sculptures for Spoleto. Giant wrenches, huge pincers, mammoth, elegantly tapered tongs were packed in wooden crates to be shipped to the States, to his studio at Bolton Landing, the farm above Lake George, New York, that he called Terminal Iron Works. Nothing like this had fallen into his hands before; he could not believe his luck.

David Smith was used to incorporating machine parts within the overall fabric of his sculpture. For the *Agricola* works from the early 1950s, he had cannibalized farming equipment. For the series called *Tanktotem,* which he had elaborated until the end of the decade, he had worked off an initial association he had had to the gently swollen curve—concave/convex—of the tops to boiler tanks and what seemed to him their resemblance to the pelvic girdle, a kind of metallic seat of pleasure.

To incorporate these objects into the work, however, meant to transform them. He was not interested in the potential irony of a possible flip-flop of perception, as in that well-known sculpture by Picasso: now a bicycle seat, now a bull's head. Even less was he captivated by the idea of the ready-made, the object turned sculpture simply by nomination, Duchamp's urinal named *Fountain.* He did not want the experience of these objects' possible resistance to art, their operation within the orbit of the work, to defy the aesthetic paradigm because of the obviousness of their non-art status, their utilitarian meanings. What interested him in the importation of the found object was the persistence of its physicality, its brute, material character, its struggle with the lyric possibilites of his own metal "line drawing." It provided him with a certain kind of non-figurative grit, the sand in the machine of his illusionistic ability to push his material toward the weightlessness of pure profile. He used the found object in the way that González, his acknowledged "first master of the torch," had used it before him.

Once at Bolton Landing, the Italian tools filled his studio with a kind of antique presence, with elements that had little relation to the shiny, crisp profiles of modern equipment. And their size was such that he could use them for full-scale works; the arm of one of his Italian wrenches, for example, was as long as a man's leg. The twenty-five *Voltri-Bolton Landing* sculptures were harvested from these crates of tools.

Giuturna, 1978; *Colonna Traiana,* 1978

102

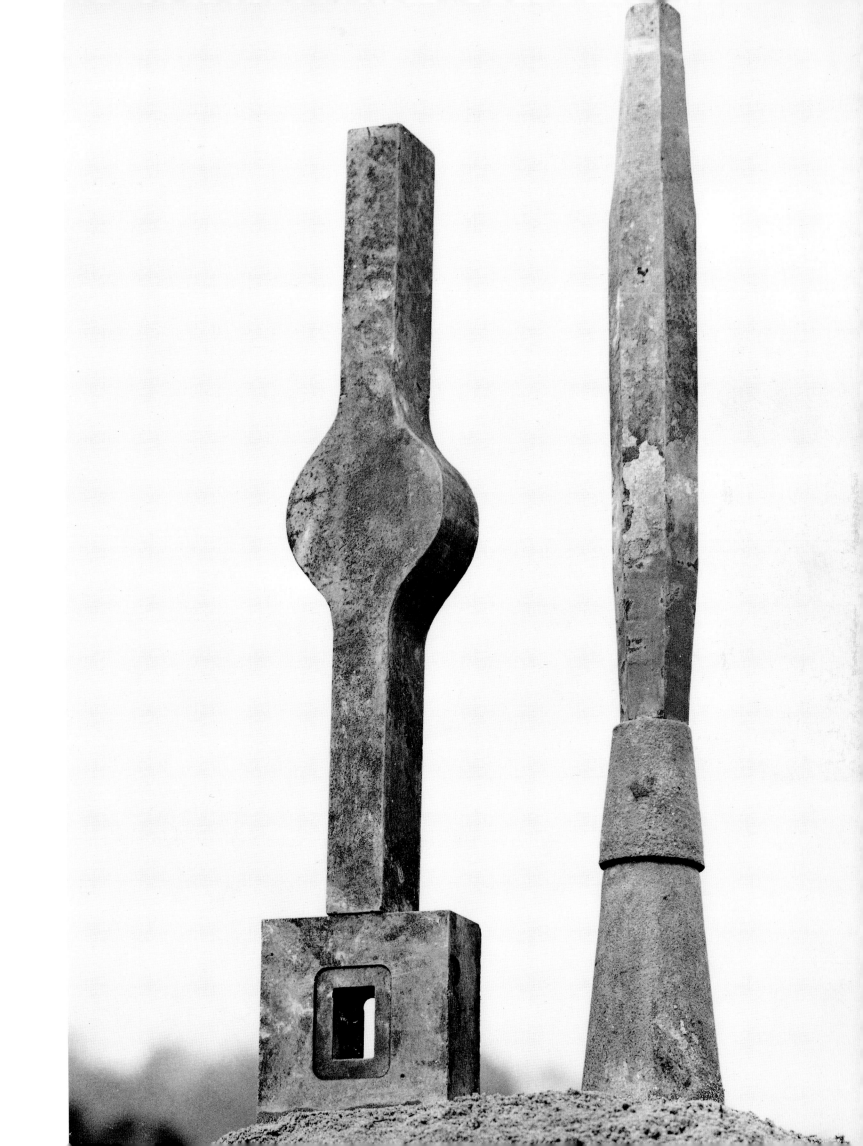

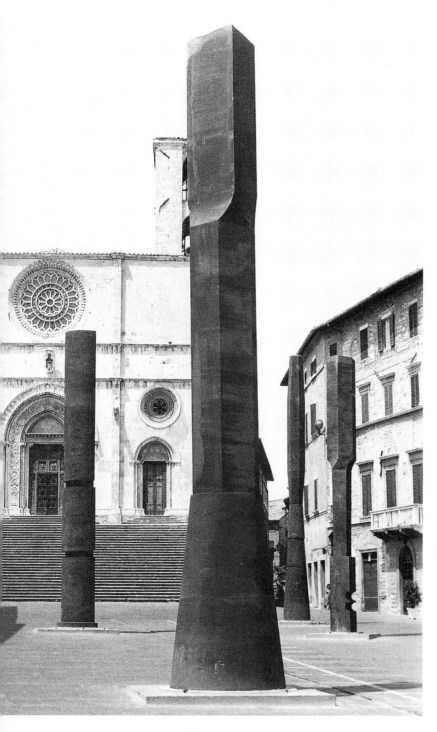

Piazza di Todi: l. to r.: *Colonna Senatoria*, 1979;
Colonna Martius, 1979; *Colonna Traiana*, 1979;
Colonna Aventinus, 1979

Opposite: Installation of works in Piazza di Todi,
Italy, 1979

Pages 106–107: Installation of *Colonna Aventinus*
in Piazza di Todi, Italy, 1979

Pages 108–109: Piazza di Todi: l. to r.: *Colonna
Traiana*, 1979; *Colonna Aventinus*, 1979; *Colonna
Senatoria*, 1979; *Colonna Martius*, 1979

When she turned away from the webbed works and began
to forge tools, she was interested in these forms neither for
the game of ready-made that might be played with them
nor, as Smith had sought, for the ductile shapes and
possibilities of incorporating them into a linear construction.
Instead, it was their total density, the fact that they were
solid through and through, which is to say that they seemed
to have *no* center. They were the tools that chipped and
chiseled away at something else to give it form. They were
the weapons of a worked material's "truth." But as for
themselves, in their obdurate solidity, they had none. A kind
of honest dignity, but no "truth." So the tools that she made
were of course forged. The massive weight of the drop-
forge would hit the molten steel to shape it: chisel shapes,
levers, mallets, files, wedges.

Beyond a certain scale the tools could no longer be made
in this manner, for the metal became too heavy to manipulate
under the forge. So she had to cast the forms. In the summer
of 1979, four of them filled the piazza in the Umbrian hill
town of Todi: thirty-four feet, twenty-eight feet, thirty-four
feet, thirty-six feet high. They were unregenerately vertical,
so she named them columns.

She had lived for twenty years in a city famous for soaring
vertical markers: the Column of Trajan in the Forum, the
monument to Marcus Aurelius in the Piazza Colonna, the
obelisk in the center of the Piazza del Popolo. There is a
way of moving through Rome as an incessant archaeologist,
constantly tying these objects back into the moment or
moments in history of which they are the remains, the
remanent witnesses. But these markers are also live in the
present, in a contemporary experience of the city, as guides
to one's movement through it, as visual measures of the
relation of urban volumes to sky.

She wanted to know if sculpture could be made out of
this latter experience of the column. The works at Todi were
her answer, as was *Polygenesis* (1981) in Houston, and
Vertical Presence—Grass Dunes (1985) in Buffalo. In the last
of these the sculpture is not simply the vertical projection
of the "tool"—here, the visually tapering screw of an
immense drill bit—but includes as well the slow sweep of
a circular "piazza," as flanges of metal sculpt dunes of
grass within the hundred-fifty-foot field around the work.

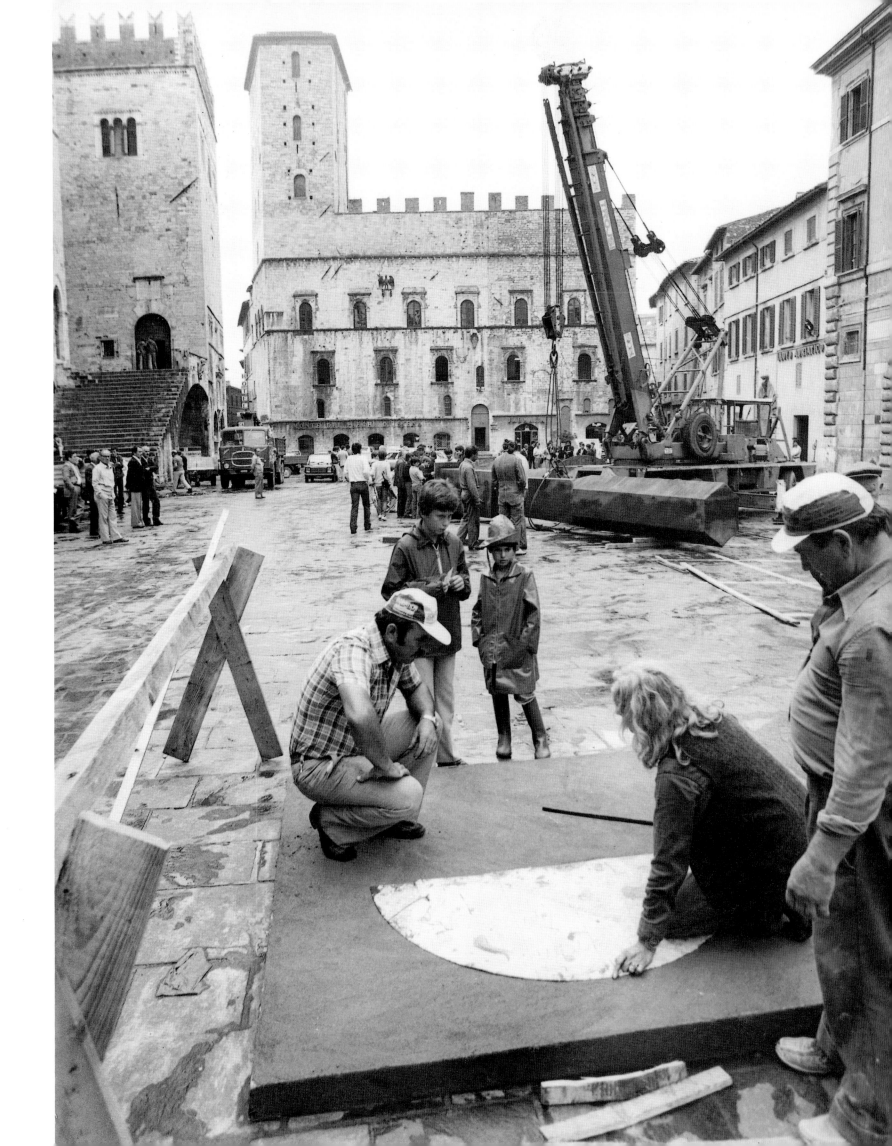

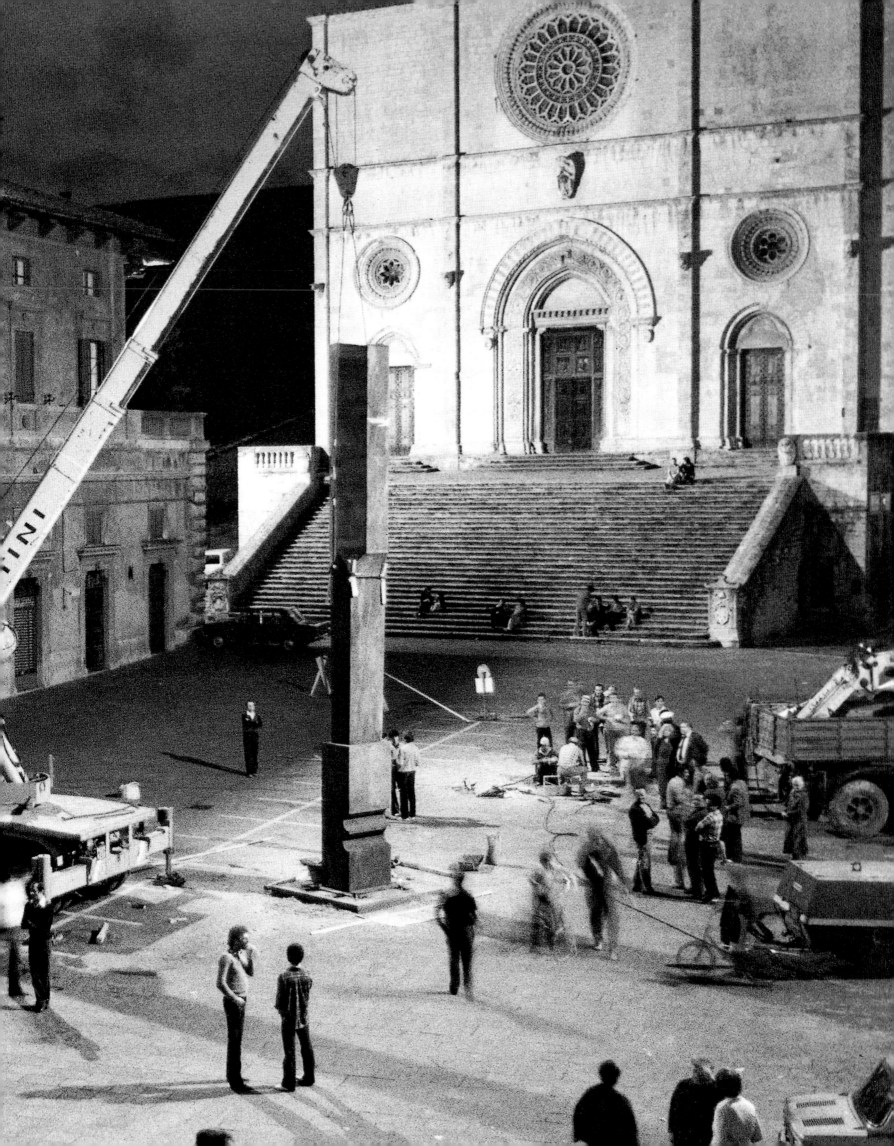

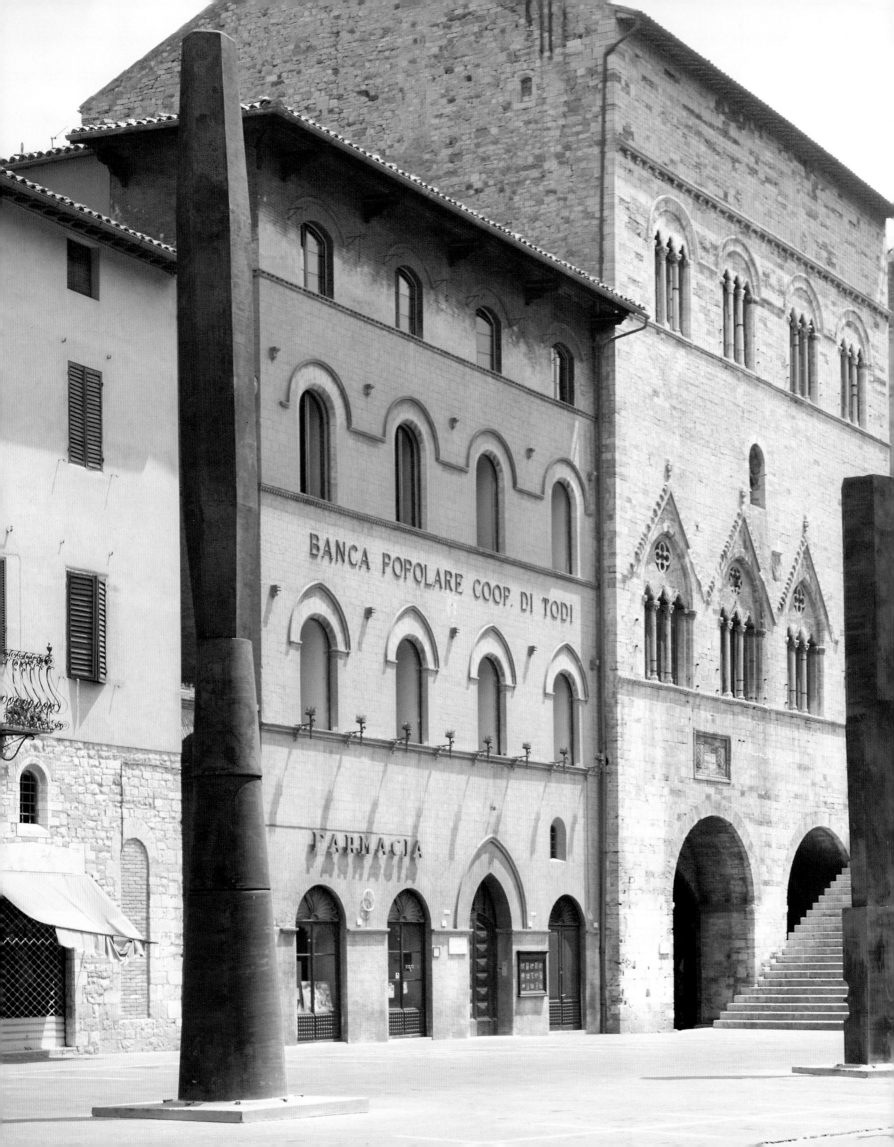

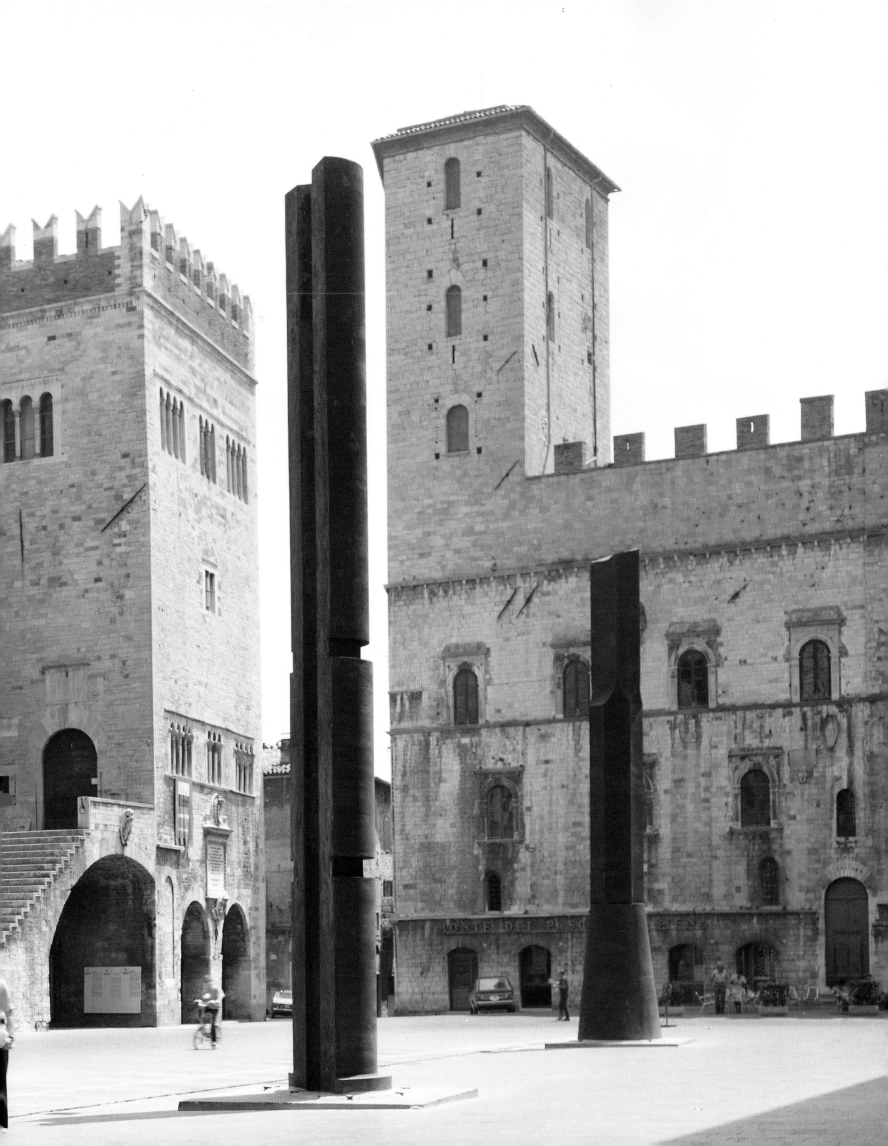

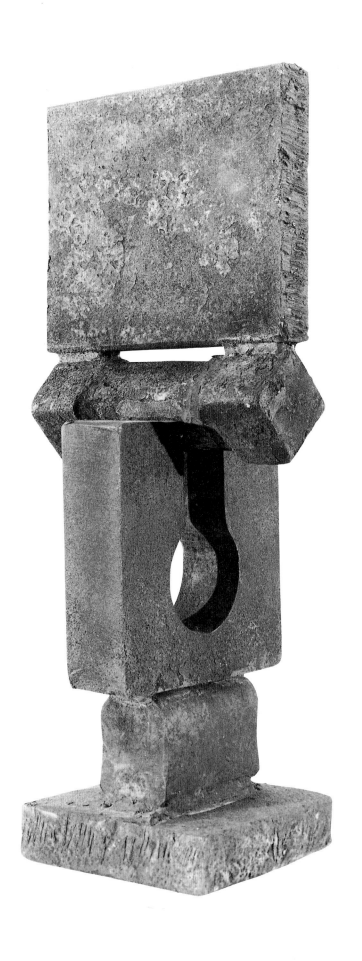

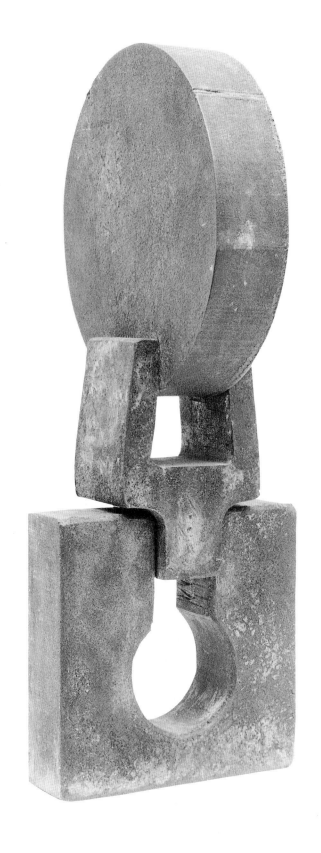

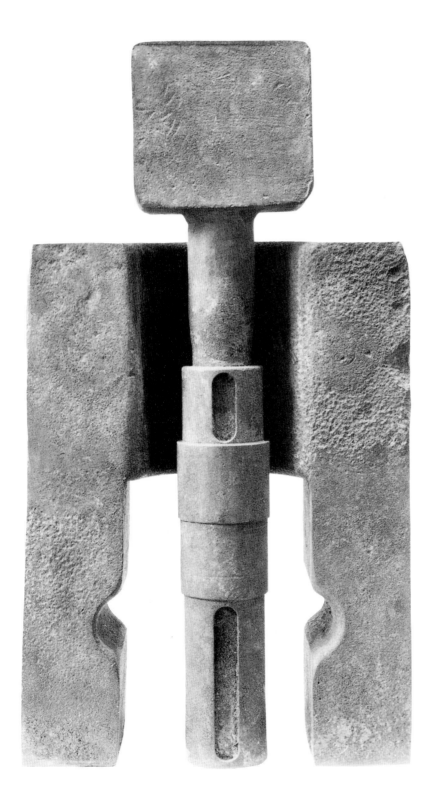

Ternana Wedge Column, 1979–80; *Oedipus Wedge,* 1979; *Volterra Portal,* 1979

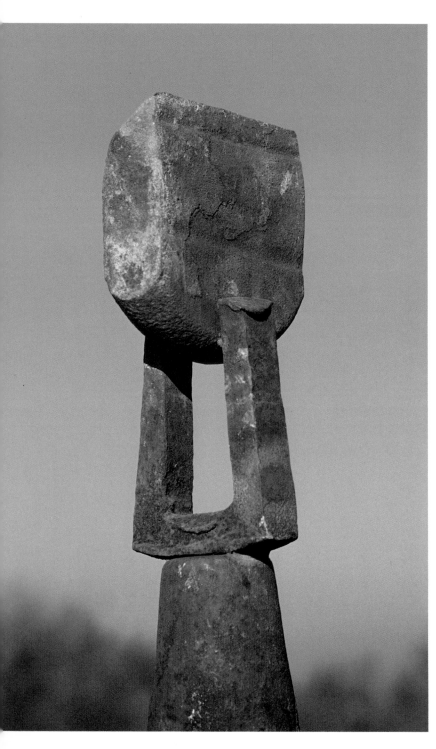

Goliath Wedge, 1978

In moving from the first forged tools in 1980, some of which were wedges—*Damiano Wedge* (22½ inches high), *Octavio Wedge* (11½ inches high), *Goliath Wedge* (22 inches high)—to the first series of castings, she made *Ternana Wedge* (7 feet, 5 inches high). Its vocabulary of use—chipping away, prizing up, slicing through matter—secured an experience of density for the object, a feeling reinforced by the prismatic cleft in the upper bladelike flange of the form, a triangular cut whose faceted sides excavate the thickness of the metal. But the predominant sense of *Ternana Wedge,* as one faces it, over-life-size, planted in one's path at right angles to one's point of view, is of a plane, flattened out to a paper-thin silhouette, rendered almost nothing but shape.

She looked at *Ternana Wedge* with a sense of recognition, having returned, through a strange circle in the logic of development, to the paradox of sculptural pictorialism she had explored in the mirrored stainless volumes of the late 1960s. Sculpture-as-picture violates the paradigm of sculpture-as-such, the purity of the aesthetic either/or. She had worked with this violation, this challenge to the paradigm, even before she had arrived at the mirrored objects. In *Homage to Piet* (1966) she pared away at the model of three-dimensional volume that a Constructivist vocabulary provides, with its play of planes abutting at right angles to describe analytically the relations of depth, to breadth, to height. She had pushed sculptural Constructivism toward its pictorial parallel, toward that fusion of the two- and the three-dimensional that had been the dream of de Stijl painters and designers in the 1920s, and of which Piet Mondrian had spoken when he wrote about painting's relation to architecture.

Homage to Piet is a sculpture whose subject is the flatness of the picture plane. It stands four-square in front of the viewer, bisecting his angle of vision with the abruptness that David Smith had used in *Hudson River Landscape* (1951), *The Banquet* (1951), and *Cubi XVII* (1965). It was through this homage to Constructivism, to Mondrian, and to Smith, that she entertained in her own work this particular maneuver past the either/or that theoretically separates painting from sculpture, and this had opened her own way to the achievement of the mirrored pieces of the following year. So the particular lateral spread of *Ternana Wedge* before her plane of vision felt welcome, like a return.

Ternana Wedge, 1980

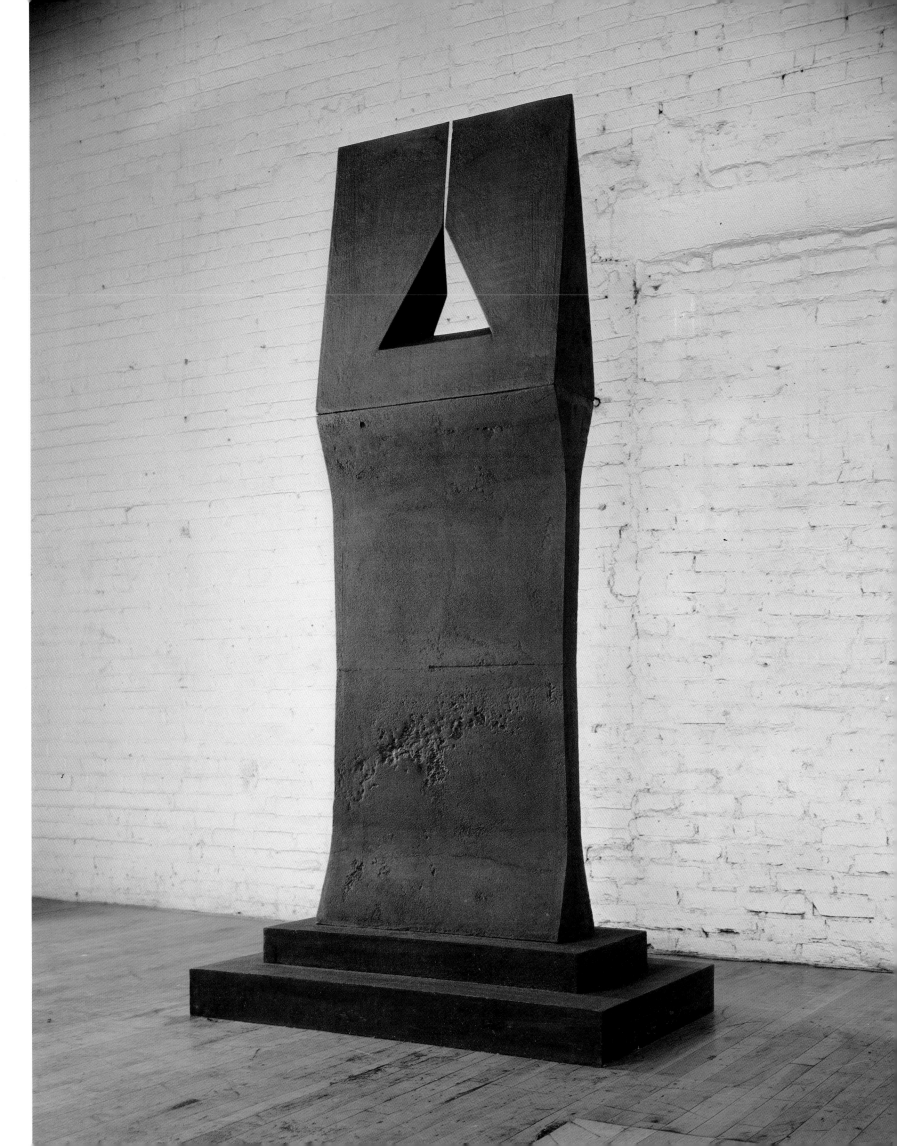

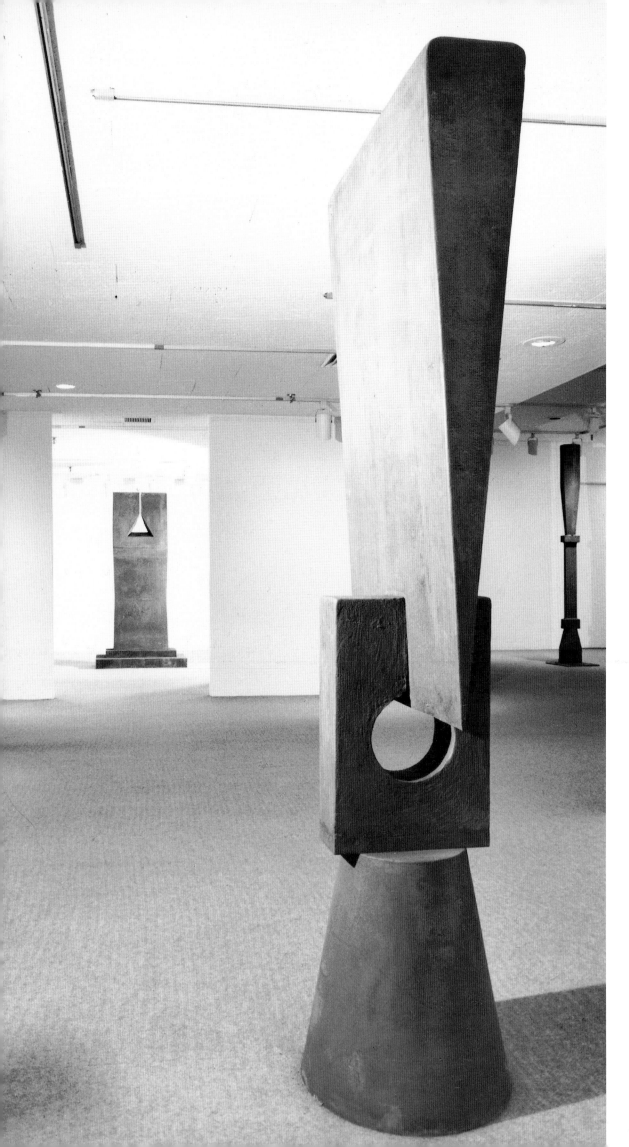

Normanno Wedge, 1980 (foreground)

Opposite, l. to r.: *Normanno Column,*
1979–80; *Tarquinia Spiral I,* 1979–80;
Claudia Column, 1980; *Mauro Column,*
1980; *Normanno Wedge,* 1980;
Claudio Column I, 1979–80

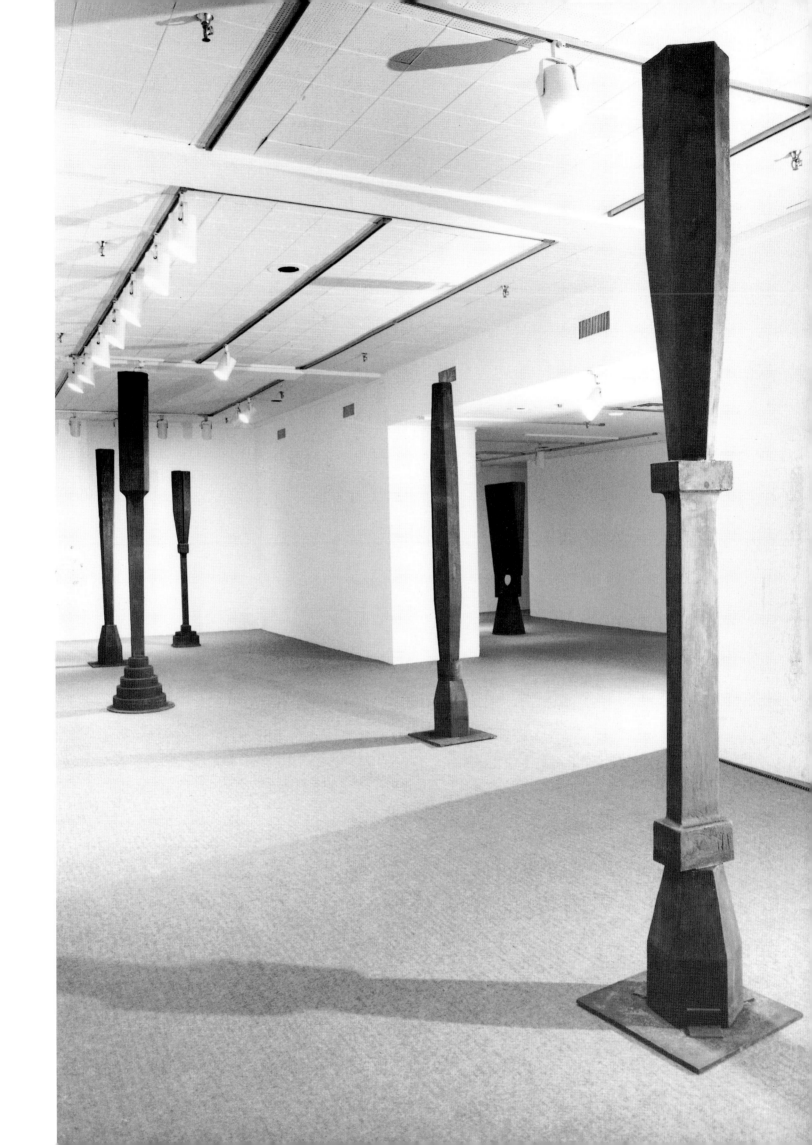

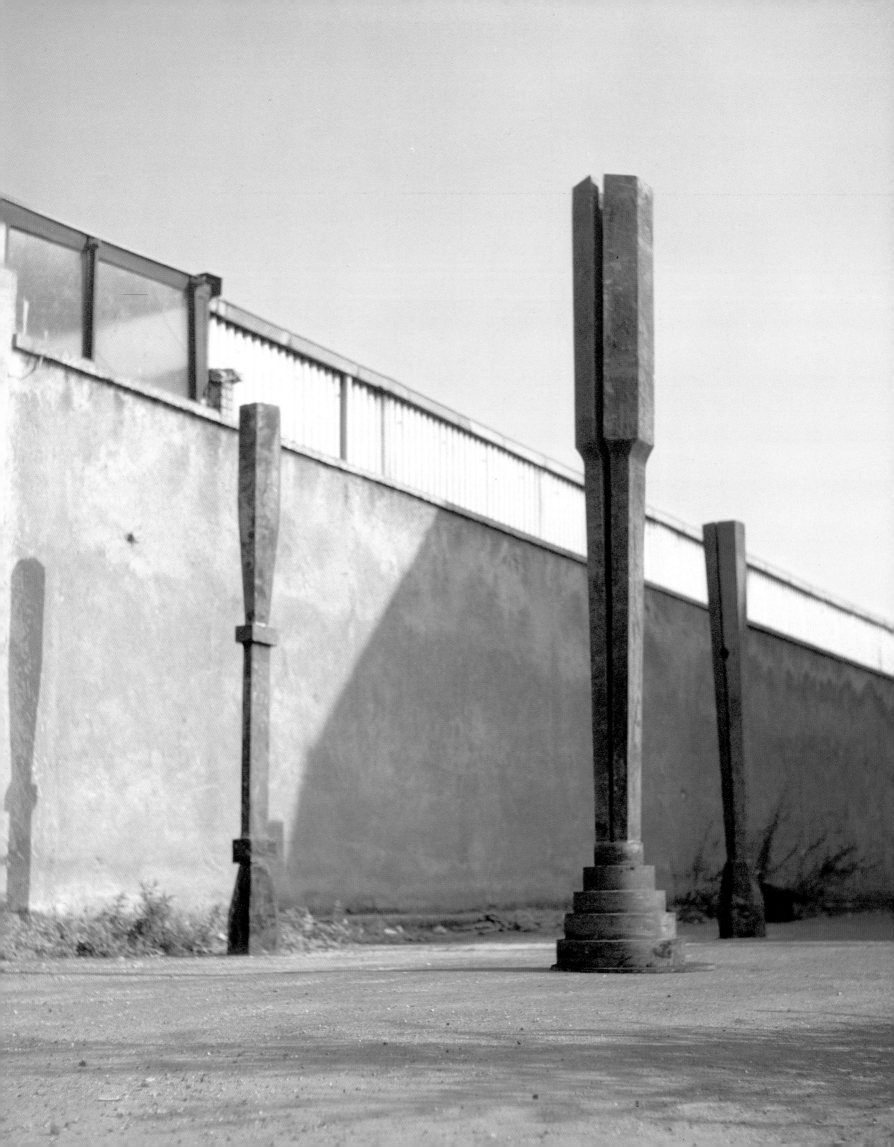

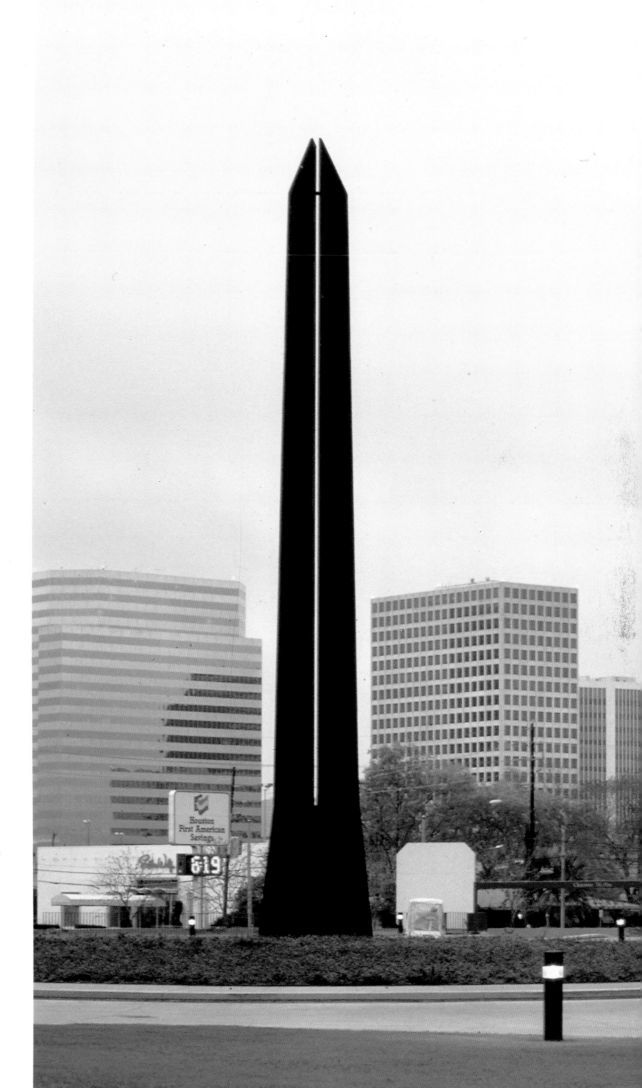

Polygenesis, 1981

Opposite: *Claudio Column II*, 1979–80;
Tarquinia Spiral II, 1979–80; *Normanno
Column*, 1979–80

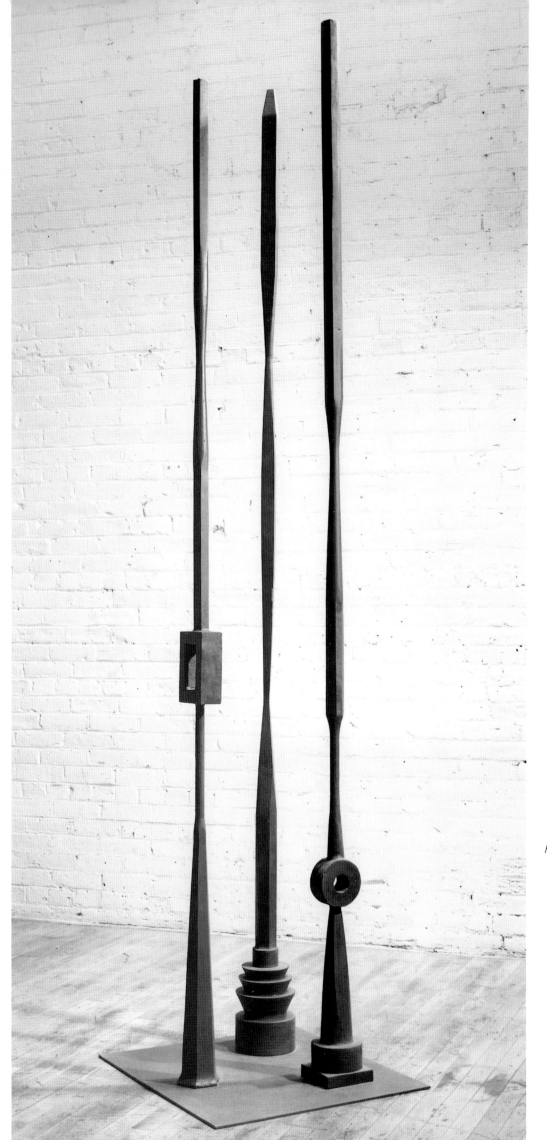

Harmonius Triad, 1982–83

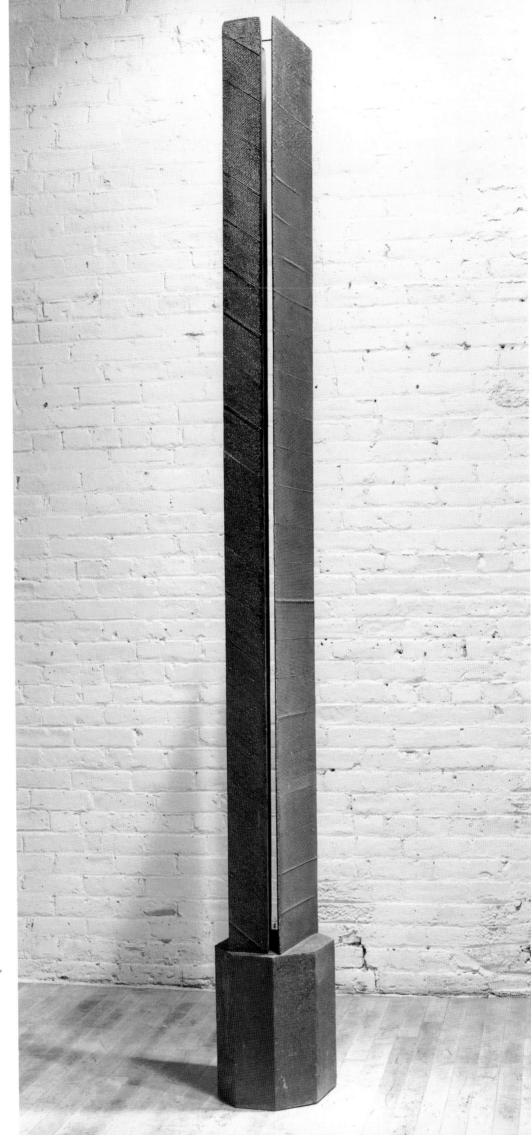

Toltec Marker, 1981

Pages 120–121: *The Moline Markers,* 1981, l. to r.: *Coupled Column; Diamond Sentinels; Primary Presence; Triangle Sentinels; Pythias Presence; Mute Metaphor; Fundamental Presence; Sentinel Marker*

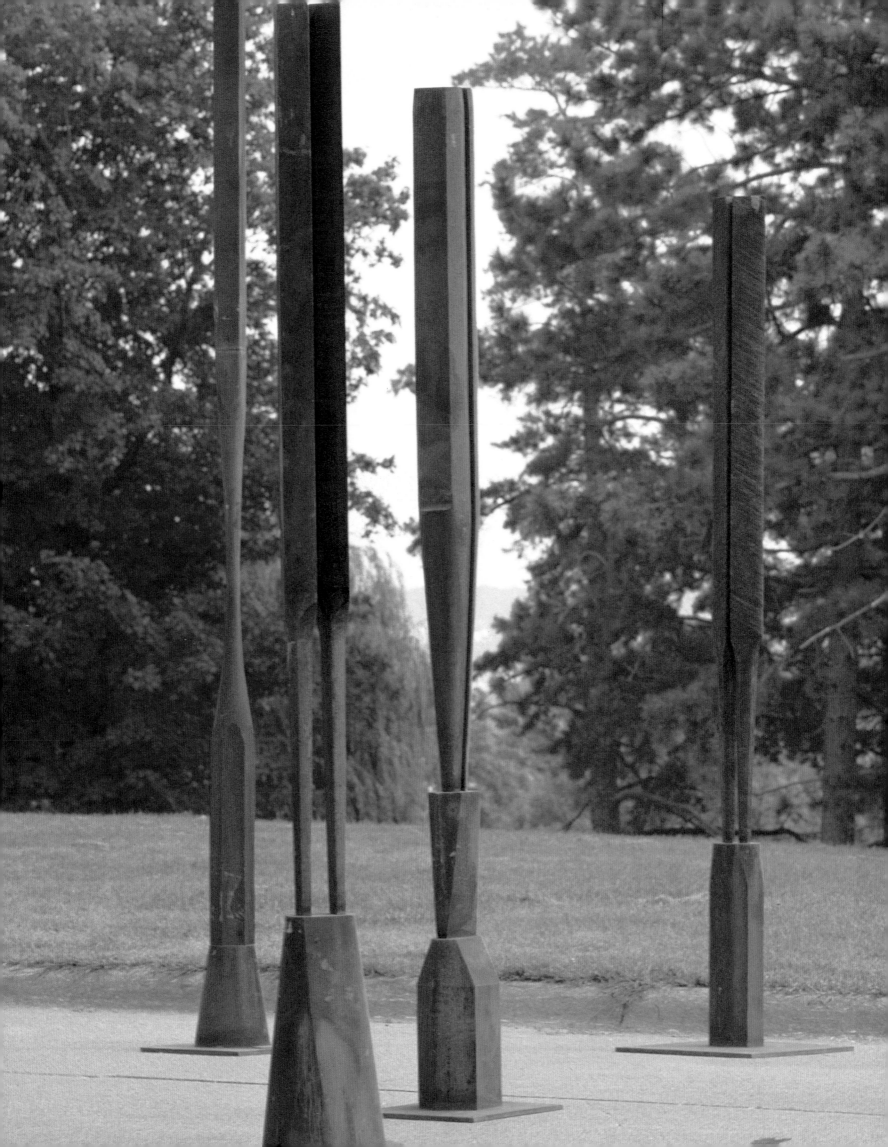

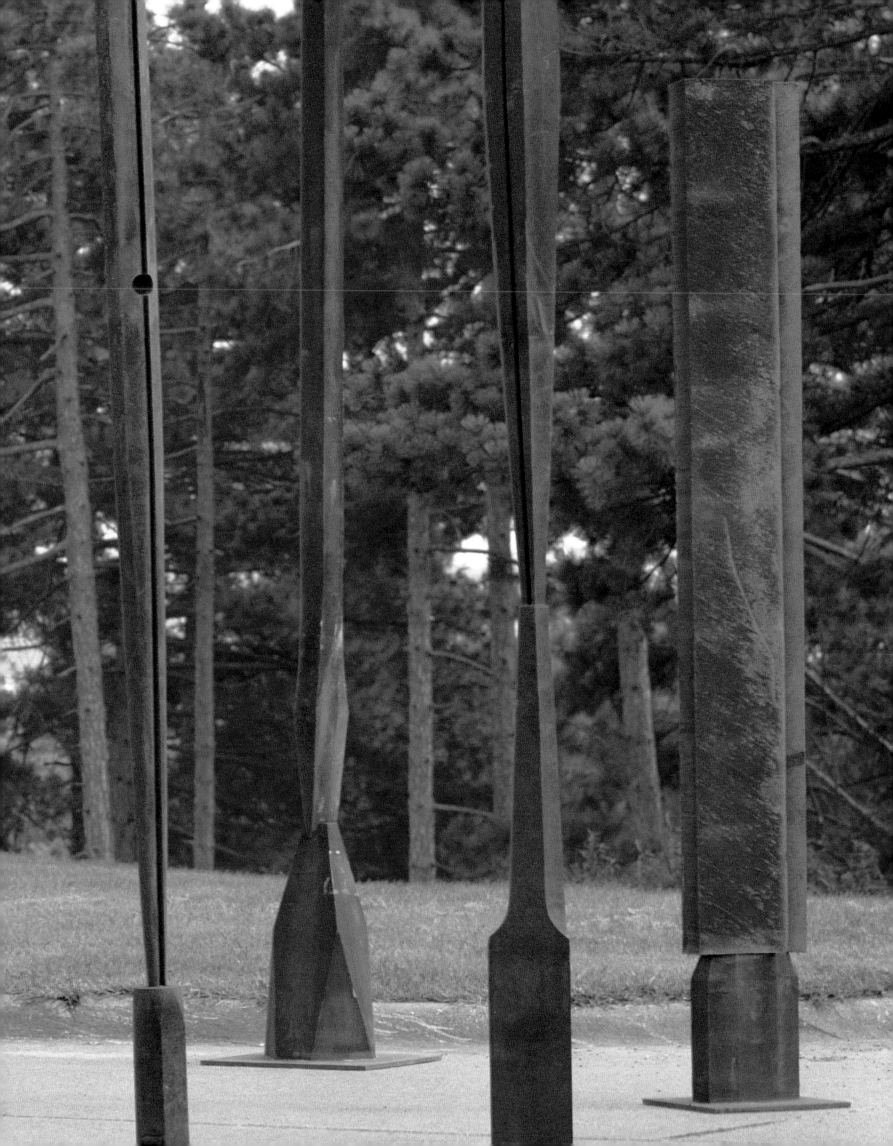

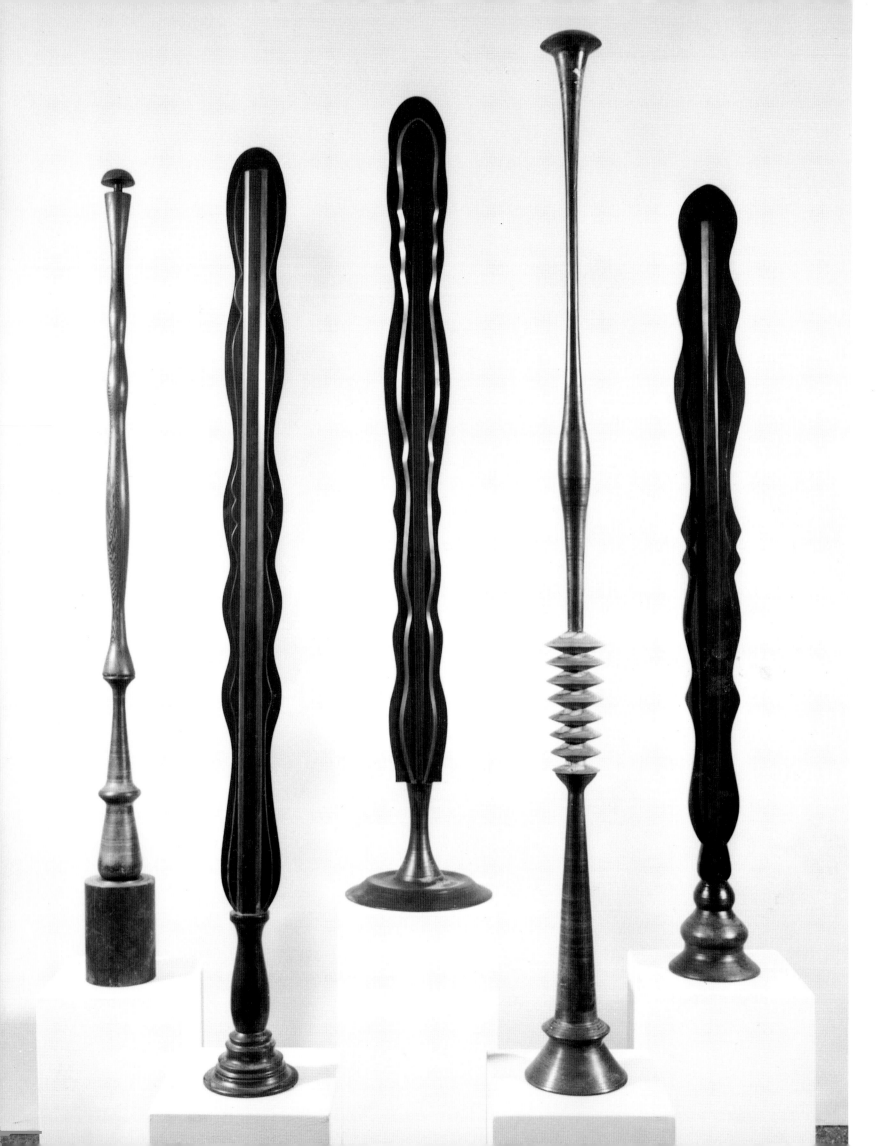

But the *Ternana Wedge* is not just a return; it is also a departure. It is not literally pictorial in the way the mirrors had been. And, in its identity as "tool," it retains the rigid autonomy and density of an object. A picture/object, then, something freestanding.

The freestanding pictures of Italy are altarpieces: pictures plus frame. Painted for the most part on wooden panels, they are picture/objects, the wood of their pictorial surfaces materially no different from the wood of their ornately sculpted frames. Indeed, the roundels and flattened spaces within these very frames are often employed as the surfaces to carry other, smaller, paintings. Their identity as mixed breed is underscored by the relatively primitive quality of the pictures, in late Gothic and early Renaissance examples, as compared with the exuberant display of craft devoted to the supporting frameworks. Art historians during the first half of the century were busy trying to create individual authors for these countless panel-pantings by nameless hands. Contemporary art historians have begun to feel that this mistakes the nature of the enterprise of this outpouring of Italian altarpieces in the fourteenth and fifteenth centuries. They have come to think that the anonymity of these paintings is not just a historical accident, but something integral to the social reality of these works. That is to say, that in the grip of a craft tradition these altarpieces might have been centrally conceived (and indeed commissioned) as two-dimensional sculptures, as the gilded, carved tracery of the *frames* into which the scenes of the passion and the liturgy were inserted more or less routinely: copies of copies of copies, so many visual buzzwords in service to the far more opulent and important display of the "house" of the image, which is to say, the frame.[20]

She saw *Ternana Wedge* as an "urban altar," the first of a projected series of altars wedged into contemporary experience and against the grain of the modernist paradigm. The suspension between sculpture and painting, between the anonymity of the tool shape's parentage—born long ago from collective necessity—and the particular context into which it was to be put, the fact that the sculpted metal served to "frame" the tiny pyramidal opening at the top of the work; all of this operated in a distant but important relation to the logic of the altarpiece and its *own* unraveling of the traditional paradigms of art.

□

Zoe, 1983–84; *Sagittate*, 1983–84; *Artemus*, 1983–84; *Benet*, 1983–84; *Aristo*, 1983–84

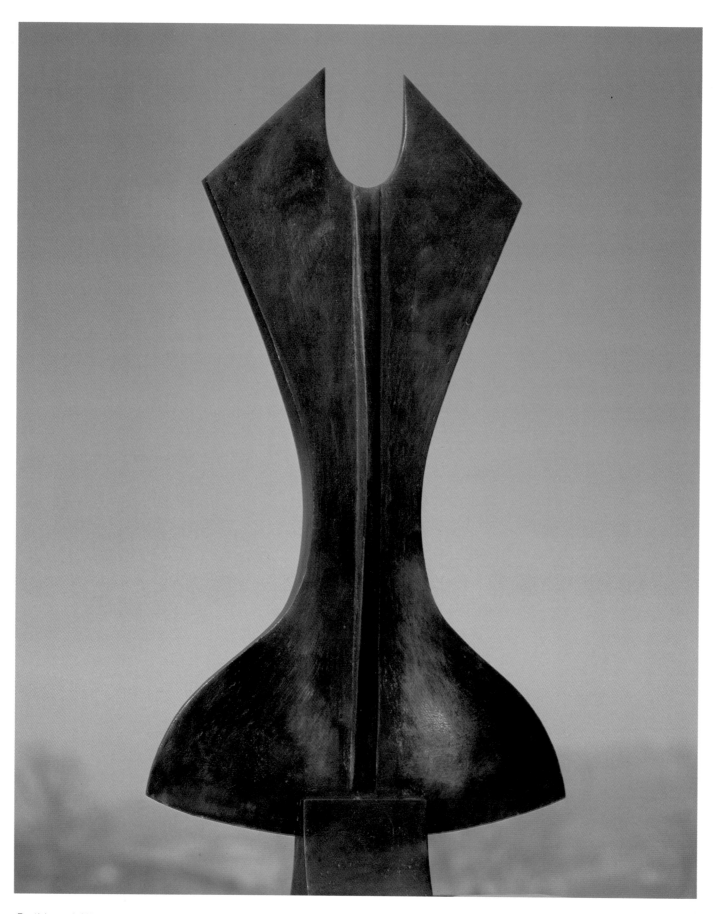

Earthbound Altar, 1986

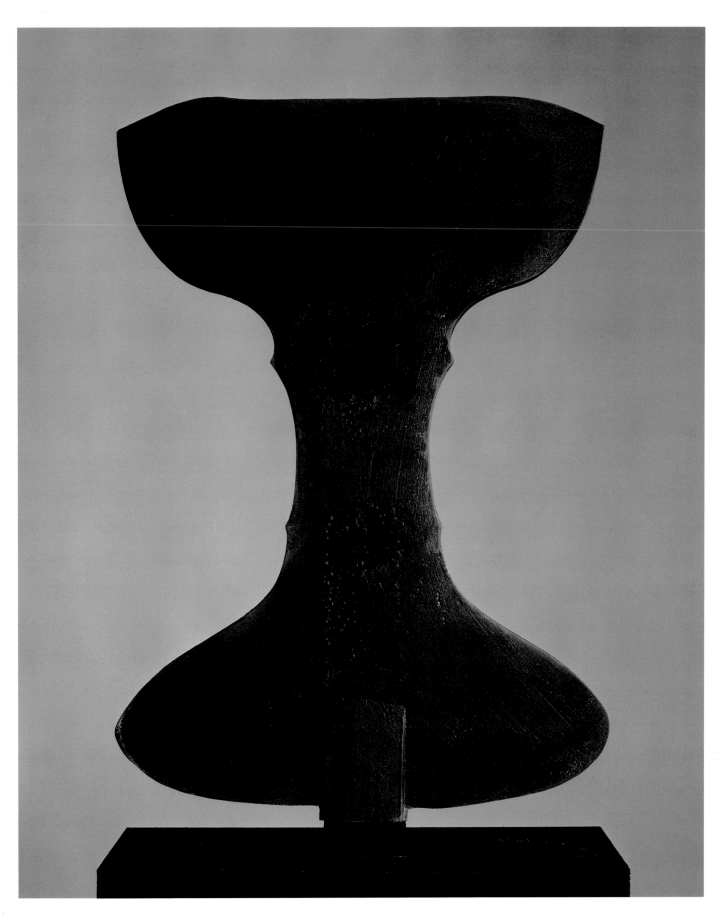

Janus Altarpiece, Black on Red on Rust (Janus Ternary), 1986

At work on model of *Sand Dunes*, 1971 version

They had already come across small, crushed monuments, made of stones so pressed by the roots which fixed them to the ground as though by paws that they no longer seemed to have been built by men but by vanished beings accustomed to this life without horizon, to this underwater darkness.[21]

André Malraux, *La Voie royale*

She stood in front of them at a blackboard, outlining the overall configuration of the beach: the fourteen-foot drop as the dunes slope down to the carpet of sand, the hundred-foot run as the sand stretches toward the beginning of the stone jetty that stands sentinel over this passage of Florida shore, the projection of the jetty out into the water, a rigid line against the sea's constant motion. She was explaining the project to these six young sculptors who had been selected for the workshop and who were going to help her think through and execute this work. She was telling them about the *bottegha* tradition in Italy, in which apprentices and masters collectivized their energies. It was from the *botteghas* that the carvings had come, and the altarpieces. Although she began by talking, lecturing at the board, she was not happy until they were all scrambling over the beach, crawling on it, measuring it, feeling its almost imperceptible grade.

It was the spring of 1985, and she was about to take up a project dormant since 1971, the sand sculpture she had dreamed of almost fifteen years before. She had imagined a Florida beach in March as a blessed release from the icy mud of those sites for permanent installations of public sculpture at which she had been working in a struggle against heavy rain and frost, in Baltimore, Buffalo, Saint Louis. But Florida was cold that spring, with a stiff wind blowing incessantly and the sand gray and moist from constant spray. The sun would erupt suddenly from leaden skies to pocket the beach with bursts of shadow and a memory of warmth. Yet all of this served only, in the end, to heighten the experience of the beach as a structure, a sharp division between earth and water, stillness and motion, dark and light.

She wanted a work that would intervene in the neat divide of those distinctions, that would interrupt their field the way the jetty's finger protruded into the continuum of the ocean. She wanted the water to creep up along the channel of the sculpture and cut its own wedge into the expanse of sand.

At work on *Sand Dunes*, 1985 version, at the Atlantic Center for the Arts, New Smyrna Beach, Florida

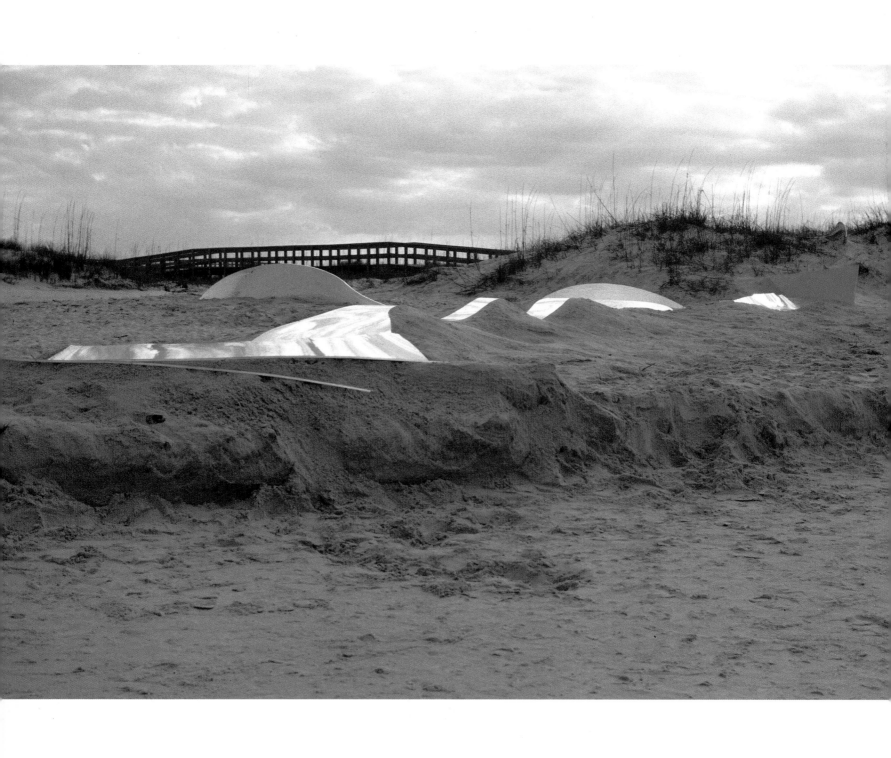

Sand Dunes, 1985

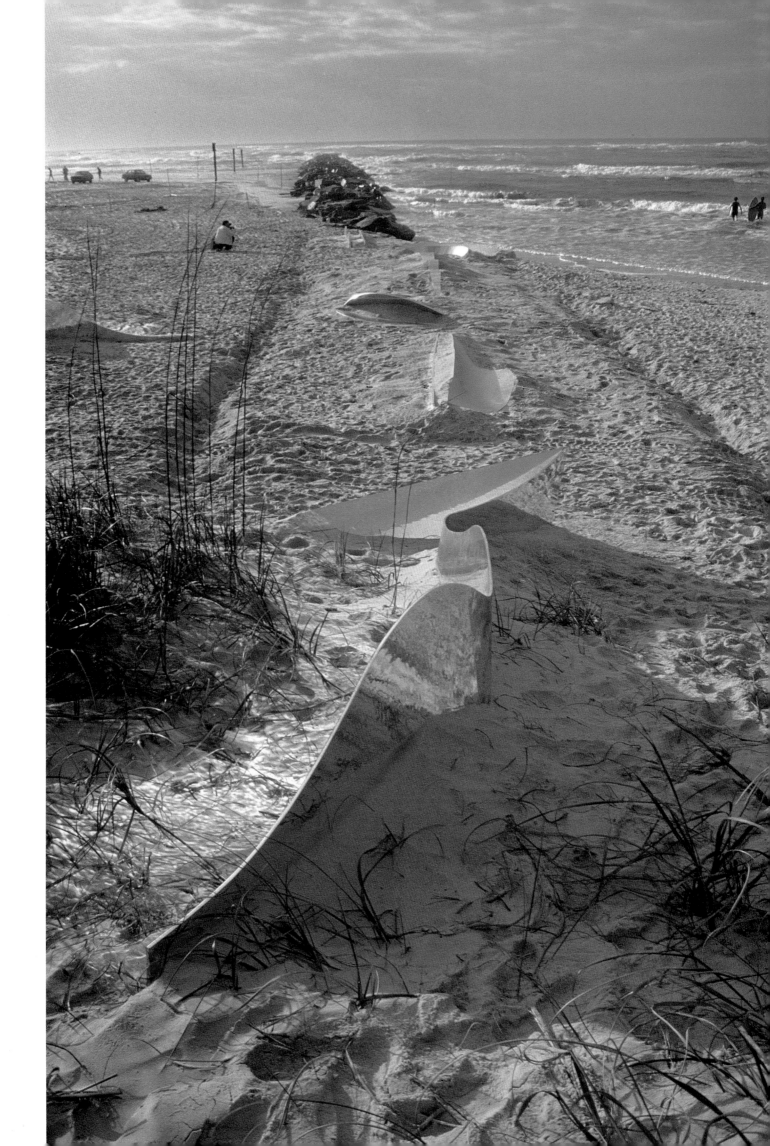

Dallas Land Canal and Hillside, 1971–75

But between the times of high tides, she wanted the sculpture itself to "water" the beach through the way its own material would capture the reflections of the sky. She wanted the profiles of the dunes to descend into the forms of the work and thereby to ridge the beach's flatness. But beyond all of this she wanted, as in the first horizontal sculptures and in the *Dallas Land Canal and Hillside*, to create a representation of an "inside" that was not the sculpture's own, because it belonged to the depths of the land.

Turning from the blackboard, she said of her own ideas about the work, "I want some above ground, some below ground. What you don't see is very important. Because you're going to *feel* it."

All of them experimented with cardboard maquettes in a sandbox that had been set up in the art department's studio. One of this group of younger sculptors kept making forms that resembled sea shells: chambered nautiluses, conches, abalones. The advantage of these elements was that they could serve to channel water, like enormous sections of culvert. The disadvantage, where she was concerned, was that they belonged to that family of technically perfect structures of which the eggshell is the ultimate example: an even spread of surface of incredible tensile strength, an armor plate of minimal weight, a casing, an enclosure. The closed geometries, the self-contained sheathings that mimed the sea shells were too close to the organicist model and its dream of sculptural "truth." It was a pretty idea, but she couldn't use it.

Mostly she was on camera, talking to the sculptor-apprentices, or being interviewed, or examining the beach. The Atlantic Center for the Arts, New Smyrna Beach, Florida, for whom this workshop had been set up, had asked for a project in several media. So there was to be the sculpture, but also a video, and a sound score as well. Morton Feldman was there to compose the music. Barbara Rose made the video. At one point Ms. Rose interviewed the sculptor-apprentice who had explored the idea of the shells. She asked him how it felt to bend his own sculptural notions to the will of someone else. He obviously did not mind. This was because, he said, he was so astonished by the idea of sculpting on this *scale*, of fashioning something one hundred feet long, of attacking a beach, just like that. It was a way of working that he was learning. He did not much care, within this experience, whose forms they were using.

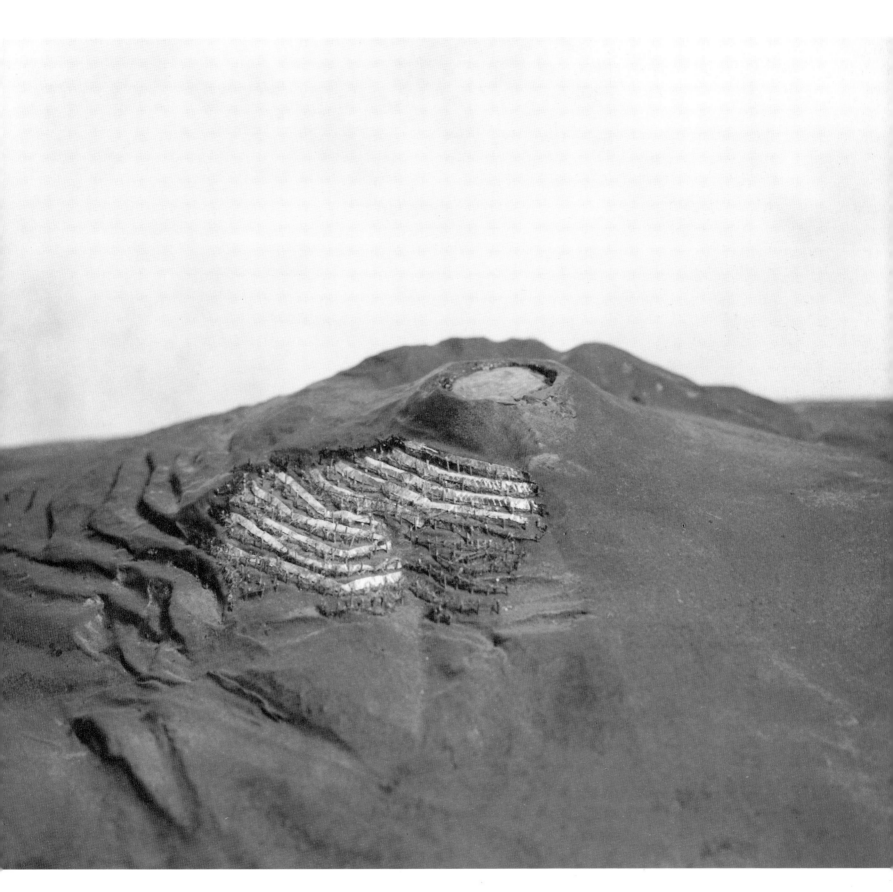

Model, *Mt. Vesuvius project,* 1972

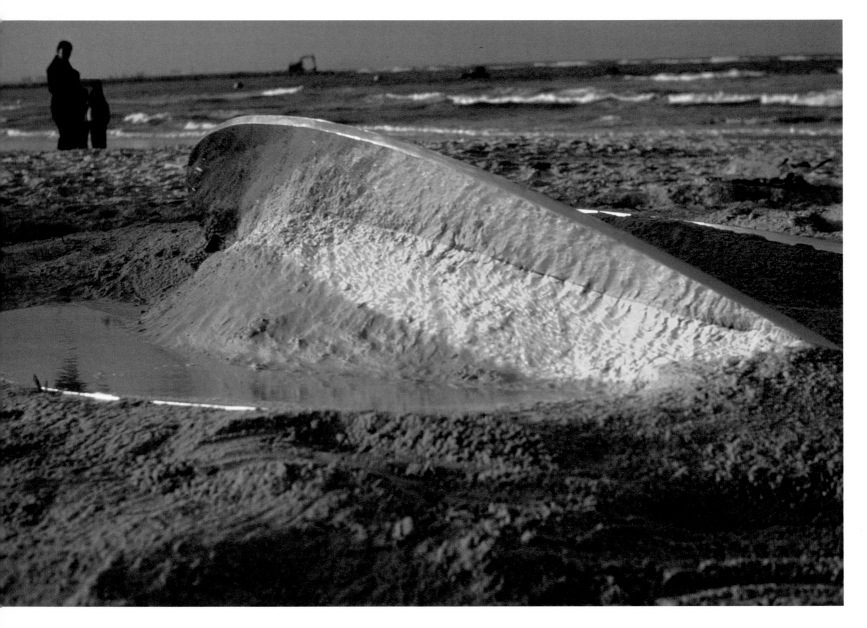

Sand Dunes, 1985

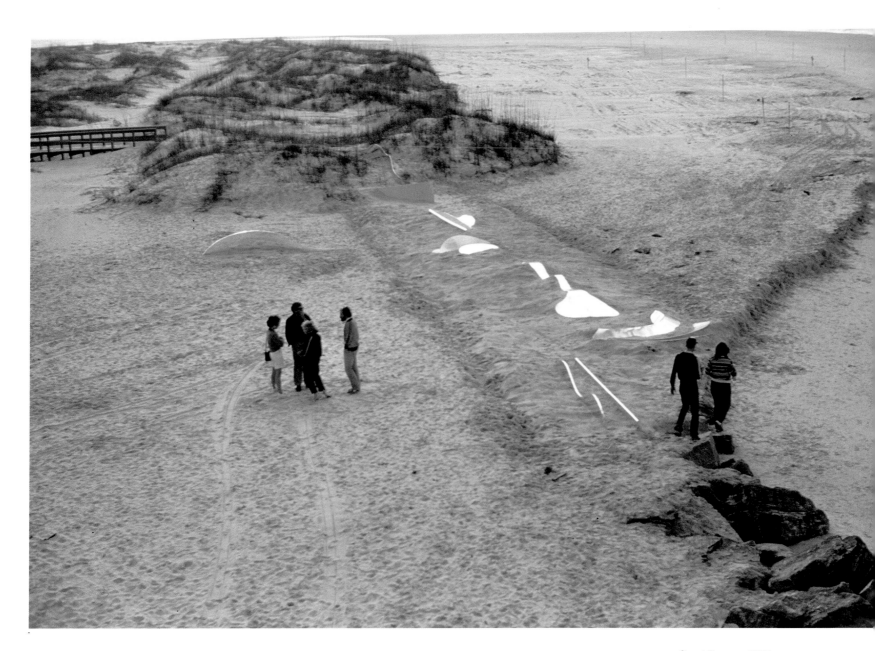

Sand Dunes, 1985

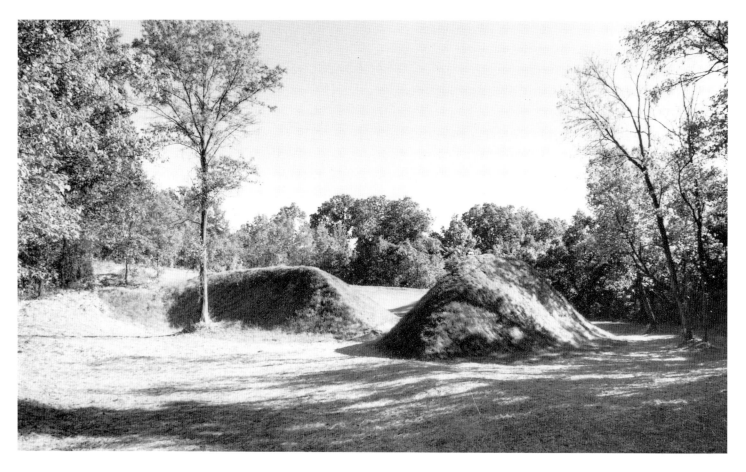

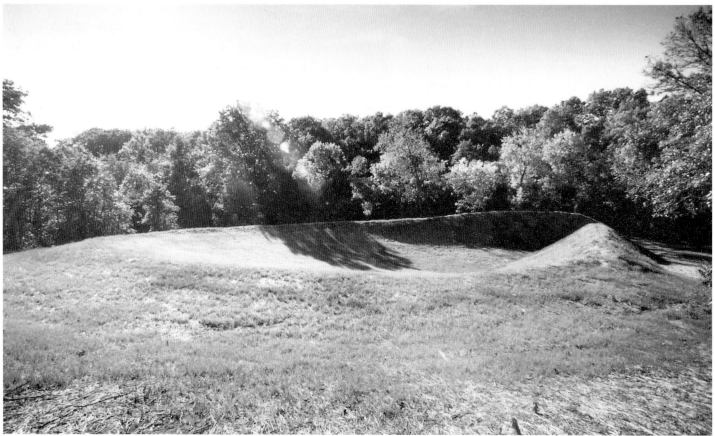

Cromech Glen, in progress

The experience was, of course, provisional, the work temporary. They would stretch Mylar over the curved wooden forms they would design and build. The mirrorlike shine of the Mylar skin would reflect the sky and the wetness as though it were stainless steel.

The apprentices didn't miss the stainless, which they would not have been able to work anyway. But she did. There is a difference between a blade that knifes into a soft mound of sand and a fence that feels like it's only perching on it. "You're going to *feel* it," she had told them. But she was mostly talking to herself.

The maquette that she had found high up on a shelf in her studio in Italy and had taken down and dusted off to look at before coming to Florida had shared the forms of her work of the early '70s, the concave and convex triangular forms with their straight edges and long points, the plows and the pyramids of the *Dallas Land Canal and Hillside*. But the Florida sand sculpture, though it still represented the slicing through, the cutting of a trench, was a series of curves and dishes and waves, an undulant line running through the beach. The sculpture was a composite of incident. There were buried wedges shaped like parallel tiers of crescents; there was a running series of hillocks crested with a band that sent a ripple along their tops; there was a long vertical fin, like the prow of a half-buried ship. The relation to curving forms and to the measurement of slow grade had begun in *Amphisculpture* and continued into the work she was making in Saint Louis for Laumeier Park, *Cromech Glen* (1985), all terraced sod and a grove of trees.

The sun came out the day they actually installed the Florida piece, beginning their work at dawn and finally finishing it against a wild backdrop of sunset. The video camera aimed straight into the shine of the low finlike wall. Within its surface there was reflected a scattered frieze of blurred silhouettes, black against a dazzling blue, the crew catapulted for a frozen moment into the pictorial panorama of this work of art.

Their joining the processional of the sculpture was, of course, temporary, almost as provisional as the work itself. But moving along it as the sculpture snaked over and cut into the bulwark of the shore, blurring distinctions as it went, the little frieze of figures appearing in the video frame created a hidden analogy: this beach and that jungle, this sense of open shore and that remembered vastness of scale.

□

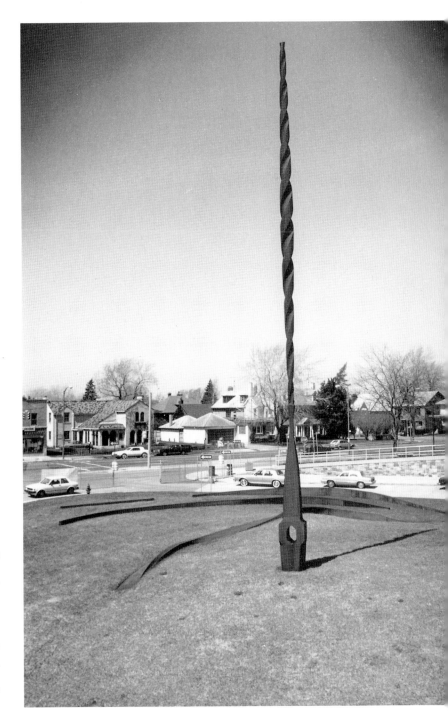

Vertical Presence—Grass Dunes, 1985

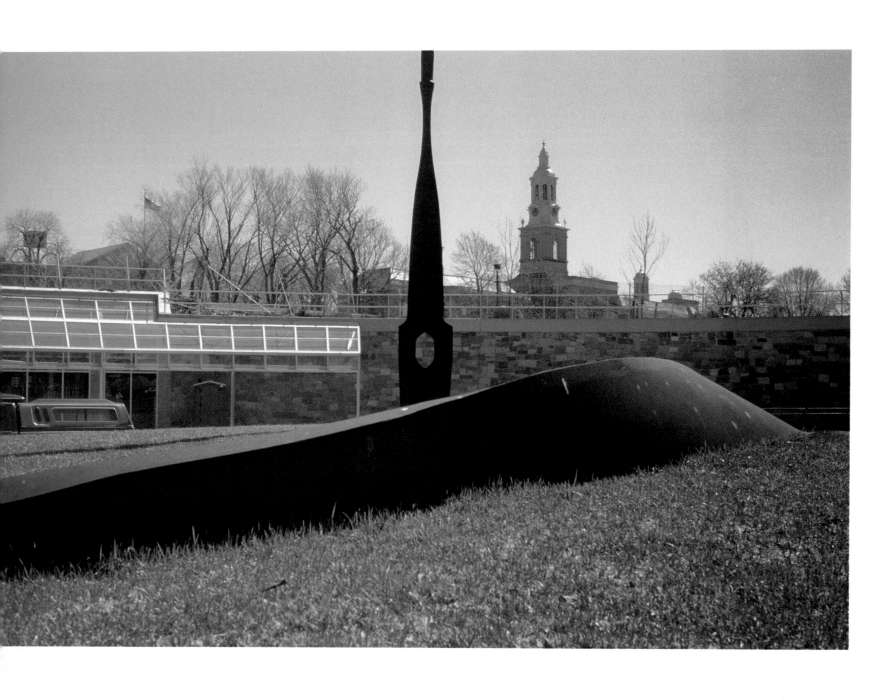

Details, *Vertical Presence—Grass Dunes,* 1985

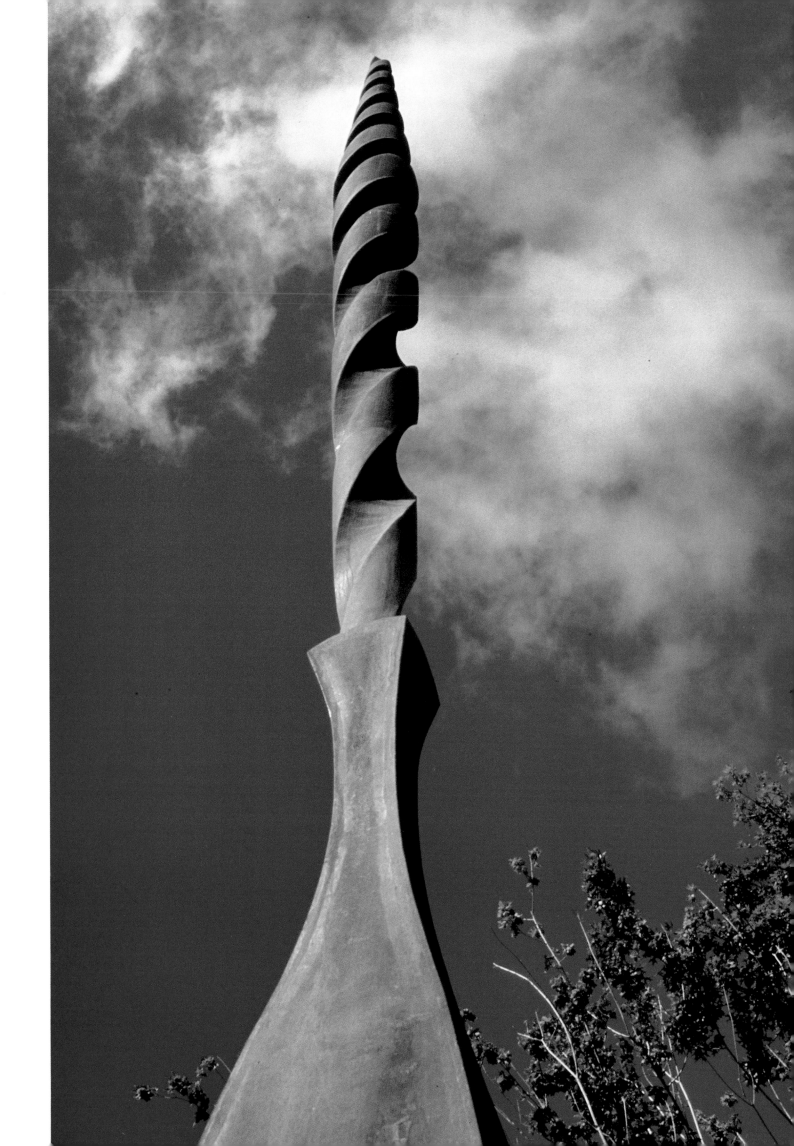

Drawings, *Sol i Ombra Park*

The bullring, symbolic of so much in hierarchical, religious Spain, is structured on many paradigms, one of which is the division between sides: one in sunlight, the other in shadow—a basic opposition—*Sol i ombra*. This, she said, was the theme around which she had conceived her work for *Sol i Ombra Park*, an earth sculpture in the north of Barcelona on a site the size of two football fields, a work to be executed over the course of three or more years, the first phase to have been completed in the summer of 1986, a work in which two massive elements will oppose each other as "sun and shade."

The first part of the opposition—sun—will consist of a long undulating mound of earth and grass for the most part encased in serpentine, ceramic-covered walls, slithering over one hundred-thirty-three feet of greensward to rise at one pyramidal end to a height of twenty-three feet. The second element—shade—is a spiral of trees wheeling their way down the terracing of earth in which they are planted, its shape articulated by the running curb of multicolored tiles that edges the levels of the pinwheel of green, one-hundred-fifty feet in diameter.

There is much in this work that pays obeisance to the traditions of Barcelona, above all to the presence of Antonio Gaudí. Gaudí's Park Güell, with its glinting, tile-encrusted walls snaking their way through the lush foliage of exotic plantations; his Casa Mila, with its façade in wave motion, balconies of cast-iron seaweed awash over the ripples of its surface, roof turrets of fantastic shape gorgeously encrusted with ceramic chips like the bejeweled carapace of Des Esseintes's tortoise in Huysman's novel: these establish Barcelona's relation both to an aesthetics of tile polychromy on an architectural scale and to the curvilinear wall in a landscape setting. But most of all, in the very notion of the dual theme—sun and shade—there is attention paid to the structuring terms of Spanish life.

Except that in *Sol i Ombra Park*, as in so much else of her work, the model is invoked only to be thwarted, imploded.

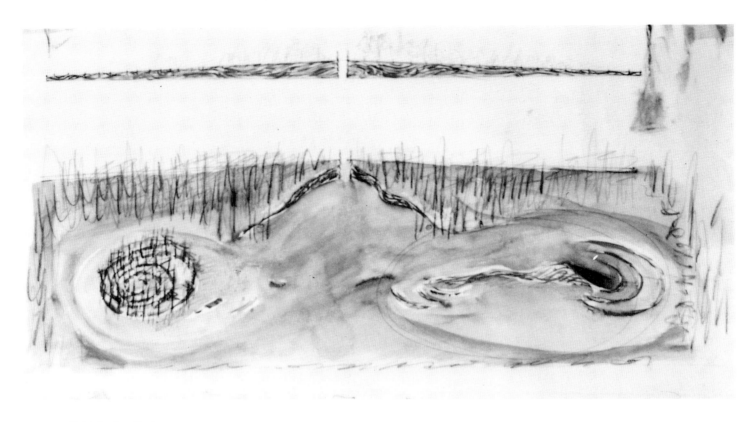

Drawing, *Sol i Ombra Park*

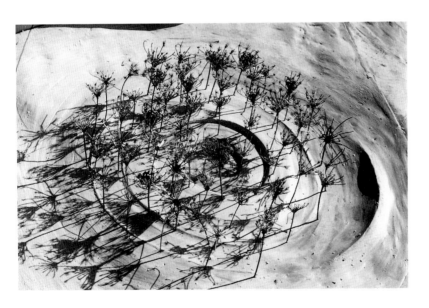
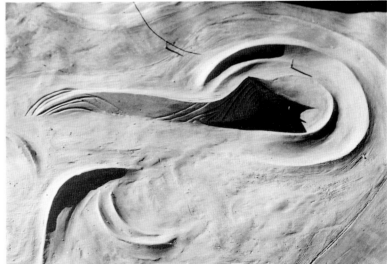

Details, model of *Sol i Ombra Park*

Sol i Ombra Park: Watercolor detail study for tile work of the outside wall

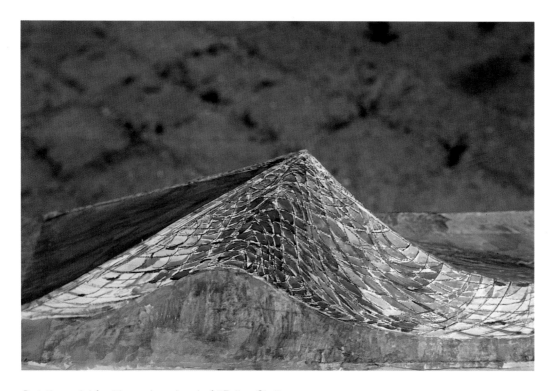

Detail, model for tile work and sod of "Fallen Sky"

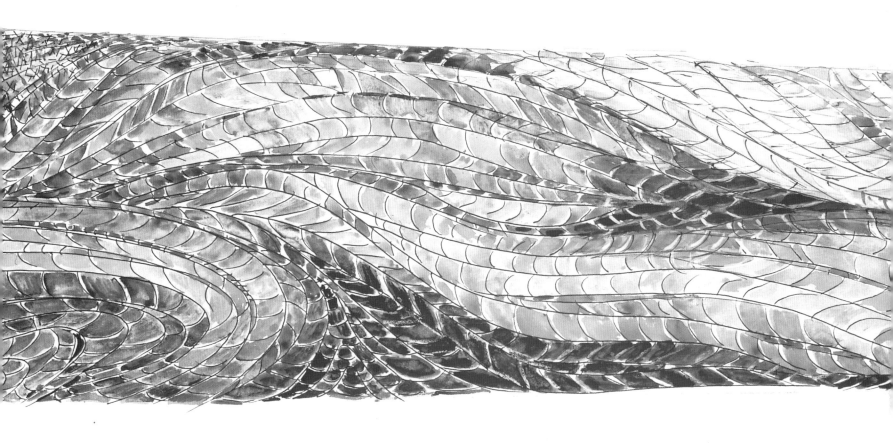

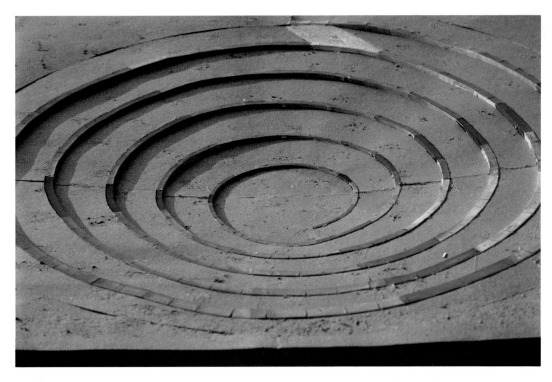

Detail, model for tile work and pressed-earth setback of "Spiral of Trees"

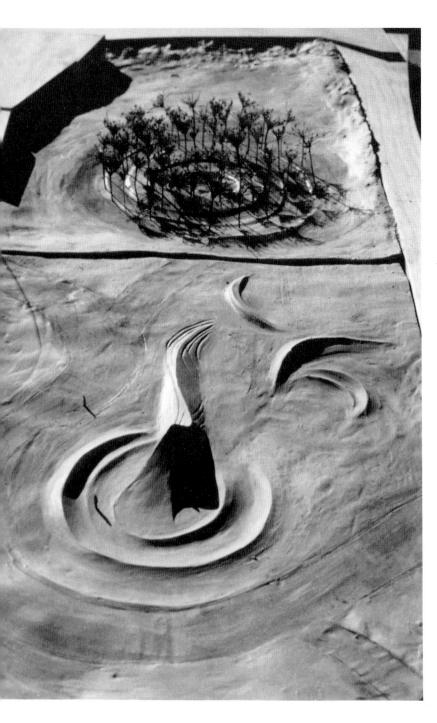

Detail, model of *Sol i Ombra Park*

The mound and the spiral—sun and shade—are linked by a path that flips a long figure-eight of pressed earth around the perimeter of the two elements, both articulating their difference, their opposition, and joining them. And this figure, looping back over itself as it reverses direction, is the very embodiment of chiasmus, of crossover. It spells a confusion in the distinction between *a* and *b* because part of *a* has broken away to lodge itself in the region of *b* and vice versa. It represents the *pretzeling* of logic, the loop of infinity. This figure warns us to return to the beginning, to reexamine that neat distinction between sun and shade.

Of course that massive serpent slithering through the blackness under the swell of its purple-blue tile casing is yet another incarnation of the chthonic presence-in-absence of *Odescalchi*, of the *Dallas Land Canal and Hillside*, of *Thel*. Earth has thrown up more earth in the form of massive ceramic scales. And serpentine walls, we remember, are also a major element of the temple complex at Angkor Wat, as they, too, do built battle against those other, more active, more devouring serpents: the banyan roots, confusing direction by dropping from above to churn up stone. The sun in the form of the serpent takes a more ancient persona, darker and more brutal. Compared to this the grove of trees at *Sol i Ombra Park*—shade—seems breezily open, as its terracelike base excavates the earth in regular, conic sections. An echo from a more classic past, its form is somehow sunnier, brighter. It is in this crossover that the logic of opposition begins to erode.

There is also, of course, the ceramic tile, a whole range of blues and lavenders, treated as rich but transparent washes, treated as an almost liquid surface. The shining bluish purple glaze also has a history in her work. And this is likewise a succession of crossovers. The sky reflecting itself in the chromed mirror finishes of *Venezia Blu* and *Excathedra* had settled into a confusion with the enameled blue of contiguous panels; the blue dropping from the sky onto the field of the work on the Florida beach had washed its surface with a sheath of undulant wetness. These crossovers of above and below, of outside and in are courted once again in the shine of the tile in *Sol i Ombra Park*—on the pyramidal mound, in the spiral grove, and on the work's third element, its walled entry gate. The tile's complexity goes further, however, because it not only reflects the expanse wheeling above the work, it also mimes that

atmospheric blue. So that imitation and reflection chase each other across surface and depth, within this work, like the serpent with its tail in its mouth.

"I walked into Angkor Wat a painter," she had said, "and I left a sculptor." But the paradigm of painting/sculpture was one that she had long since exploded. As she continues to do. And nowhere so explicitly as in this park in the north of Barcelona.

Rosalind E. Krauss

1. André Malraux, *La Voie royale*, collected in Malraux, *Romans* (Paris: Gallimard, 1976), p. 202. (My translation.)

2. See, for example, Phyllis Tuchman, "Beverly Pepper: The Moline Markers," *Bennington Review* (Bennington, Vermont), no. 14 (Winter 1982), p. 43.

3. Harold Rosenberg, *The Tradition of the New* (New York: McGraw-Hill, 1965), p. 3l.

4. Jean-Paul Sartre, *Nausea*, Lloyd Alexander, trans. (New York: New Directions, 1964), pp. 12, 33, 178-80). All further references to this work appear in parentheses after the citation. My own discussion of the chestnut tree in Sartre owes much to that of Denis Hollier, *Politique de la prose* (Paris: Gallimard, 1982), pp. 241 ff.

5. Jean-Paul Sartre, "Sculpture à *n* dimensions" in *Les écrits de Sartre*, Michel Contat and Michel Rybalka, eds. (Paris: Gallimard, 1970), p. 663. (My translation.)

6. Howard Smagula, *Currents: Contemporary Directions in the Visual Arts* (New York: Prentice-Hall, 1983), p. 25.

7. Sartre, "Sculpture à *n* dimensions," p. 663.

8. Clement Greenberg, "Towards a Newer Laocoon," *Partisan Review* (New York), VII, no. 4 (July–August 1940), pp. 296–310.

9. Clement Greenberg, "The New Sculpture" in *Art and Culture* (Boston: Beacon Press, 1961), p. 144.

10. In "The New Sculpture," Greenberg writes: "Instead of the illusion of things, we are now offered the illusion of modalities: namely, that matter is incorporeal, weightless and exists only optically like a mirage. This kind of illusionism is stated in pictures whose paint surfaces and enclosing rectangles seem to expand

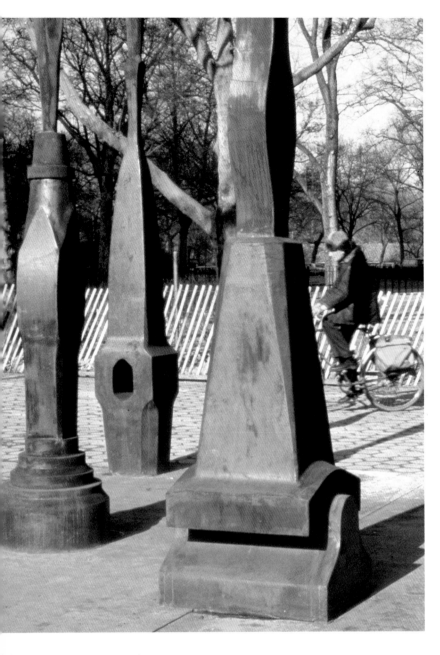

Detail, *Central Park Plaza*, 1983

into surrounding space; and in buildings that, apparently formed of lines alone, seem woven into the air; but better yet in Constructivist and quasi-Constructivist works of sculpture" (pp. 144–45).

11. Rosalind E. Krauss, *Terminal Iron Works: The Sculpture of David Smith* (Cambridge, Massachusetts: The MIT Press, 1971), p. 62.

12. Eleanor Munro, *Originals: American Women Artists* (New York: Simon and Schuster, 1982), p. 349.

13. Krauss, *Terminal Iron Works.* pp. 62–63.

14. Herbert Read, *Henry Moore, Sculptor* (London: Zwemmer, 1934), p. 29.

15. This interview is published in the catalogue text for the artist's exhibition in 1968 at the Marlborough Gallery, Rome.

16. Robert Smithson, "The Spiral Jetty" in *The Writings of Robert Smithson*, Nancy Holt, ed. (New York: New York University Press, 1979), p. 113.

17. Roland Barthes, *Roland Barthes by Roland Barthes*, Richard Howard, trans. (New York: Hill and Wang, 1977), p. 92.

18. Paul Valéry, "Eucalinos ou l'architecte" in *Oeuvres*, vol. II (Paris: Gallimard, 1960), p. 121. (My translation.)

19. Tensegrity is the name coined by Buckminster Fuller for a type of metal skeletal structure whose members are in tension rather than compression. This principle of construction was subsequently employed for sculpture by Kenneth Snelson in the 1960s.

20. See Creighton Gilbert, "Peintres et menuisiers au début de la renaissance en Italie," *La Revue de l'art* (Paris), no. 37, 1977, pp. 9–28.

21. Malraux, *La Voie royale*, p. 221.

22. Françoise Gilot and Carlton Lake, *Life with Picasso* (New York: McGraw-Hill, 1964), p. 222.

Central Park Plaza, 1983, l. to r.: *Volatile Presence; Valley Marker; Interrupted Messenger; Measured Presence*

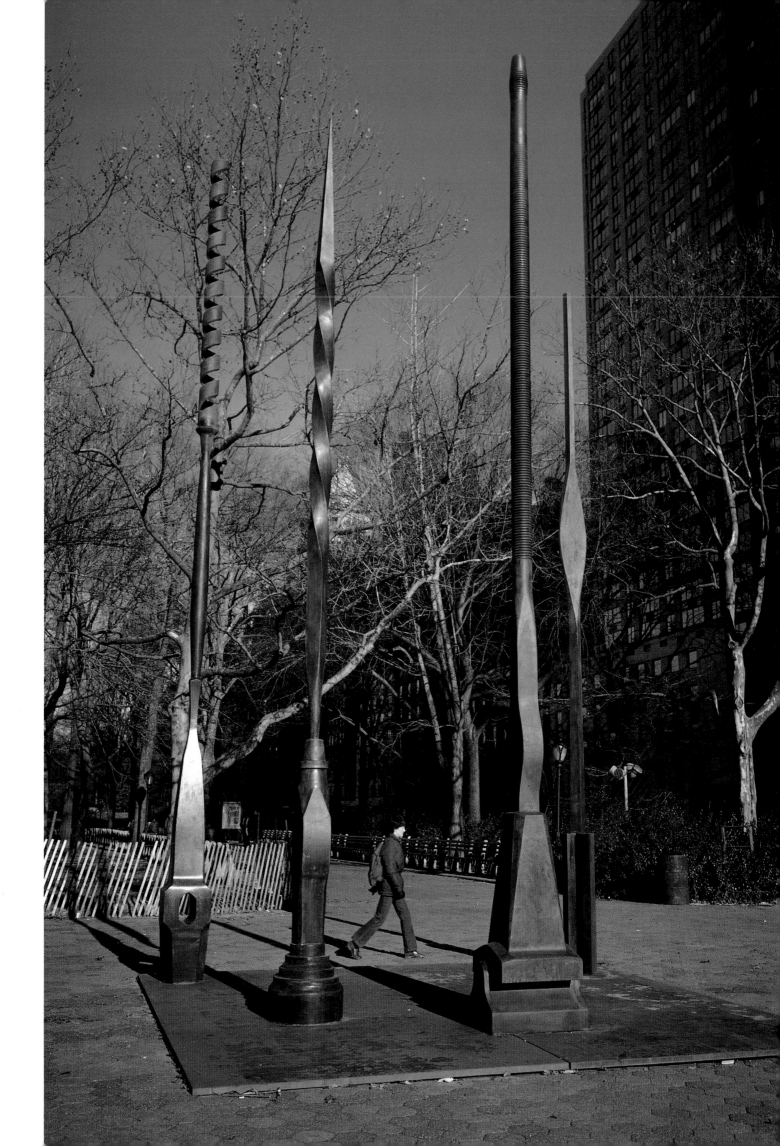

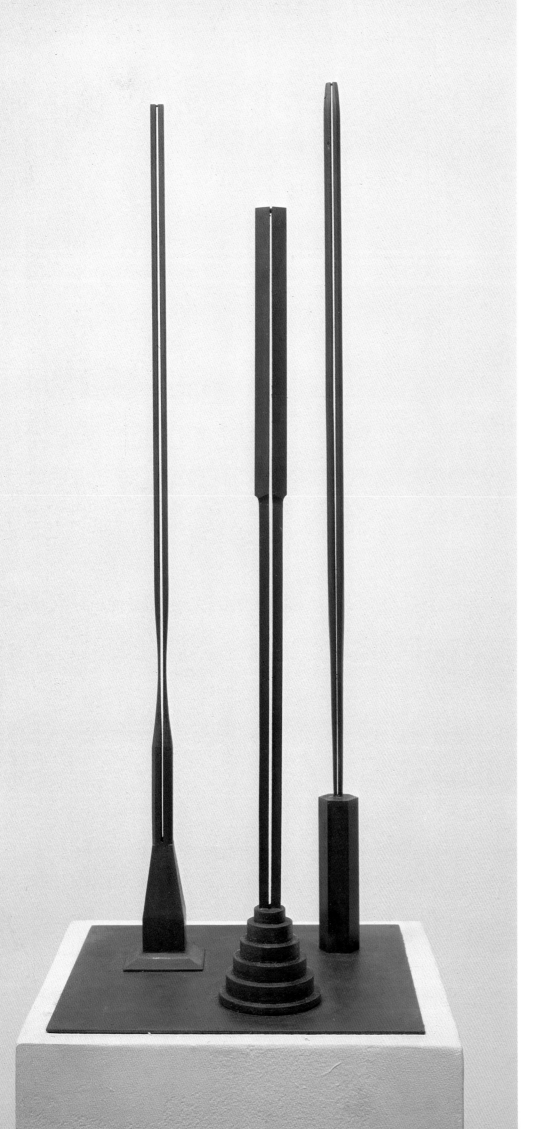

Tarquinia Plaza Sculpture, 1983

Opposite: *Serene Presence*, 1982–83;
Constantine Ritual, 1982–83

Page 148: *Dual Ascent*, 1984

Page 149: Detail, *Dual Ascent*, 1984

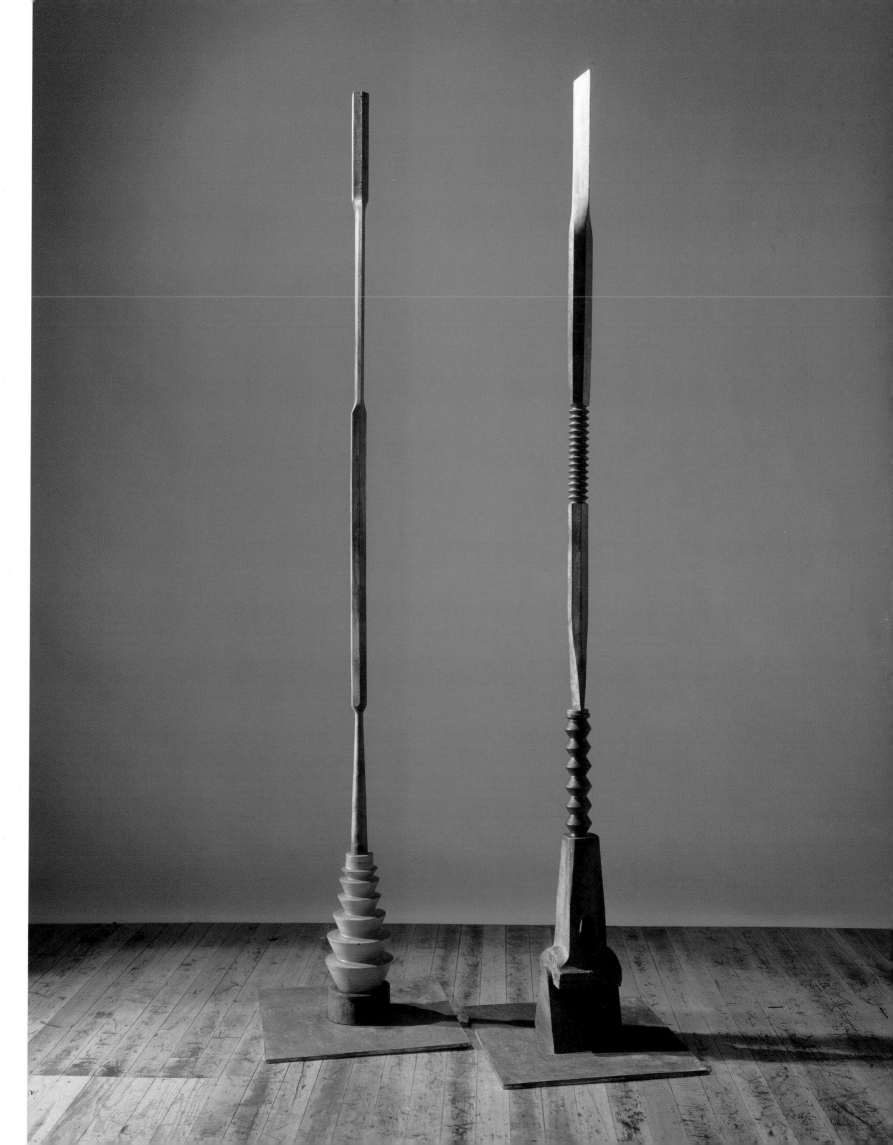

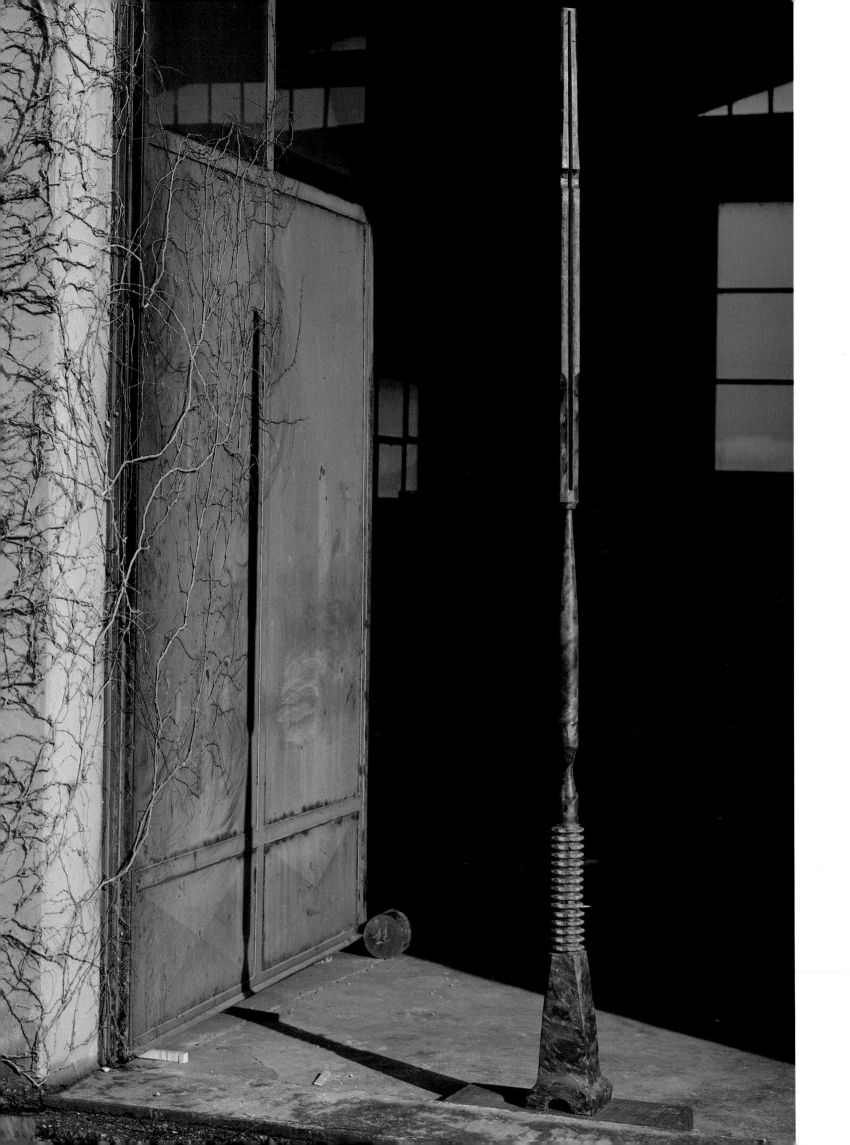

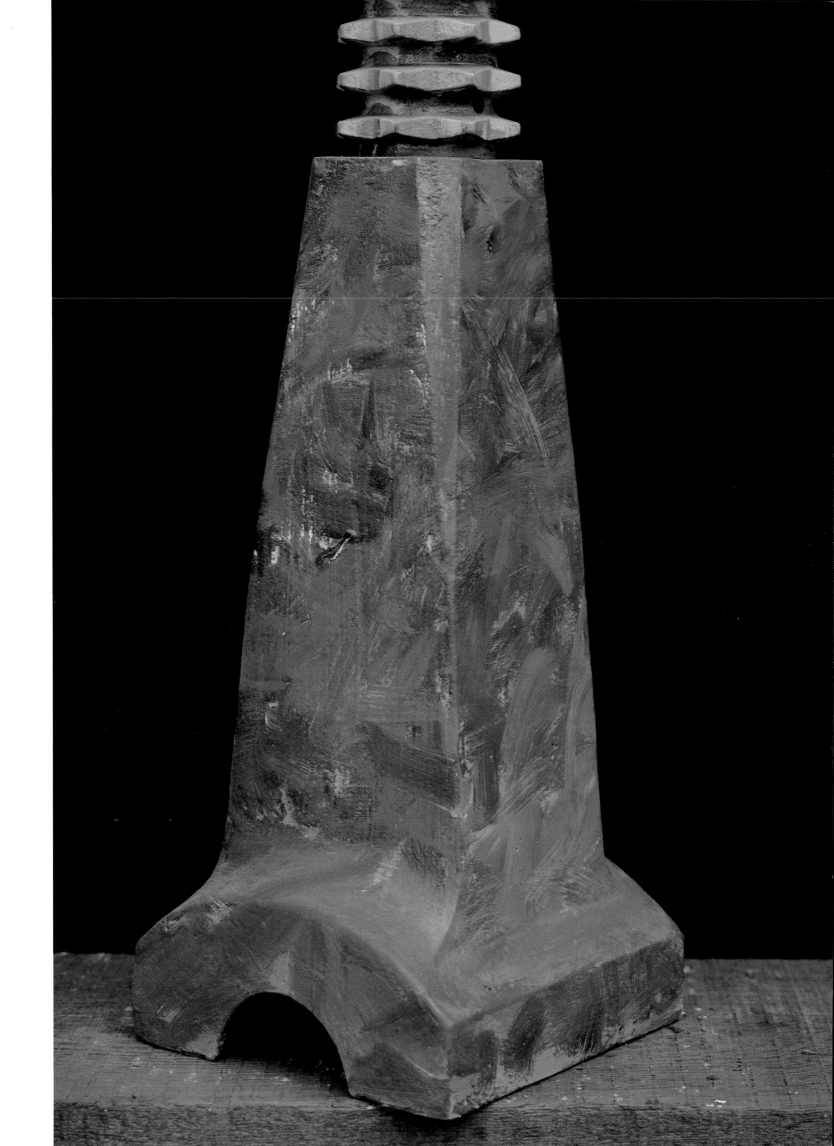

Detail, *Corio Column,* 1985

Opposite, l. to r.: *Nefetari Column,* 1985; *Rameses Column,* 1985;
Livy Column, 1985; *Corio Column,* 1985; *Gaddi Column,* 1985

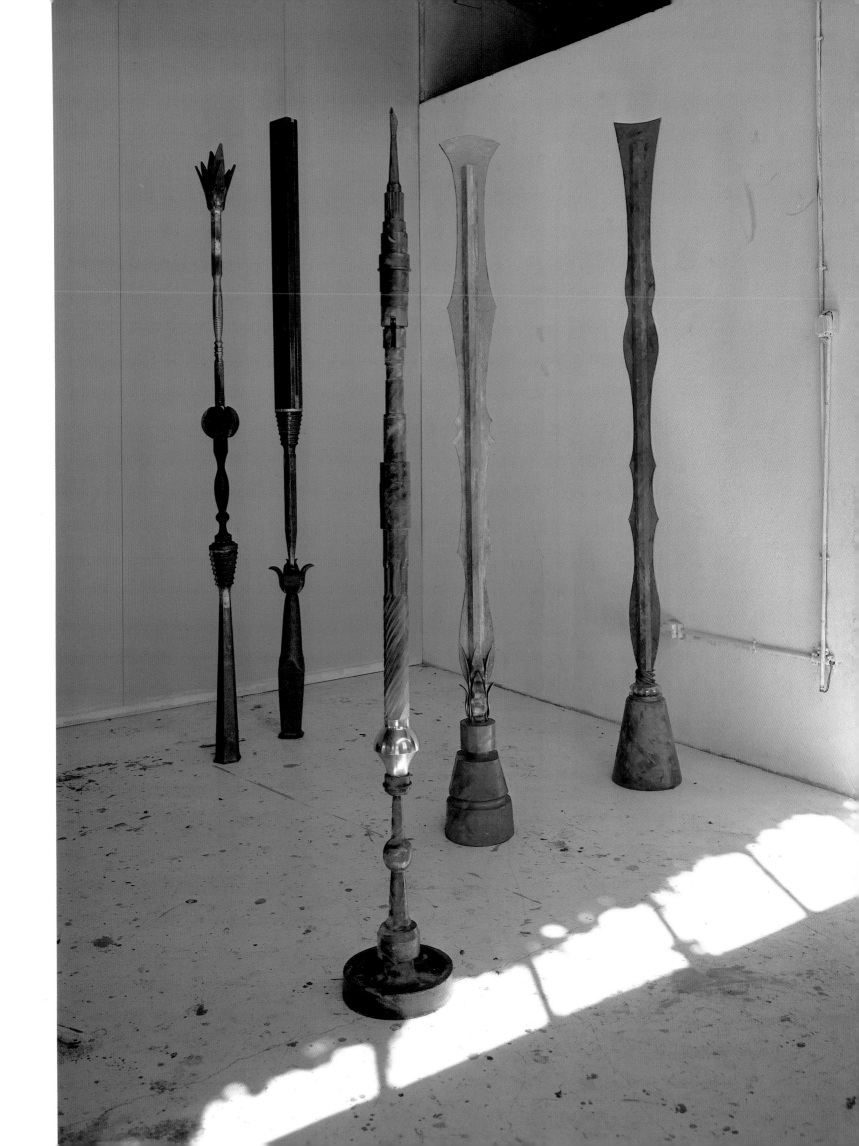

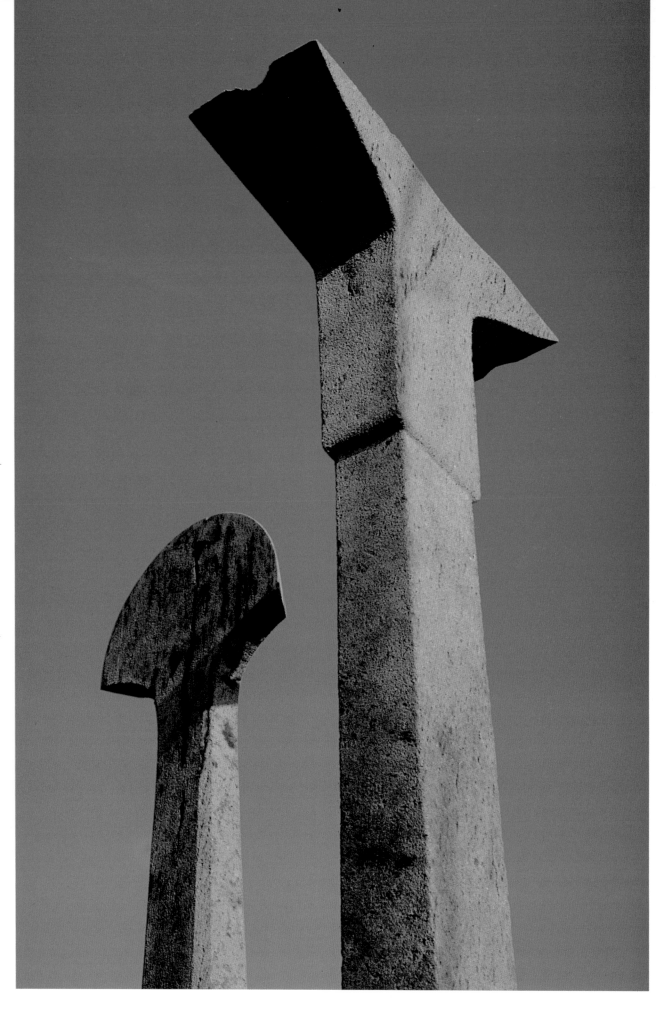

Detail, *Basalt Ritual*, 1985–86

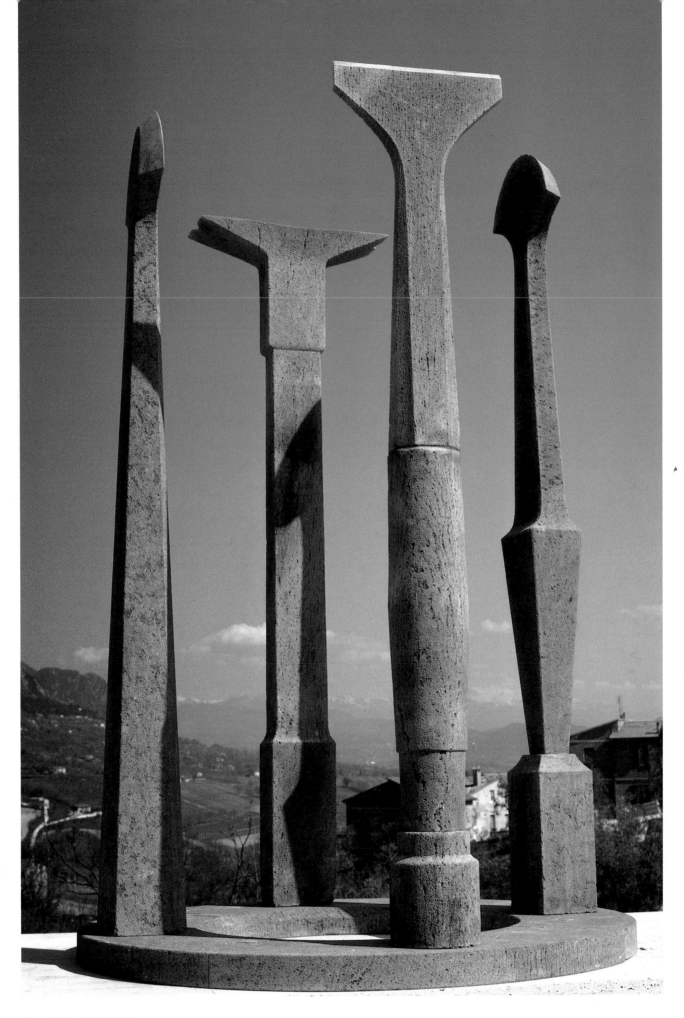

Basalt Ritual, 1985–86

Page 154: *Genesis Altar*, 1985–86
Page 155: *Genesis Altar*, 1985–86; *Trapezium Altar*, 1985–86

153

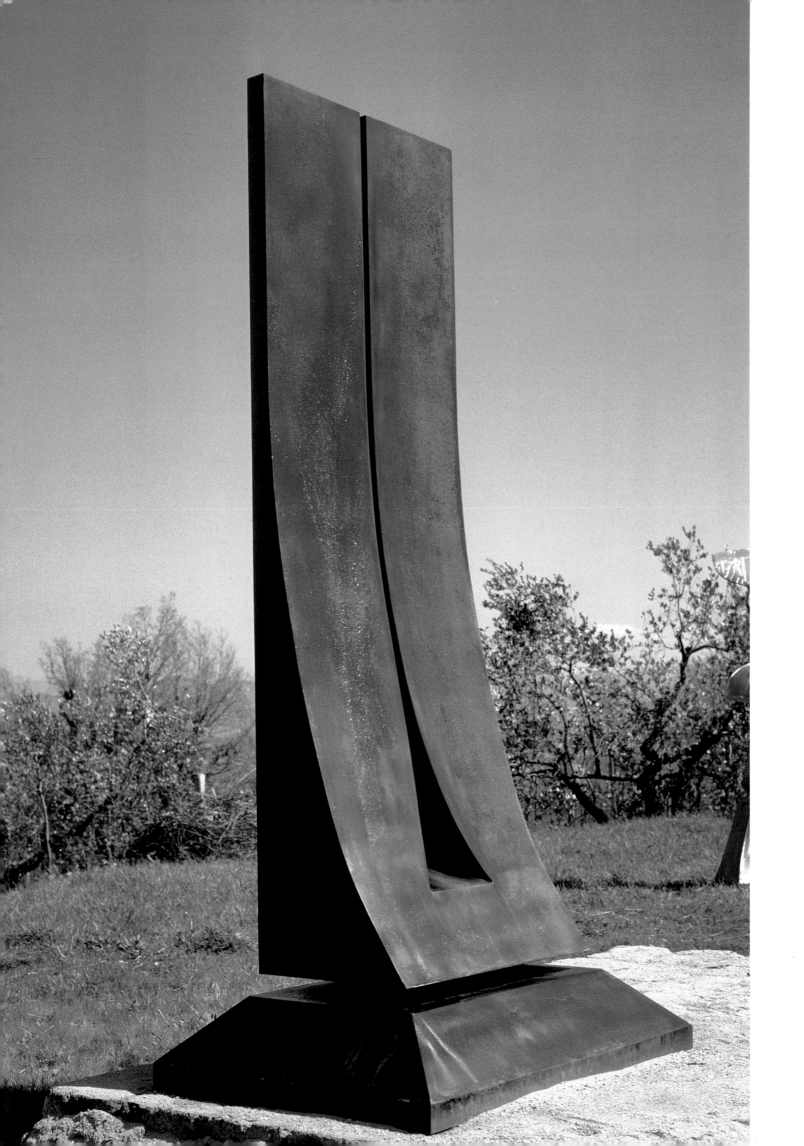

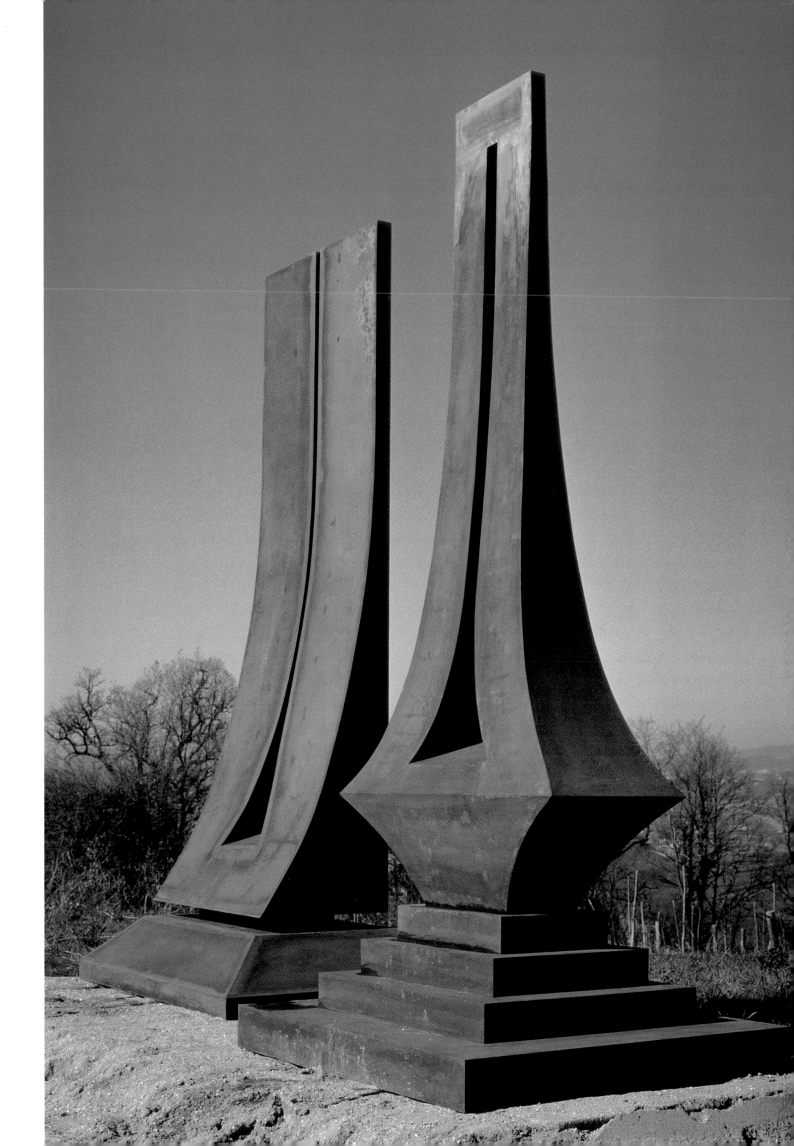

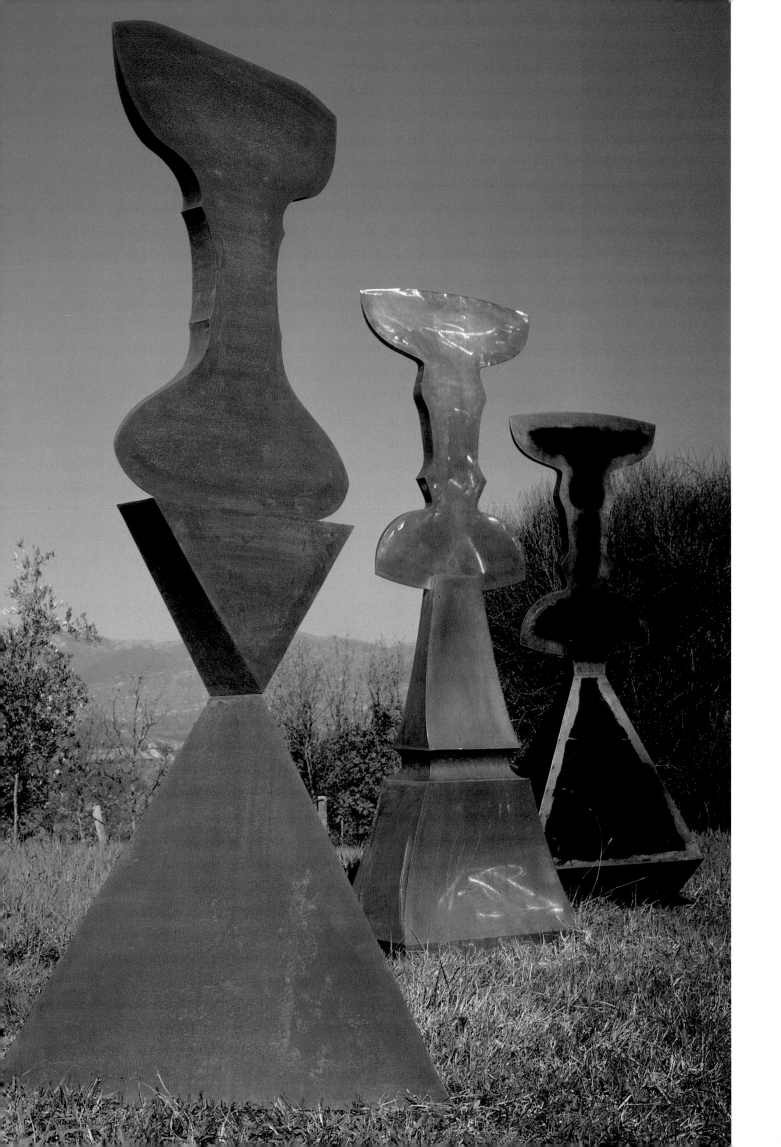

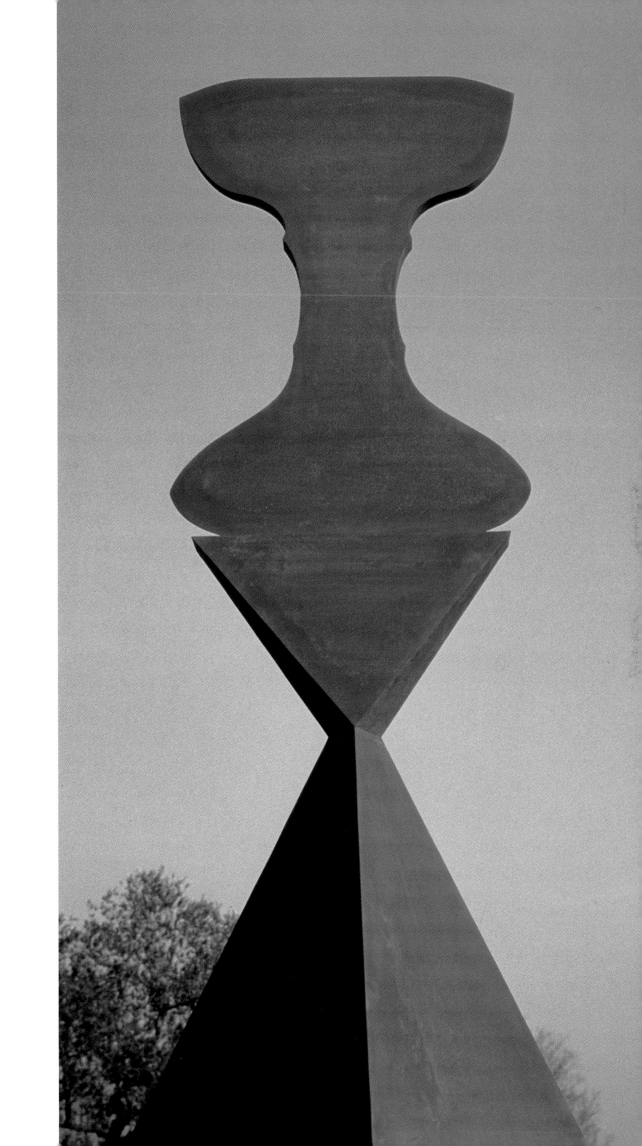

Ternary Altar, 1985

Opposite: *Ternary Altar*, 1985;
Tetrachord Altar, 1985–86;
Dactyl Altar, 1985

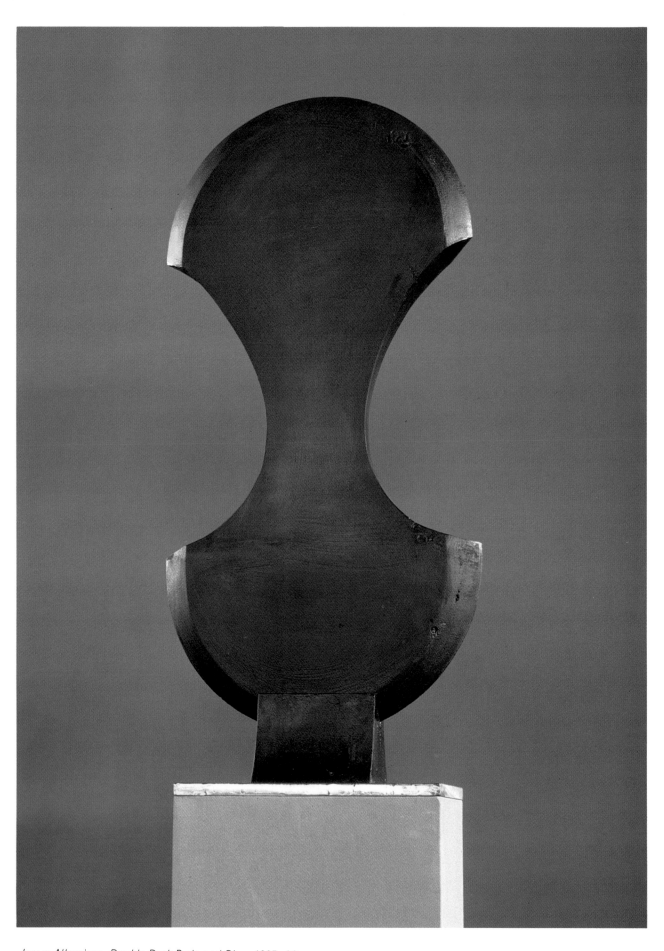

Janus Altarpiece, Double Dark Reds and Blue, 1985–86

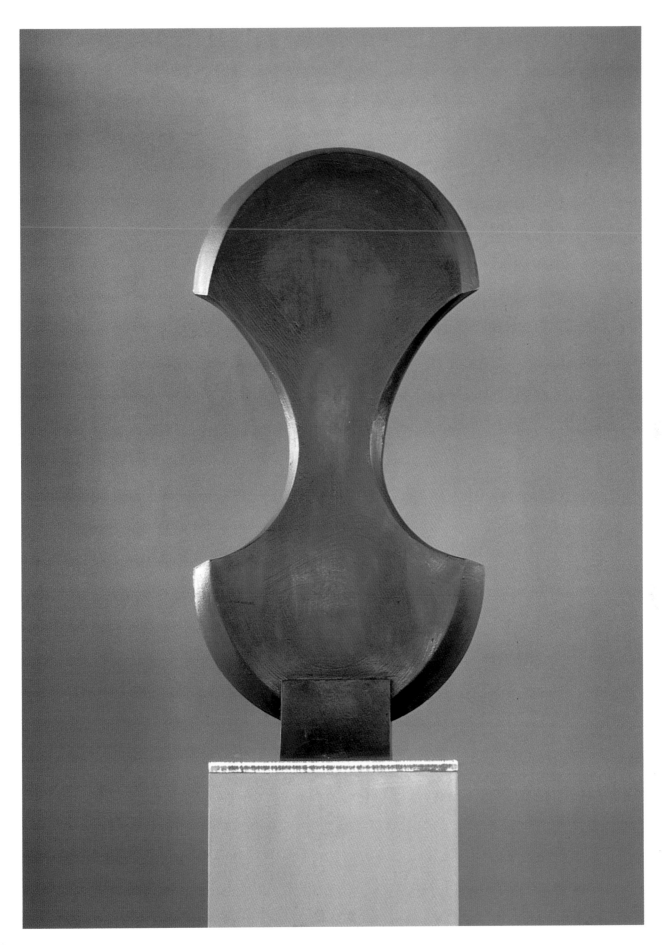

Janus Altarpiece, Rembrandt Blue on Prussian Blue on Black, 1986

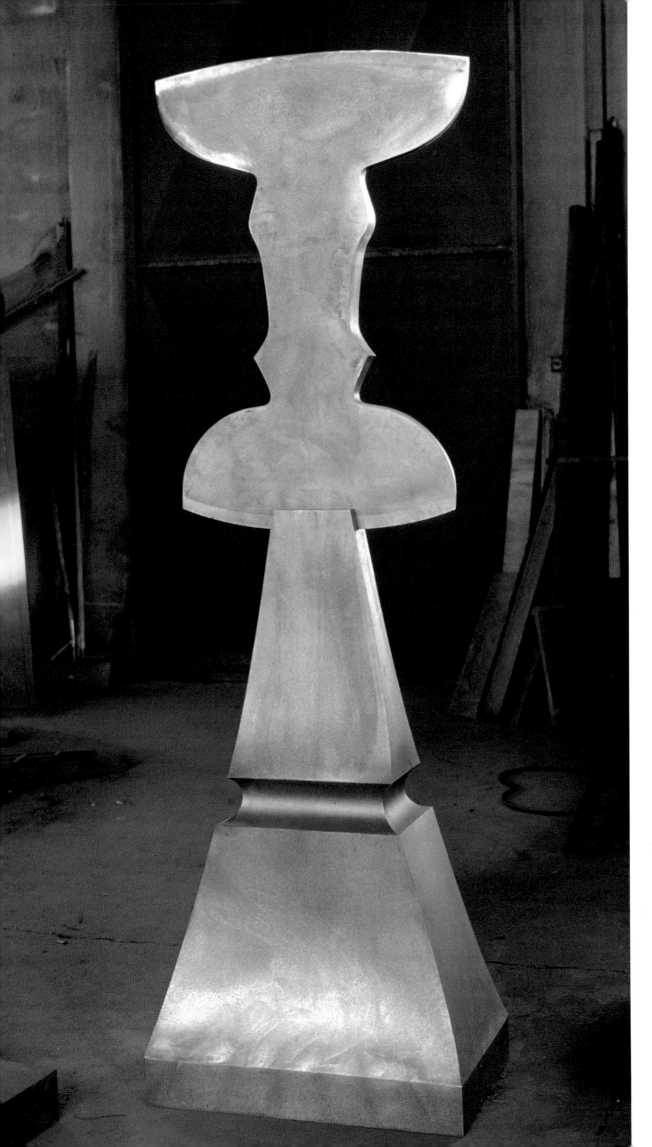

Tetrachord Altar, 1985–86

BEVERLY PEPPER

CHRONOLOGY, EXHIBITIONS,
AWARDS, GRANTS, COMMISSIONS,
INSTALLATIONS, AND COLLECTIONS

Romulus Column, 1978; *Remus Column*, 1978

CHRONOLOGY

1924–48 Born Beverly Stoll, December 20, Brooklyn, New York. At sixteen, enters Pratt Institute, Brooklyn, to study advertising design, photography, and industrial design. Begins career as commercial art director. Studies at Art Students League and attends night classes at Brooklyn College, including art theory with Georgy Kepes, who introduces her to the work of László Moholy-Nagy and Man Ray.

1949 Studies painting in Paris at the Académie de la Grande Chaumière. Attends classes with André L'Hôte, and with Fernand Léger at his atelier. Visits the studios of Ossip Zadkine and Brancusi. Marries Curtis Gordon (Bill) Pepper.

1950–52 Returns to the United States, then travels throughout Europe and the Middle East. Lives and paints in Paris, Haute de Cagnes, Rome, and Positano. Daughter Jorie born. Painting fellowship from Italian Ministry of Foreign Affairs. Settles in Rome. First solo exhibition of paintings at Galleria dello Zodiaco, Rome. Critical support from Lionello Venturi.

1954–58 Son John born. Several solo and group exhibitions in the United States. Begins making small clay and wood sculptures.

1960 Travels throughout the world. Spends time in Japan and Angkor Wat, Cambodia, where she is deeply affected by Japanese Haniwa funerary statues and Khmer statuary. Discovers thirty-nine felled trees in a field adjacent to her home in Rome and subsequently uses them in her sculpture.

1961 First group show as sculptor, Rome–New York Art Foundation, *The Quest and The Quarry,* organized by Herbert Read; shows *Laocoön.* First solo exhibition of sculpture at Galleria Pogliani, Rome. Works are organic, integrating wood carving and metal casting. Giovanni Carandente invites ten sculptors (including Pepper, David Smith, Alexander Calder, Arnaldo Pomodoro, Lynn Chadwick, and Pietro Consagra) to fabricate works in Italsider factories in Italy for an outdoor exhibition, *Sculture nella città,* to be held in Spoleto during the summer of 1962. Working directly in the factory (as she would with subsequent major sculptures,) Pepper creates *The Gift of Icarus, Leda, Spring Landscape,* two other large works, and seventeen smaller ones.

1962 First sculpture exhibition in the United States, Thibaut Gallery, New York. Works based on loops and intertwinings of wood are translated into steel, becoming more open and airy. First large-scale commission, from architect William Lescaze, *Contrappunto.*

1965 Joins Marlborough Galleria d'Arte, Rome. Solo exhibition reveals shift from expressionistic to geometric forms; uses stainless steel or Cor-Ten with painted interiors. Frank O'Hara writes poem "New Particles from the Sun" for exhibition catalog. Works during summer at the Terninoss Steel Mill, Terni, on *John F. Kennedy Memorial* for the Weizmann Institute, Rehovoth, Israel.

1966 Works during winter at Steel and Alloy Tank Company, Newark, New Jersey, on *Strands of Mirror* for the Joseph Meyerhoff Corporation, Memphis, Tennessee. Fabricates twelve small works of stainless steel with brush-polished exteriors and painted interiors. Works at Hildreth's blacksmith shop, Watermill, Long Island, during summer. Experiments with chrome plating, which results in mirrorlike surfaces. Joins Marlborough Gallery, New York.

1967–69 Develops highly polished stainless-steel illusionist works: *Zig Zag* and *Excathedra.* Experiments with environmental projects, using grass, sand, hay, cars. Develops "connective-art," artwork that is connected with society, especially with urban areas and nature.

1969 Jan van der Marck organizes first traveling exhibition of Pepper sculpture.

1970 Uses Cor-Ten in increasingly earthbound sculptures. Begins *Split Pyramid.*

1971–75 Installs first large environmental project in Dallas, *Dallas Land Canal and Hillside* (1971–75). Completes commissions, *Sudden Presence* (1971) for City of Boston, and *Campond* (1973) for the Albany Mall.

1972 Exhibits at *XXXVI Biennale di Venezia.* Moves to Todi (Perugia), Italy.

1973 Associated with Earth Art movement.

1974–76 Creates *Amphisculpture* (1974–76) for the AT&T Communications Headquarters (formerly Longlines Building), Bedminster, New Jersey. First exhibition at André Emmerich Gallery, New York. Four monumental works (*Alpha, Ascension/Descension, Perazim, Ascension*) shown at Dag Hammarskjold Plaza Sculpture Garden, New York. Critic Robert Hughes writes: "*Alpha* . . . is arguably one of the most successful pieces of monumental sculpture produced by an American in the past decade." Works with Henry T. Hopkins on an exhibition of Pepper's work from 1971–75.

1976–77 Completes 130-foot land-hugging *Thel,* Dartmouth College, Hanover, New Hampshire. *Web* series shown at André Emmerich Gallery. Work included in *Documenta 6,* Kassel, West Germany.

1977–78 Begins series of small-scale forged and cast-iron totemic sculptures.

1979 Works in Terninoss Steel Mill, Terni, to create four monumental steel columns for exhibition in Piazza di Todi: *Aventinus* (28 feet 5 inches), *Martius* (35 feet 7 inches), *Senatoria* (34 feet 4 inches), and *Traiana* (35 feet 10 inches). Participates in symposium, *Earthworks as Land Reclamation,* Seattle, Washington, with Robert Morris, Herbert Bayer, Mary Miss, Dennis Oppenheim, among others. Designs the *Montlake Landfill,* a refuse viewing-chamber, University of Washington, Seattle, Washington.

1980 First of the *Markers,* primordial cast-iron columns, appears.

1981 Pioneers use of ductile iron in sculpture at John Deere Foundry, East Moline, Illinois. Casts twelve *Moline Markers, Spirit of Place,* and *Trapezium.* Completes *Polygenesis (60 feet)* for complex by Cesar Pelli, Four-Leaf Towers, Houston, Texas.

1982 Receives honorary doctorate, Pratt Institute, June. Installs three ductile iron *Markers* (26 to 45 feet), indoors, at Richard J. Hughes Justice Complex, Trenton, New Jersey.

1983–84 Columns evolve into taller and slimmer free-standing verticals. Patina bronzes, oil-painted surfaces, and wood mixed with metal reappear in work. Receives honorary doctorate, Maryland Institute College of Art, Baltimore, May 1983.

1985 Completes *Cromech Glen,* earthwork set in the woodlands of Laumeier International Sculpture Park, St. Louis, Missouri. Begins *Sol i Ombra Park,* Barcelona, Spain.

1986 Completes *Urban Altars.* Completes *Janus Agri Altar* for Iowa State University at Ames. Artist-in-residence, American Academy, Rome.

ONE-ARTIST EXHIBITIONS

1952 Galleria dello Zodiaco, Rome, Italy.
Italy by Beverly Pepper, November 9–December 4.
Catalog, text by Carlo Levi.

1954 Barone Gallery, New York, New York.
Beverly Pepper, November 9–December 4.

1955 Obelisk Gallery, Washington, D.C.

1956 Barone Gallery, New York, New York.
Beverly Pepper, November 9–December 5.

Galleria Schneider, Rome, Italy.
Trentatre desegni di Beverly Pepper.

1958 Barone Gallery, New York, New York.
Beverly Pepper, November 10–December 3.

1959 Galleria L'Obelisco, Rome, Italy.
Beverly Pepper, November 21–[n.d.].
Brochure, text by Giancarlo Vigorelli.

1961 Galleria Pogliani, Rome, Italy.
Pepper, September [n.d.]–October 15.
Catalog, text by G. C. Argan.

1962 Thibaut Gallery, New York, New York.
Beverly Pepper, October 23–November 13.
Catalog, text by Giovanni Carandente.

1965 Marlborough Galleria d'Arte, Rome, Italy.
Beverly Pepper, November.
Catalog, texts by Milton Gendel, Frank O'Hara, and Karl Katz.

1966 McCormick Place, Chicago, Illinois.
Beverly Pepper, May 13–18.
Catalog.

1968 Marlborough Galleria d'Arte, Rome, Italy.
Beverly Pepper, February.
Brochure, interview with the artist and Piero Dorazio by Giuseppe Ungaretti.

The Jewish Museum, New York.
Zobaum, March 15–(n.d.)

Galleria d'Arte La Bussola, Turin, Italy.
Beverly Pepper, April 6–[n.d.].
Catalog, texts by Renzo Guasco and Giuseppe Ungaretti.

Galleria Paolo Barozzi, Venice, Italy.

1969 Marlborough-Gerson Gallery, Inc. New York, New York.
Beverly Pepper: Recent Sculpture, February 1–22.
Catalog, text by Jan van der Marck.
Traveled to Museum of Contemporary Art, Chicago, Illinois (March 8–April 13); Hayden Court and Plaza, Massachusetts Institute of Technology (May 21–September 1); Albright-Knox Art Gallery, Buffalo, New York (September 29–November 2); Everson Museum of Art, Syracuse, New York (January 18–April 19, 1970).

1970 Studio Marconi, Milan, Italy.
Beverly Pepper: Recent Work, April.
Brochure, statement by the artist.

Rotonda della Besana, Milan, Italy.
Beverly Pepper, June 25–July 25.

1971 Parker Street 470 Gallery, Boston, Massachusetts.
Beverly Pepper: Sculpture, November 14–December 11.

Galerie Hella Nebelung, Düsseldorf, West Germany.

Piazza Margana, Rome, Italy.
Pepper Sculpture in Piazza Margana, May 17–June 16.
Catalog, text by Italo Mussa.

1972 Galleria Editalia qui Arte Contemporanea, Rome, Italy.
Beverly Pepper, May–[n.d.].
Brochure, text by Giovanni Carandente.

Marlborough Galleria d'Arte, Rome, Italy.
Beverly Pepper, May.
Catalog, text by Marisa Volpi Orlandini.

1973 The Tyler School of Art in Rome, Temple University Abroad, Rome, Italy.
Beverly Pepper: Sculpture 1960–1973, March 1–April 4.
Catalog, texts by Stephen Greene, Jan van der Marck, G. C. Argan, Giovanni Carandente, Karl Katz, Milton Gendel, Giuseppe Ungaretti, Marisa Volpi Orlandini, and statement by the artist.

1975 André Emmerich Downtown, New York, New York.
Beverly Pepper: New Work, May 10–June 27.

Hammarskjold Plaza Sculpture Garden, New York, New York.
Beverly Pepper: New Sculpture, May 10–September 1.

1977 Indianapolis Museum of Art, Indiana.
Beverly Pepper Sculpture, April 9–[n.d.].

André Emmerich Gallery, Inc., New York, New York.
Beverly Pepper: New Sculpture, October 8–26.
Brochure.

1978 The Art Museum, Princeton University, New Jersey.
Beverly Pepper, September–November.

1979 André Emmerich Gallery, Inc., New York, New York.
Beverly Pepper: Small Sculpture 1977–78, March 3–28.
Brochure.

Hofstra University, Hempstead, New York.
Beverly Pepper: Outdoor Sculpture, April 25–July 25.
Brochure.

Piazza Mostrá and Sala delle Pietre, Todi, Italy.
Beverly Pepper in Todi, July 7–September 2.
Catalog, texts by Roberto Abbondanza, Marisa Volpi Orlandini, and Sam Hunter.

1980 Thomas Segal Gallery, Boston, Massachusetts.
Beverly Pepper: Recent Sculpture, January 5–February 6.

Nina Freudenheim Gallery, Buffalo, New York.
Beverly Pepper: Sculpture Drawings, May 16–June 20.

André Emmerich Gallery, Inc., New York, New York.
Beverly Pepper: Large Sculpture, October 2–29.
Brochure.

Gimpel & Hanover Galerie and Galerie André Emmerich, Zurich, Switzerland.
Beverly Pepper, May 10–July 15.

The Greenberg Gallery, St. Louis, Missouri.
Beverly Pepper—Recent Sculpture, October 5–
November 14.

1981 Makler Gallery, Philadelphia, Pennsylvania.
Beverly Pepper, January 12–February 14.

Linda Farris Gallery, Seattle, Washington.
Beverly Pepper: Large and Small Scale Sculpture,
May 21–June 14.

Davenport Art Gallery, Iowa.
Beverly Pepper: The Moline Markers, August 30–
October 4.
Catalog, text by Phyllis Tuchman.

Hanson Fuller & Goldeen Gallery, Inc., San Francisco,
California.
Beverly Pepper: Iron Sculpture, October 28–
November 21.

1982 André Emmerich Gallery, Inc., New York, New York.
Beverly Pepper: New Work 1981–82, April 29–May 22.
Brochure.

Laumeier International Sculpture Park, St. Louis,
Missouri.
Pepper at Laumeier, SITES, columns concepts 1970–82,
May 8–July 5.

Galleria il Ponte, Rome, Italy.
Beverly Pepper: mostrá antologica 1964–68, October 20–
[n.d.].
Catalog.

Yares Gallery, Scottsdale, Arizona.
Beverly Pepper: Recent Sculpture, November 7–30.

1983 Gimpel & Hanover Galerie and Galerie André Emmer-
ich, Zurich, Switzerland.
Beverly Pepper: Saulen & Platze 1982, February 25–
March 19.

Huntington Galleries, West Virginia.
Beverly Pepper In Situ at the Huntington Galleries,
September 18–November 18.
Catalogue.

André Emmerich Gallery, Inc., New York, New York.
Beverly Pepper, October 6–29.

John Berggruen Gallery, San Francisco, California.
Beverly Pepper: Recent Work, November 16–
December 10.

1984 André Emmerich Gallery, Inc., New York, New York.
Beverly Pepper: New Sculpture, November 10–
December 8.
Brochure.

1985 John Berggruen Gallery, San Francisco, California.
Beverly Pepper: Recent Sculpture, May 15–June 15.

Adams-Middleton Gallery, Dallas, Texas.
Beverly Pepper Sculpture, October 17–November 30.

Opius, 1978

SELECTED GROUP EXHIBITIONS

1954 Palazzo dello Esposizioni, Rome, Italy.
I mostra d'arte dei borsisti stranieri.
(Organized by the Ministry of Foreign Affairs).

Wakefield City Art Gallery, England.
Contemporary Italian Art.
Catalog, text by Robert Melville. Traveled to Liverpool, Newcastle-upon-Tyne, and York, England.

1961 Rome–New York Art Foundation, Inc., Rome, Italy.
The Quest and the Quarry, May–September.
Catalog, text by Herbert Read.

1962 Spoleto, Italy.
Sculture nella città, summer.

1964 Galleria Civica d'Arte Moderna, Turin, Italy.
Sculture in metallo.

1965 Rome, Italy.
V rassenga di arti figurative di Roma e Lazio.
Catalog.

1967 Republic of San Marino.
VI Biennale di San Marino: Nuove tecniche d'immagine.

The Jewish Museum, New York, New York.

The Museum of Modern Art, New York, New York.
Jewelry by Contemporary Painters and Sculptors,
October 3–6.
Catalog, text by Renée S. Neu.
Traveling exhibition.

1968 Albright-Knox Art Gallery, Buffalo, New York.
Plus by Minus: Today's Half Century, March 3–
April 14.
Catalog, text by Douglas McAgy.

1970 Indianapolis Museum of Art, Indiana.
Painting and Sculpture Today, April.
Catalog.

Galleria Nazionale d'Arte Moderna, Rome, Italy.
Ommaggio a Roma.

Jacksonville Art Museum, Florida.
Arts Festival XII, Finalists.

1972 Venice, Italy.
XXXVI Biennale di Venezia, June 11–October 1
Catalog.

1973 Institute of Contemporary Art, Boston,
Massachusetts.
Jewelery as Sculpture as Jewelry.

1974 Finch College Museum of Art, New York, New York.
Grafica oggi.

Marlborough Gallery, Inc., New York, New York.
Twentieth Century Monumental Sculpture.

Museum of the Philadelphia Civic Center and Port
of History Museum, Pennsylvania.
Woman's Work: American Art '74.

1975 Janie C. Lee Gallery, Houston, Texas.
Monumental Sculpture in the 1970's.

Parkersburg Art Center, West Virginia.
Renaissance in Parkersburg, September.

1976 USIS Cultural Center, Milan, Italy.
Nineteen Americans 1970/1975, January.

New Orleans Museum of Modern Art, Louisiana.
IX International Sculptor's Conference.

1977 Kassel, West Germany.
Documenta 6, June 24–October 2.
Catalog.

Palazzo della Ragione, Padova, Italy.
XXI Biennale internazionale della piccola scultura.

Rome, Italy.
*Quadriennale Nazionale d'Arte di Roma—Artisti
Stranieri Operanti in Italia.*

John Weber Gallery, New York, New York.
Drawings for Outdoor Sculpture 1946–1977.

1977–78 Los Angeles County Museum of Art, California.
Private images: Photograph by Sculptors, December
20, 1977–March 5, 1978.

1978 Freedman Gallery, Albright College, Reading,
Pennsylvania.
Perspective '78—Works by Women, October 8–
November 15.

1979 King County Administration Building, Seattle,
Washington.
Earthworks: Land Reclamation as Sculpture, Part II,
July 30–August 18.
Catalog.

1980 Nina Freudenheim Gallery, Buffalo, New York.
Drawings, January 12–February 7.

State Museum of Art, Copenhagen, Denmark.
*Art in Embassies: Collection of Ambassador and
Mrs. Warren Manshel,* May 1–June 1.
Catalog.

Washington, D.C.
International Sculpture Conference XI, June.

National Collection of Fine Arts, Smithsonian Institution, Washington, D. C.
Across the Nation, June 4–September 1. Traveled to Hunter Museum of Art, Chattanooga, Tennessee, January–March 1981.

Nassau County Museum, Syosset, New York.
Sculpture at Sands Point, summer–fall.
Catalog.

Civici Musei e Gallerie di Stroria e arte, Instituto per L'Enciclopedia del friuli Venezia Giulia, Udine, Italy.
Arte Americana contemporanea, September 20–November 16.

1980–81　Manhattan Psychiatric Center, Ward's Island, New York.
Area Sculpture—Ward's Island, May 1980–April 1981.

Joe and Emily Lowe Art Gallery, Syracuse University, New York.
All in Line: An Exhibition of Linear Drawing, November 23, 1980–January 18, 1981.
Traveled to Terry Dintenfass Gallery, Inc., New York, New York, January 31–February 27, 1981.

1981　Women in Focus, Vancouver, Canada.
Three Dimensional, May 1–16.

1982　Navy Pier, Chicago, Illinois.
Mayor Byrne's Mile of Sculpture, May 14–29.
Catalog.

Palo Alto, California.
Palo Alto's Outdoor Sculpture Exhibition, June 5–October 1.

Fuller Goldeen Gallery, San Francisco, California.
Casting: A Survey of Cast Metal Sculpture in the '80's, July 8–August 28.
Catalog, text by Albert Elsen.

1983　The Rotunda Gallery, Brooklyn, New York.
Born in Brooklyn, May 18–August 3.

Janie C. Lee Gallery, Houston, Texas.
Sculpture, June 4–September 10.

Thomas Segal Gallery, Boston, Massachusetts.
Sculpture as Architecture, July 7–August 18.

Pratt Manhattan Center Gallery, New York, New York.
Iron Cast, November 21–December 23.
Brochure, text by Ellen Schwartz.
Traveled to Pratt Institute Gallery, Brooklyn, New York, January 12–February 17, 1984.

1983–84　The Public Art Trust, Washington Square, Washington, D. C.
Bronze at Washington Square, October 6, 1983–February 3, 1984.
Catalog, text by Elena Canavier.

Nassau County Museum of Fine Art, Roslyn Harbor, New York.
Sculpture: The Tradition in Steel, October 9, 1983–January 22, 1984.
Catalog, texts by Janis Parente and Phyllis Stigliano.

Comune di Foligno, Perugia, Italy.
Vitalita deli'astrattismo, November 27, 1983–January 7, 1984.
Catalog, text by Cesare Vivaldi

1984　Storm King Art Center, Mountainville, New York.
20th Century Sculpture: Selections from the Metropolitan Museum of Art, May 19–October 31.
Catalog, text by Lowery Sims.

The Guinness Hop Store, Dublin, Ireland.
ROSC '84, August 19–November 17.

André Emmerich Gallery, Inc., New York, New York.
Seven Sculptors, September 6–29.

University Art Gallery, Sonoma State University, California.
Works in Bronze: A Modern Survey, November 2–December 16.
Exhibition traveled throughout California, to Boise, Idaho, and Spokane, Washington, through 1986.

1984–85　Seattle Art Museum, Washington.
American Sculpture: Three Decades, November 15, 1984–January 27, 1985.

André Emmerich Gallery, Inc., New York, New York.
Contemporary Classics, December 13, 1984–January 5, 1985.

1986　The Brooklyn Museum, New York. *Public and Private: American Prints Today,* February 7–May 5.
Catalog.

AWARDS AND GRANTS

1966 Gold Medal and Sculpture Purchase Award, Mostra Internazionale, Fiorino, Italy.

1970 First Prize and Purchase Award, Jacksonville Art Museum, Florida.

 Best Art in Steel Award, Iron and Steel Industry, New York.

1974 Reynolds Metals Company, R. S. Reynolds Memorial Award, Sculpture.

1975 General Services Administration Grant, Washington, D.C.

 National Endowment for the Arts Award.

1979 National Endowment for the Arts Award.

1982 Honorary Doctor of Fine Arts, Pratt Institute, Brooklyn, New York.

1983 Honorary Doctor of Fine Arts, Maryland Insitute, College of Art, Baltimore, Maryland.

1986 Artist-in-Residence, American Academy in Rome, Italy.

SELECTED COMMISSIONS AND INSTALLATIONS

1962 Spoleto, Italy, *Festival dei due mondi. Icarus.*

1963 New York, New York, William Kaufman Company, U.S. Plywood Building. *Contrappunto.*

1965 Rehovoth, Israel, Weizmann Institute. *John F. Kennedy Memorial.*

1966 Memphis, Tennessee, Joseph Meyerhoff Corporation. Southland Mall. *Strands of Mirror.*

1969 Atlanta, Georgia. *Flags Over Georgia, Torre.*

1971 Boston, Massachusetts, Government Center. *Sudden Presence.*

 Dallas, Texas, North Park. *Dallas Land Canal and Hillside.*

1972 New York, G. Oestreicher Company. *Chinsura Lampo.*

1973 Albany, New York, Albany Mall. *Campond.*

 Rome, Italy, Carlo Palazzi. *Alpha.*

1974 New York State Council on the Arts, New York State Award. *Council.*

1974–76 Philadelphia, Pennsylvania, Federal Reserve Bank. *Phaedrus .*

 Bedminster, New Jersey, AT&T Communications Headquarters (formerly Longlines Building). *Amphisculpture.*

 Baltimore, Maryland, Johns Hopkins Hospital. *Ascension/Descension.*

1974 New York State Council on the Arts, New York State Award. *Council.*

1974–76 Philadelphia, Pennsylvania, Federal Reserve Bank. *Phaedrus .*

 Bedminster, New Jersey, AT&T Communications Headquarters (formerly Longlines Building). *Amphisculpture.*

Baltimore, Maryland, Johns Hopkins Hospital. *Ascension/Descension.*

1975 San Diego, California, San Diego Federal Building. *Excalibur.*

 Richmond, Virginia, Reynolds Metals Company. *Conversion.*

1976 Hanover, New Hampshire, Dartmouth College. *Thel.*

1978 Niagara Falls, New York, The Carborundum Company. *Palimpsest 6.*

 Rome, Italy, FAO (Food and Agricultural Organization). *Broken Seed* medal.

1979 Toledo, Ohio, City Hall. *Major Ritual II.*

 Seattle, Washington, Physiocontrol Company. *Ascension/Descension.*

 Todi, Italy. Piazza di Todi. *Colonna Martius, Colonna Aventius, Colonna Senatoria, Colonna Traiana.*

 Toledo, Ohio, Toledo Civic Center. *Major Ritual.*

 Buffalo, New York, Buffalo Convention Center. *Maxi. Zig Zag.*

1981 Trenton, New Jersey, Richard J. Hughes Justice Complex. *Symbiotic Marker. Mute Metaphor. Primary Presence.*

1982 Houston Texas, Four-Leaf Towers. *Polygenesis.* Pontiac, Michigan, Phoenix Center fountain (in progress).

1983 New York, New York, Museum Tower, The Museum of Modern Art. *Untitled. First Triad.*

 New York, New York, The Metropolitan Museum of Art. *Harmonius Triad.*

 Blacksburg, Virginia, Virginia Polytechnic Institute & State University. *Polytech Marker.*

 New York, New York, Doris C. Freedman Plaza, Central Park. *Messenger Series: Interrupted Messenger, Measured Presence, Volatile Messenger, Valley Marker.*

1984 Seattle, Washington, First Interstate Center. *Claudio Column, Deere Split Column, Lima Marker III, Mauro Column II, Triangle Sentinel I.*

1985 St. Louis, Missouri, Laumeier International Sculpture Park. *Cromech Glen.*

 Baltimore, Maryland, Johns Hopkins Hospital. *Great Ascension.*

 New York, New York, Sloan-Kettering Memorial Cancer Center. *Genesis.*

 Buffalo, New York, State University of New York at Buffalo. *Vertical Presence—Grass Dunes.*

 New Smyrna Beach, Florida. Temporary Installation. *Sand Dunes.*

1986 Ames, Iowa. Iowa State University. *Janus Agri Altar.*

SELECTED COLLECTIONS

AT&T, Bedminster, New Jersey
Albertina Museum, Vienna, Austria
Albright-Knox Art Gallery, Buffalo, New York
Atlantic Richfield Company, Los Angeles, California
The Brooklyn Museum, New York
Dartmouth College, Hanover, New Hampshire
Davenport Art Gallery, Iowa
John Deere Foundry, East Moline, Illinois
Everson Museum of Art, Syracuse, New York
Federal Reserve Bank, Philadelphia, Pennsylvania
Fidelity Union Life Insurance Company, Dallas, Texas
Fogg Museum, Cambridge, Massachusetts
Galleria Civica d'Arte Moderna, Turin, Italy
Galleria d'Arte Moderna, Florence, Italy
Hirshhorn Museum and Sculpture Garden, Washington, D. C.
Richard J. Hughes Justice Complex, Trenton, New Jersey
Huntington Art Gallery, West Virginia
Indianapolis Museum of Art, Indiana
Instituto Italiano di Cultura, Stockholm, Sweden
Jacksonville Museum of Modern Art, Florida
Massachusetts Institute of Technology, Cambridge, Massachusetts
The Metropolitan Museum of Art, New York, New York
Milwaukee Arts Center, Wisconsin
Mount Holyoke College, South Hadley, Massachusetts
Museum of Fine Arts, Boston
Parkersburg Art Museum, West Virginia
Charles Rand Penney Foundation, Olcott, New York
Power Institute of Fine Arts, Sydney, Australia
Rochester Art Museum, New York
Rutgers University, New Brunswick, New Jersey
Smithsonian Institution, Washington, D. C.
Vassar College, Poughkeepsie, New York
Walker Art Center, Minneapolis, Minnesota
Western Washington University's Outdoor Museum, Bellingham, Washington
Worcester Art Museum, Massachusetts

Osiris Column, 1979

169

SELECTED BIBLIOGRAPHY

1952 "Beverly and Her People." *Time* (New York), vol. 60, December 8: 76.

1954 C[ampbell], L[awrence]. "Reviews and Previews: Beverly Pepper." *ARTnews* (New York), vol. 53, no. 8, December: 54–55.

F[einstein], S[am]. "Fortnight in Review: Beverly Pepper." *Arts Digest* (New York), vol. 29, no. 5, December 1: 33.

1956 M[unro], E[leanor]. "Reviews and Previews: Beverly Pepper." *ARTnews* (New York), vol. 55, no. 8, December: 11.

1958 B.D.H. "In the Galleries: Beverly Pepper." *Arts* (New York), vol. 33, no. 3, December: 62.

1960 Gendel, Milton. "Art News from Rome: Italians, Americans in One-Man Shows." *ARTnews* (New York), vol. 59, no. 4, Summer: 51.

1962 C[ampbell], L[awrence]. "Reviews and Previews: Beverly Pepper." *ARTnews* (New York), vol. 61, no. 7, November: 15

1965 Eliot, Alexander. "Adventures Abroad." *Art in America* (New York), vol. 53, no. 2, April: 149.

1966 Lucas, John. "Rome: The Quadriennale - With Some Omissions Repaired." *Artsmagazine* (New York), vol. 40, no. 3, January: 44.

1969 A[shbery], J[ohn]. "Reviews and Previews: Piero Dorazio and Beverly Pepper." *ARTnews* (New York), vol. 68, no. 1, March: 16.

B[attcock], G[regory]. "In the Galleries: Beverly Pepper." *Arts* (New York), vol. 43, no. 5, March: 61.

Mellow, James R. "New York Letter." *Art International* (Lugano, Switzerland), vol. 13, no. 4, April: 39.

1970 Francalanci, Ernesto Luciano. "Milano e Venezia." *Art International* (Lugano, Switzerland), vol. 14, no. 6, summer: 118–19.

W[elish], M[arjorie]. "In the Museums: Beverly Pepper." *Arts* (New York), vol. 44, no. 4, February: 54.

1974 Kelder, Diane. "Prints: Intaglio alla Romana." *Art in America* (New York), vol. 62, no. 5, September/October: 37.

1975 *Beverly Pepper: Sculpture 1971–1975.* San Diego, California: Fine Arts Gallery of San Diego.

Butterfield, Jan and Beverly Pepper. "Beverly Pepper: A Space has Many Aspects." *Artsmagazine* (New York), vol. 50, no. 1, September: 91–94.

Hughes, Robert. "A Red-Hot Momma Returns." *Time* (New York), June 16: 51.

Lubell, Ellen. "Beverly Pepper." *Artsmagazine* (New York), vol. 50, no. 1, September: 19.

Zucker, Barbara. "New York Reviews: Beverly Pepper." *ARTnews* (New York), vol. 74, no. 7, September: 110.

1977 Frackman, Noel. "Beverly Pepper/Classical Art." *Artsmagazine* (New York), vol. 52, no. 4, December: 18–19.

Krauss, Rosalind. *Passages in Modern Sculpture.* New York, Viking Press.

Perlberg, Deborah. "Beverly Pepper, André Emmerich Gallery." *Artforum* (New York), vol. 16, no. 4, December: 65–66.

Ratcliff, Carter. "New York Letter." *Art International* (Lugano, Switzerland), vol. 21, no. 6, December: 69.

1978 Barnes, Helen. "Torre Olivola in Umbria: The Studio/Home of Sculptress Beverly Pepper." *Architectural Digest* (Los Angeles), vol. 35, no. 10, October.

Cohen, Ronny H. "Beverly Pepper at André Emmerich." *Art in America* (New York), vol. 66, no. 2, March/April: 140.

1979 Foote, Nancy. "Monument—Sculpture—Earthwork." *Artforum* (New York), vol. 18, no. 2, October: 32–37.

Gibson, Eric. "New York: Beverly Pepper." *Art International* (Lugano, Switzerland), vol. 23, no. 2, May: 20.

Hale, Nide. "New York Exhibitions: Beverly Pepper." *Art/World* (New York), vol. 3, no. 7, March 16–April 16: 9.

Keefe, Jeffrey. "Reviews: Beverly Pepper, André Emmerich Gallery." *Artforum* (New York), vol. 17, no. 9, May: 59.

Licht, Fred S. "The Todi Festival: Public Sculpture Umbrian Style." *Art in America* (New York), vol. 67, no. 6, October: 11, 13.

van der Marck, Jan. *Acquisitions 1974–78.* Hanover, New Hampshire: Dartmouth College Museum and Galleries.

Rickey, Carrie. "Beverly Pepper, Andre Emmerich Gallery." *Artforum* (New York), vol. 17, no. 9, May: 58–59.

Sheffield, Margaret. "Beverly Pepper's New Sculpture." *Artsmagazine* (New York), vol. 54, no. 1, September: 172–73.

1980 Cohen, Ronny H. "Beverly Pepper, André Emmerich Gallery." *Artforum* (New York), vol. 14, no. 4, December: 75.

Forgey, Benjamin. "It Takes More than an Outdoor Site to Make Sculpture Public." *ARTnews* (New York), vol. 79, no. 7, September: 88.

Frank, Elizabeth. "Beverly Pepper at André Emmerich." *Art in America* (New York), vol. 68, no. 9, November: 142.

Noah, Barbara. "Cost-Effective Earth Art." *Art in America* (New York), vol. 68, no. 1, January: 12–15.

Tannous, David. "Report from Washington: The 11th International Sculpture Conference." *Art in America* (New York), vol. 68, no. 9, November: 39–45.

1981 "Beverly Pepper." *Prometheus* (Philadelphia: Makler Gallery), no. 57, January: 2.

Baldwin, Nick. "Art and Industry: A Happy Marriage." *Des Moines Sunday Register* (Des Moines, Iowa), August 30: 5C.

Campbell, R. M. "Sculpture is Boldly Assertive." *Seattle Post-Intelligencer*, May 23: 1.

Cebulski, Frank. "Refining Primitive Influence." *ART WEEK* (Oakland, California), vol. 12, no. 38, November 14: 6.

1982 Hawthorne, Don. "Does the Public Want Public Sculpture?" *ARTnews* (New York), vol. 81, no. 5, May: 56–63.

King, Mary. "Crossings of the Formal and the Poetic." *St. Louis Post-Dispatch*, May 16: 5F.

Munro, Eleanor. *Originals: American Women Artists.* New York: Simon and Schuster.

Rubenstein, Charlotte Streiffer. *American Women Artists.* New York: Avon Books.

Tuchman, Phyllis. "Beverly Pepper: The Moline Markers." *Bennington Review* (Bennington, Vermont), no. 14, winter: 41–43.

1983 Ameringer, Will. "The New Sculpture of Beverly Pepper." *Artsmagazine* (New York), vol. 58, no. 2, October: 108–09.

Baker, Kenneth. "Vertical Movement, Sequence." *The Christian Science Monitor* (Boston), June 6: 24

Cooper, James F. "Pepper's Abstract Art is Less Ominous but Strikingly Beautiful." *The New York City Tribune*, October 28: 6B.

Glueck, Grace. "Beverly Pepper." *The New York Times*, December 30, 1983: C21.

Kalil, Susie. "Works of 13 Sculptors at Janie C. Lee Gallery." *The Houston Post*, July 10: 8F.

Smagula, Howard. *Currents: Contemporary Directions in the Visual Arts.* New York: Prentice-Hall.

1984 "Fabricating to Resemble Casting." *International Sculptor* (Washington, D. C.), vol. 3, no. 1, February: 9.

Baker, Kenneth. "Interconnections: Beverly Pepper." *Art in America* (New York), vol. 72, no. 4, April: 176–79.

Bannon, Anthony. "Pepper and Her Subway Art: Both Have Style." *The Buffalo News*, Sunday, June 10, 1984.

Berger, David. "Markers Please Eyes in Plaza." *The Seattle Times*, Friday, November 16: C6.

Cooper, James F. "Galleries." *The New York City Tribune*, Friday, December 7: 5B.

Cooper, James F. "Hurry to Sculpture and Still Life Exhibits." *The New York City Tribune*, Friday, December 7: 5B.

Hackett, Regina. "A Gift to the City Makes its Mark on the Art World." *Seattle Post-Intelligencer*, Saturday, November 17, 1984: D3.

Henry, Gerrit. "Beverly Pepper/André Emmerich." *ARTnews* (New York), vol. 83, no. 1, January: 158.

1985 Baker, Kenneth. "Sculpture in Good Standing: New Show of Beverly Pepper's Works." *San Francisco Chronicle*, May 17: 74.

Bell, Jane. "Beverly Pepper." *ARTnews* (New York), vol. 84, no. 2, February: 135.

Kutner, Janet. "New Heights in Sculpture." *The Dallas Morning News*, October 31: 1F.

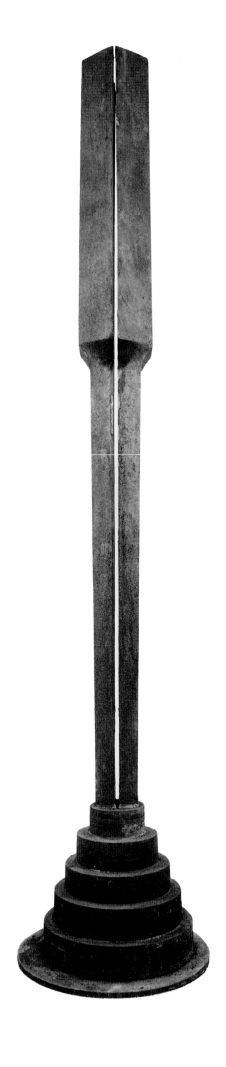

ACKNOWLEDGMENTS

The steadfast support and cooperation of Beverly Pepper were key ingredients in the formulation of this project. Were it not for her willingness to give freely of her time and knowledge and to contribute as called upon at many levels, this exhibition would not have been possible. It has been a privilege and a pleasure to work with Beverly Pepper over the last several years and to have had an opportunity to know more of her artistic vision and zestful approach to life. Her intellectual curiosity has enlivened our interaction and, in turn, affected the course of the exhibition. For all of this, I am grateful to her, and wish to express my deepest appreciation.

During my visits to the artist's studios and homes in Todi and New York, I have always enjoyed the warmth and friendship of Bill Pepper. Janet Goleas, the artist's studio assistant, provided invaluable assistance. She responded to our many requests for information with efficiency and with great devotion to the artist.

This volume is, indeed, the result of the efforts of many individuals. We are most indebted to Rosalind Krauss for her provocative essay, which lends insight into the particular factors that have influenced the artist's evolution since 1960. I wish to express my thanks to Georgette Hasiotis for her fine editing and supervision of the publication; to Alex and Caroline Castro of Hollowpress, Baltimore, for their sensitivity and skill in the design of the book; and to Robert E. Abrams, Alan Axelrod and Sharon Gallagher of Abbeville Press for their cooperation throughout the preparation of the book.

On behalf of Albright-Knox Art Gallery, I would like to acknowledge our appreciation to the lenders to this exhibition. It is only through their generosity and cooperation in sharing the artist's work over an extended period that an exhibition of this scope became possible.

The support with public funds from the New York State Council on the Arts and from the National Endowment for the Arts as well as a generous grant from GFI/Knoll International Foundation have enabled us to realize more fully the final exhibition.

Tarquinia Spiral III, 1979–80

We are particularly grateful to the directors of the museums participating in the tour of the exhibition for their cooperation: Henry T. Hopkins, Director, San Francisco Museum of Modern Art; Budd Harris Bishop, Director, Columbus Museum of Art; Robert T. Buck, Director, The Brooklyn Museum; and Robert H. Frankel, Director, Center for the Fine Arts, Miami.

The extraordinary dedication and assistance of the following individuals were also essential: André Emmerich; Nathan Kolodner and Dorsey Waxter of the André Emmerich Gallery, New York; Edward P. Caraco, Director, Adams-Middleton Gallery, Dallas; Nina Freudenheim, Nina Freudenheim Gallery, Buffalo; John Berggruen, John Berggruen Gallery, San Francisco; Charlotta Kotik, Curator of Contemporary Art, The Brooklyn Museum; and Steven W. Rosen, Chief Curator, Columbus Museum of Art. To each of these individuals, I would like to express special gratitude.

A large measure of the credit for the exhibition is due to the enthusiastic and capable efforts of the registrar of the Albright-Knox Art Gallery, Laura Catalano, who also acted as Curatorial Coordinator throughout the many months during which the exhibition was being organized. The following staff members have contributed to the project: Francis C. Ashley, Comptroller; Barbara C. Barber, Development Officer; Bette Blum, Administrator, Director's Office; Lenore Godin, Gallery Shop Manager; Judith Joyce, Assistant Editor; Ida Koch, Secretary to the Director; John Kushner, Building Superintendent, and his team of installers; Annette Masling, Librarian; Leta K. Stathacos, former Coordinator of Marketing Services; and Jan Volpini, Curatorial Secretary.

Throughout the organization of this exhibition, I have enjoyed the support and encouragement of Seymour H. Knox, Honorary Chairman of The Buffalo Fine Arts Academy.

Douglas G. Schultz
Director, Albright-Knox Art Gallery

LIST OF WORKS ILLUSTRATED

Dimensions are given with height preceding width and depth.
All works are from the collection of the artist unless otherwise noted.

175

INDEX

All photographs courtesy of the artist unless otherwise noted

Art Resource, New York: p. 30
Grant Barker for André Emmerich Gallery: pp. 110 (left), 114, 115
Carlo Bavagnoli: pp. 39, 42, 46
Steve Bickley: p. 96
©Dan Budnick: pp. 4–5 (Courtesy André Emmerich Gallery), 75
Mitchell D. Cohen, Davenport Art Gallery, Iowa: pp. 102, 120–121
Dana Duke: p. 20
André Emmerich Gallery: pp. 15, 86, 87, 99, 103, 146, 162
Ferruzzi: p. 65
Marcella Galassi: pp. 92–93
Phillip Galgiani: p. 113
Giraudon/Art Resource, New York: p. 28
©Gianfranco Gorgoni: pp. 88, 89, 90–91, 97, 98, 100, 145
Alberto Griffi: pp. 48, 49, 50, 51
©Mimmo Jodice: pp. 6, 10
©Debra Kolodczak: pp. 136, 137
Rosalind E. Krauss: p. 45
Laumeier International Sculpture Park: p. 134
Joel M. Leven: p. 135
Marlborough Galleria d'Arte: pp. 14, 38, 52, 55, 73
Marlborough-Gerson Gallery Inc: pp. 63, 67, 68
©Moses: pp. 78–79
Antonia Mulas: p. 70
Ugo Mulas: pp. 43, 47, 54, 56, 58, 60, 61, 62, 71
Raymond D. Nasher: p. 84
Geoffrey Nimtzel: p. 94
Bill Pepper: pp. 2–3, 59, 105, 106–107
Enzo Pirozzi: pp. 69, 76, 77, 131
John Ross: pp. 12–13, 17, 44, 53, 72, 74, 108–109, 124, 125, 153–160
Kevin Ryan for André Emmerich Gallery: p. 122
©Steven Sloman: pp. 118, 119, 147
Bettina Sulzer for André Emmerich Gallery: pp. 110 (right), 111
George Tatge: pp. 16, 18 (Courtesy André Emmerich Gallery), 21, 22–23, 57, 148–152
Robert Wallace, Indianapolis Museum of Art: pp. 82, 95
William Walters: p. 144